BERNARD ASHMOLE

ARCHITECT AND SCULPTOR
IN CLASSICAL GREECE

THE WRIGHTSMAN LECTURES

BERNARD ASHMOLE

Architect and Sculptor in Classical Greece

THE WRIGHTSMAN LECTURES

INSTITUTE OF FINE ARTS, NEW YORK UNIVERSITY

DELIVERED AT

THE METROPOLITAN MUSEUM OF ART, NEW YORK

NEW YORK UNIVERSITY PRESS

PUBLISHED FOR THE INSTITUTE OF FINE ARTS, NEW YORK UNIVERSITY
BY NEW YORK UNIVERSITY PRESS, WASHINGTON SQUARE,
NEW YORK 10003

*This is the sixth volume
of the Wrightsman Lectures,
which are delivered annually
under the auspices of the
New York University Institute of Fine Arts*

LIBRARY OF CONGRESS CATALOGUE CARD NUMBER: 72-76019
SBN: 8147-0553-7
MANUFACTURED IN GREAT BRITAIN

Contents

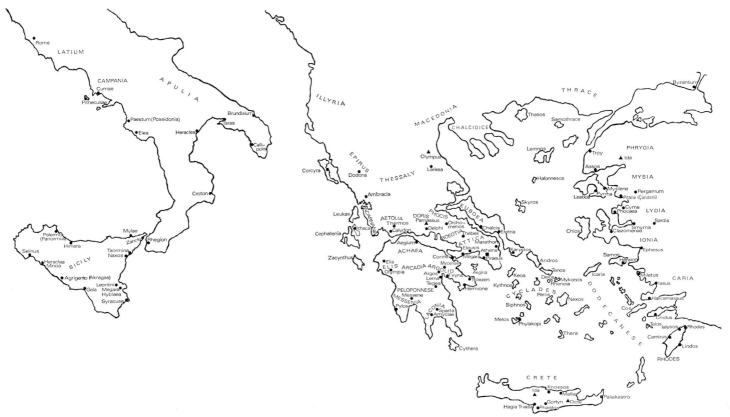

1. Map of the Greek world (from B. Schweitzer, *Greek Geometric Art*)

I

The Temple of Zeus at Olympia

THE PROJECT AND ITS FULFILMENT

WHEN, by the kindness of Mr and Mrs Charles Wrightsman, I was invited to lecture on the major Greek monuments of the fifth and fourth centuries B.C., it seemed impossible to say anything new on subjects which have already been so much and often so admirably discussed. I remembered, however, that in the course of fifty years or more I had come time and time again to some piece of classical sculpture, and almost every time had discovered in it something which either I had not seen before or of which I had not seen the significance: and, realizing that this must be a common experience, I became hopeful that, when looking together at some of the greatest works of Greek art that have survived, we might again discover something that had so far eluded us.

The period with which we are dealing extends from the end of the war with Persia, soon after 480 B.C., to the death of Alexander the Great in 323, or, to put it in the conventional terms of the history of art, from the end of the Archaic to the beginning of the Hellenistic. Just a century and a half; but it covered the lives of Myron, Pheidias and Polycleitus, the aftermath of Pheidian style at the end of the fifth century, then a generation later the classical revival under Cephisodotus and his son Praxiteles, and almost the whole careers of such innovators as Scopas and Lysippus. In short, almost all the great Greek sculptors known to us, though not of course all the great sculptors, because there were many others, especially of the Archaic period, whose names we shall never know.

We shall be confining ourselves almost entirely to sculptures designed for the adornment of architecture, and we must not forget that they are a comparatively small random sample of a vast number of statues, including almost all those considered in antiquity to be masterpieces, which are irretrievably lost. They come mainly from three buildings: one erected in the second quarter of the fifth century B.C., the temple of Zeus at Olympia (say 468–456); one built in the third quarter of the fifth century, the Parthenon at Athens (say 447–430); the third built nearly a hundred years later, round 350 B.C. – the tomb of Mausolus at Halicarnassus.

I do not propose to describe all the sculptures of these buildings in detail: that

has already been done, and done excellently, by various writers; instead I want to consider some of the general aspects of building a temple and providing sculpture for it which are apt to be forgotten; to discuss the disposition of the sculpture on the various parts of the building, with a special scrutiny of the size and the relative scale of the sculptures; and then to select a certain number of them for closer study, with the purpose of trying to discover what it is that gives them their special quality and marks them out as a product of that particular moment in the history of art.

In this first lecture, we shall consider these general problems as they affected the building of the temple of Zeus at Olympia and the provision of sculpture for it, reserving a detailed study of some of its sculptures for the second and third lectures.

In our own day, when a building is to be erected, a number of practical questions arise, which, put briefly, are these. Why are we building? What exactly do we want? Of what will it be built? What will it cost? Where do we find the money? Whom do we employ as architect, and how will the work be organized? What will the exact time-table be?

In ancient times the same questions must have been asked, and answered. Unfortunately we do not know what the answers were, and we can never hope to recover them in full; but it is well worth while examining what evidence there is – mostly little scraps of it from all over the Greek world – and making what inferences we can. I want especially to draw attention to some of the basic physical problems involved, for instance the finding, the transport and the working of the material.[1]

Let us begin, then, by applying some of these questions about ways and means to the temple of Zeus at Olympia. And first a word about the general situation in Greece. By 479 B.C. the Persians had finally retreated, leaving behind them a trail of ruined and smoking cities, and leaving, too, some very tense feelings. Some cities had resisted the invader; Athens was the shining example. Some had collaborated with him, Thebes for instance. Others had given in with suspicious ease, whilst there were others whose attitude was equivocal or defeatist. Among the last was Delphi, and this being remembered against her perhaps helped to tilt the balance in favour of Olympia as the greatest Pan-Hellenic meeting-place. Delphi never lost its religious pre-eminence, but Olympia was the great athletic centre, and devotion to athletics had been steadily increasing throughout the sixth century. Geographically, too, she was well placed (Fig. 1). She was tolerably accessible from mainland Greece and from Asia Minor, because of that great highway the Gulf of Corinth – and it is noteworthy that one of the treasuries at Olympia was built by the city of Byzantion five hundred miles away. She was also accessible from the numerous Greek colonies in Sicily and South Italy, and these cities always supported the Olympic Festival with enthusiasm. Here too the distances were great, but ships could sail direct to within a few miles of the site.

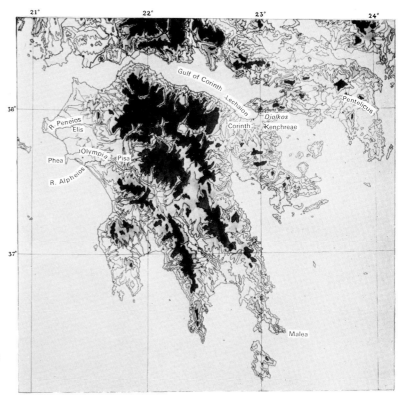

2. Map of the Peloponnese

Olympia had had little to do with the Persian invasion. She was controlled at the time by Elis, under the rule of a narrow oligarchy of comfortable landowners and cattle-breeders. They had indeed sent a contingent to the battle of Plataea, but it had arrived too late; and it was partly the shame of this that led to democrats seizing power, and setting up a new and vigorous government. Within a few years this new government solved for ever an old problem, the status of Pisa in relation to the Olympic festival.

Pisa was a city only a mile or two east of Olympia, further up the valley of the Alpheios, whereas Elis was twenty miles to the north. Pisa must have been quite small: in the time of Pausanias the traveller, the second century A.D., its site was overgrown with vines, and even before that there had been discussions as to whether it had ever really existed, so few traces were left (Fig. 2).

Pisa had almost certainly been the original founder of the Games, but Elis, at some time unknown, had usurped control. There may have been some sort of dual management, some token acknowledgment of the status of Pisa,[2] but it did not satisfy her; and about 470 she was unwise enough to revolt, with many of her neighbours as allies. Both she and they were completely defeated by Elis, and the town of Pisa was destroyed. According to Pausanias it was with the booty from this conquest that both the temple of Zeus, and the colossal gold-and-ivory statue by Pheidias, later placed within it, were built.

But what could a small town like Pisa have to offer in the way of spoils? Certainly not the enormous sum that the temple and the statue must have cost. We

3

have no figures for the gold-and-ivory statue of Zeus by Pheidias, but his other statue of the kind at Athens, the Parthenos, seems to have cost about eight hundred and fifty talents,[3] which, if one reckons the drachme as being worth about one dollar – these relative values are impossible to assess accurately, but that is probably on the low side – would be equivalent to five million one hundred thousand dollars. That is for the statue only, without the temple. Was there that much booty in Pisa? Of course not. Where then was the money? Well, first of all it was not Pisa only that was captured: Herodotus mentions six other towns as well. Nor was it the towns only, it was the whole territory of Pisa and her allies which came under the sway of Elis: a vast area of land rich in horses, cattle, vines and flax – to say nothing of valuable slaves – and this, we may assume, meant some form of steady annual tribute, whether in cash or in kind.

There was also the Olympic Festival, which Elis now controlled completely. It must have brought in a great deal of money, both directly from fees, gifts and sacrifices and – I hesitate to use the word tourism – but a small place does not receive thousands of visitors without considerable financial gain indirectly. Take a single example of the kind of perquisite there must have been. Horses, as almost everyone knows, cannot be sea-sick; but they can feel very unwell on a long sea voyage, and may need weeks to regain their top form. The chariot-teams from many cities – sometimes as many as forty teams competed – and the spare horses, must have arrived at Olympia weeks before the Games started. The Eleans had a monopoly of all the grazing-grounds, all the exercise-grounds, all the stabling and all the fodder. The prices they charged for these things would hardly have been low, nor the total profit anything but immense. So, then, the Festival was the steady source of a large income.

One further important asset accrued to the Eleans from their conquest. They obtained possession of a good harbour, Pheia, or Phea, about twenty miles away from Olympia, with the wealth that a harbour brings; and complete control of all traffic, whether coming from the harbour or not, up the valley of the Alpheios.

That, then, roughly answers the question: Where do we find the money?

To the next questions: 'Why are we building, and what do we want?' the Eleans must have answered somewhat as follows: 'We are in charge of the greatest Pan-Hellenic sanctuary, a sanctuary of Zeus, the supreme god of the Greeks, frequented by people from all over the Greek world (Fig. 3). The only temple in the sanctuary at present is an old building in one corner, with stone foundations, it is true, but mainly of sun-dried brick, timber and terra-cotta, and surrounded by a dilapidated wooden colonnade, of which the columns are rotting away one by one and being replaced by stone columns when we can afford them (Fig. 4). Inside this old temple are the cult-statues, one of Zeus wearing a helmet – which is quite out of fashion

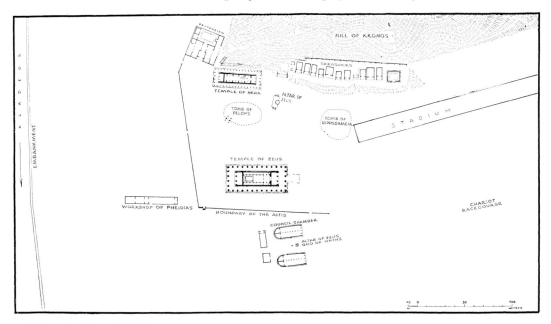

3. Olympia: Plan of the Sanctuary, *c.* 450 B.C.

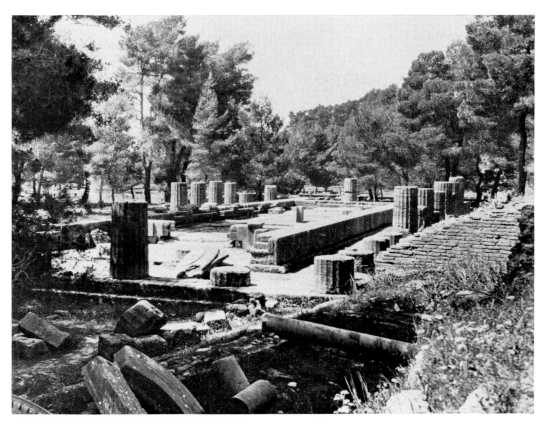

4. Olympia: The Heraion

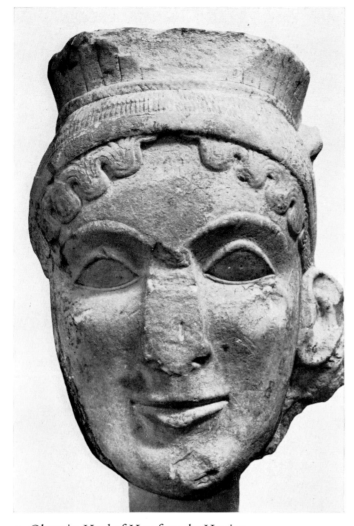

5. Olympia: Head of Hera from the Heraion

by now, since Zeus is no longer a war-god – and the other of Hera (Fig. 5). They are of limestone and quite primitive in style. This temple is highly revered as an antique; it cannot be destroyed, but it cannot very well be modernized, and it is hardly fit to be the centrepiece of a sanctuary nowadays. We want a large new temple, dedicated to Zeus alone, and placed more or less centrally in the precinct.'[4]

A project of this kind, involving immense expenditure by the new government of Elis, must have been controlled by a strong committee of Eleans empowered to take the major decisions. This committee, having taken the decision to build, must then have looked round for an architect, and apparently they did not have to look far. They appointed a local man, Libon, from Elis itself, and he must have played a leading part from now onwards. Libon was no innovator, since his temple, though a noble pure Doric structure, marked no change in design from that of Aegina built twenty or more years before: but he was a master-builder, and it was now his task to produce a building that would stand up in this earthquake-ridden district. This

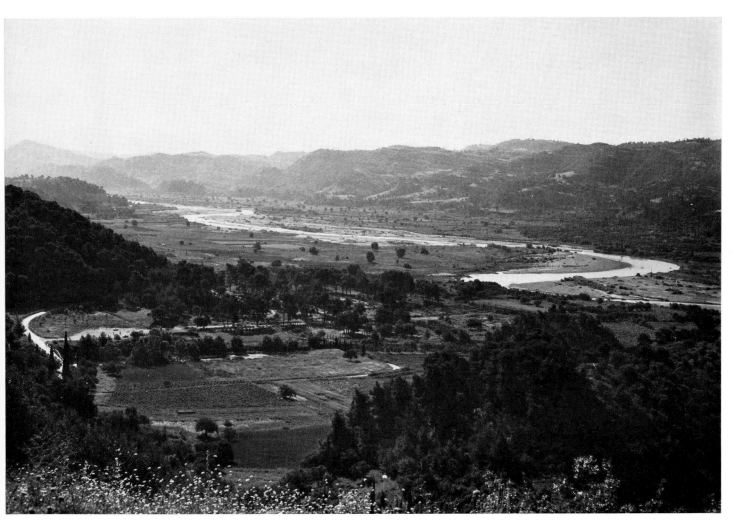

6. Olympia from the West

may seem a sensational way of putting it, but not only is Olympia in the earthquake-zone (the old museum has almost been brought to the ground within the last few years) but also the site of the temple is on alluvial soil and not directly on the rock (Fig. 6).

The traditional Greek method of building was well designed to meet these rather awkward conditions, for the foundations of a Greek temple are in effect a raft: every block is joined by metal cramps to every other block, so that the whole plat-form is a unity. This will float on the soil, and 'float' is no exaggeration, for you may remember that at Ephesus the great archaic temple of Artemis had been built on a sub-foundation of charcoal covered with fleeces to prevent it sinking into the marsh.[5] I believe a similar system has been used in Holland.

The architect must have proposed, and the executive committee of Eleans must have accepted, a scheme to raise the temple about five feet above the general level of the precinct, but the foundations went down deep through the existing level of the soil.

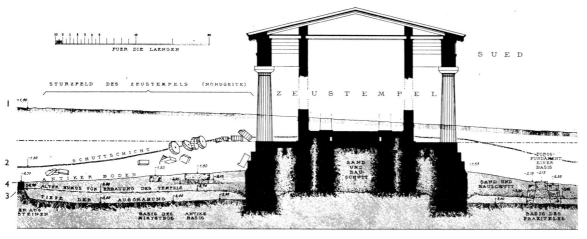

7. Olympia: Section through the sanctuary (from Curtius-Adler, *Olympia*)

After their campaigns of 1875–81 the German excavators published a sectional drawing showing in one diagram the history of the temple from the day it was built to the day it was completely excavated (Fig. 7). The topmost level (which shows in the diagram most clearly on the left of the temple), is that of the soil before the excavations began [1]. The silt deposited by periodical flooding was more than a quarter of the way up the columns, except that the columns were not there any longer – if that is not too metaphysical. Below that comes the soil-level in Byzantine times, with the fallen drums lying more or less as they are still [2]. Below that again is the level with which we are concerned at the moment, namely the ground-level before the temple was built [3]: the foundations for the heaviest parts of the building were laid in trenches cut into that. Then, when building was finished, the level of the soil was raised [4] to cover the substructures, so that in effect the temple was on an artificial mound. The foundation-blocks were of varying sizes; but for the uppermost course, forming the main platform, a particularly fine series of blocks, each eight feet square, was quarried, to support the colonnade.

It is something of a testimonial to Libon's workmanship that the temple-platform is still virtually intact (Fig. 8). The temple itself suffered much from earthquakes, possibly also from fire, and the sculptures have had major repairs and replacements made to them on at least two occasions, once about a century after the construction of the temple, and again in the second or first century B.C.

The plan was very simple, with a single main room for the cult-image and an entrance portico in front. There was a similar portico at the back, but that did not give any access to the interior (Fig. 9).

We must imagine that the architect's opinion was dominant when it came to the question of what material to use. Here the Eleans were lucky. With the ordinary Greek temple, by which I mean a temple not built of marble, almost any kind of good limestone would serve, because the whole building was given a coat of stucco.

8

8. Olympia: The platform of the temple of Zeus from the North

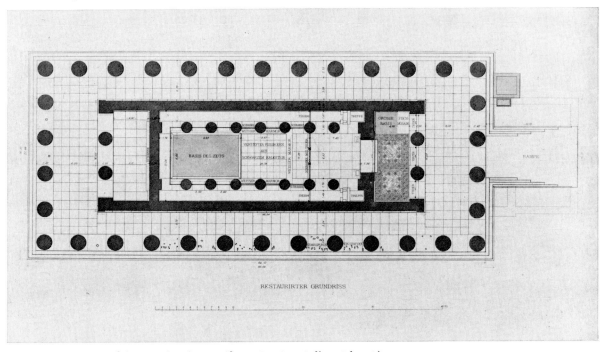

9. Olympia: Plan of the temple of Zeus (from Curtius-Adler, *Olympia*)

The Greeks were free of the kind of aesthetic theory which demands that a building or sculpture shall show at once what it is made of and how it was made. In a Greek temple the elements to be judged were not the blocks of stone, though the Greeks did appreciate fine masonry, but the shapes the architect has created from them — for instance, he wants his column to read as a monolithic shaft, and not as a pile of drums. Hence the almost invisible jointing of the Parthenon, and hence also the extraordinarily fine quality of Greek stucco, composed largely of calcined marble dust, giving a surface almost indistinguishable from marble, and enabling the architect to conceal any joints which he did not wish to be seen.

The Eleans were lucky because quarries yielding abundance of limestone were near at hand across the Alpheios, and thus the cost of transport, the item in the accounts that all ancient contractors must have dreaded, was reduced to a minimum. The stone they used is a conglomerate full of shells, and it looks ruinous when severely weathered, but when newly quarried it can be given a good surface, and takes sharp detail.

A view taken just after the excavation nearly ninety years ago shows clearly the varying thickness of the column-drums (Fig. 10). It did not matter if they were thin, so long as they were sound, for the joints would all be covered with stucco. The blocks were delivered rough, and the carving of the flutes was done in position. This avoided damage during transport and building: it also avoided delay, because the construction above them could be completed while the blocks were rough, rough, that is, except for their upper and lower beds, which had to be made to fit the drums above them and below them perfectly. In other words, the column was complete, but still had a heavy skin of rough stone.

The smooth surfaces on one of the fallen capitals are remains of stucco (Fig. 11). The detail below the capital is still sharp, but when the weather gets in, the surface, as you see, simply breaks up. The profile is a pleasant one, not quite so much like a cushion as early archaic specimens, but not so refined as in the Parthenon. It still has just that degree of weightiness in the profile which shows that the material is a heavy one, and this is a nice parallel to the contrast between early classical and full classical sculpture. Early classical still shows the means by which an effect has been attained, and gives a hint of the effort behind the attainment: the classical is perfection, and makes no attempt to explain itself.

In the reconstruction of the whole order of the temple designed by Libon, we do not know the exact height of the column, since no single one has survived complete, but it was approximately thirty-four and a quarter feet from the stylobate to the top of the abacus (Fig. 12).

The temple now thought to be the second temple dedicated to Hera at the Greek city of Poseidonia in southern Italy, which we call Paestum (the name was changed

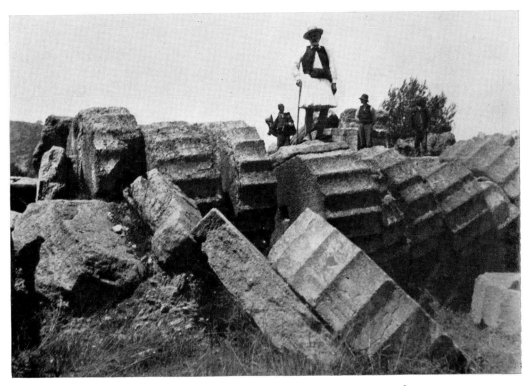

10. Olympia: Column-drums of the temple of Zeus, after the excavations of 1876–82

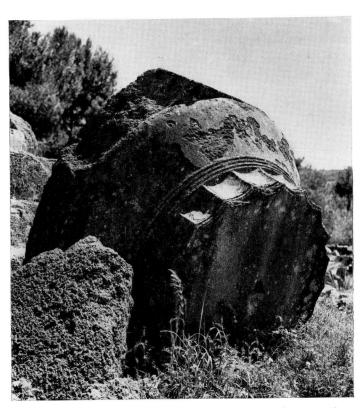

11. Olympia: Fallen capital from the temple of Zeus (from Hege-Rodenwaldt, *Olympia*)

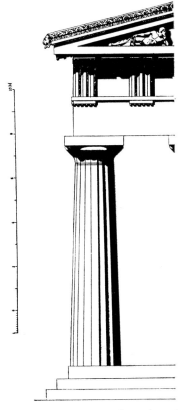

12. Olympia: Reconstructed Order of the temple of Zeus (from Curtius-Adler, *Olympia*)

even before the Romans colonized it), was built at almost the same time as the temple of Zeus at Olympia, possibly a few years after, since it seems to have copied certain features from Olympia (Fig. 13).[6] It is of almost the same size, and of very nearly the same plan, and it gives us a fair idea of what the temple of Zeus looked like, except that the building should be smooth and white all over, with details of the capitals and entablature picked out in colour and gilding. This temple at Paestum had no sculpture, almost certainly because of the cost and difficulty of bringing the marble from Greece: no marble-quarries were being worked in the Italy of those days.

To return to Olympia. Almost as soon as the designs for the temple were out, three major decisions had to be taken. What sculptures were there to be? Of what were they to be made? And, closely linked with these, Who was to be the master-sculptor?

Elis, having contacts through the Olympic Festival with most parts of Greece, would be in a good position to make the choice of a sculptor, presumably in con-sultation with the architect, who from now onwards would have to work closely with him; and it was a fairly urgent matter to get on with the carving, for it involved years of work. The architect's plans for the temple showed two pediments, each about eighty feet long and about eleven feet high in the centre; and an external Doric frieze of sixty-eight metopes. It was decided to fill the two pediments with sculpture, but to leave these metopes blank (Fig. 14). Inside the colonnade, however, there were twelve more metopes, six above the entrance portico and six above the portico at the back. Each was about five feet square and in each it was decided to have a carving in high relief (Fig. 15). The number twelve may have been arranged deliberately in order to accommodate a particular subject – the twelve labours of Heracles[7] – and, if so, it follows that the subjects for the metopes, and presumably therefore also for the pediments, had been decided before Libon made his final plans for the temple.

Then there was the material for the sculptures. Looking back from our present vantage-point we may think that only one decision on this was really possible. They must be of marble. But *was* this quite so obvious? Marble was a costly material, how costly may be judged by the temple of Hera that was being erected, about this time, by one of the richest Greek cities of Sicily, Selinus. Selinus was the most westerly of the Greek colonies in Sicily, and more than seven hundred miles away from the nearest source of marble in the Aegean. That temple was entirely of lime-stone except for parts of the female figures in the metopes which are of marble from Paros.[8] The instructions issued to the sculptors were evidently quite precise, and were faithfully followed. No more marble was to be used than was absolutely necessary, and the only parts to be made of marble were female faces, hands, feet; and limbs where they were bare, which usually meant the forearms (Fig. 16). The

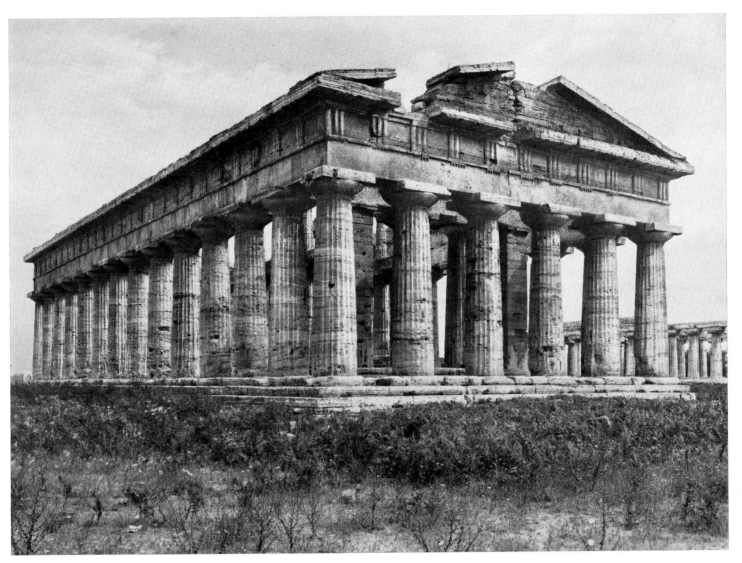

13. Poseidonia (Paestum): Temple of Hera

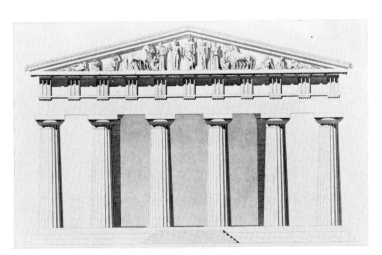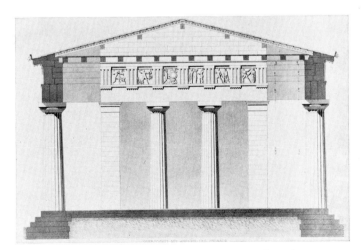

14-15. Olympia: Eastern elevation and section behind the Eastern façade of the temple of Zeus (from Curtius-Adler, *Olympia*)

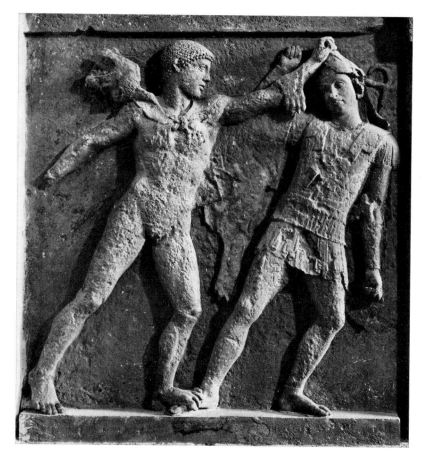

16. Selinus: Heracles and Amazon. Metope from the Heraion

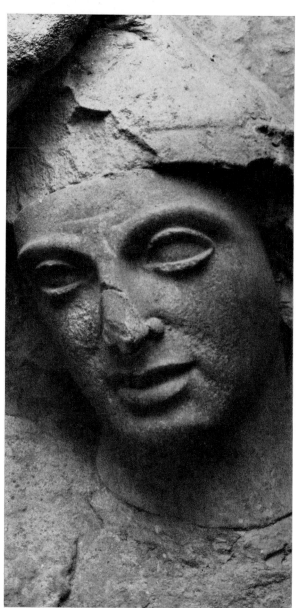

17. Head of the Amazon from the metope fig. 16

Amazon being attacked by Heracles wears the normal Amazon's dress of tight-sleeved tunic and trousers, and thus some economy was possible; only her face (Fig. 17), hands and feet were in marble. There was however a nice problem with her right foot, the toes of which were gripped by those of Heracles. This was too much for the ingenuity of the sculptor, and he was obliged to carve all the toes, male and female, in limestone. However, a piece of the precious marble was spared for the heel.

This piecing together of limestone and marble is interesting because it bears on what we are discussing at the moment, namely expense; but it is interesting also from another point of view, since it means that the colour used for these sculptures was thin enough to allow the quality of the carving to tell, and perhaps translucent enough to allow the lustre of the marble to show through.

In short, at Selinus, marble is treated as a semi-precious stone: again the reason was the cost and the difficulty of transport.

I want to quote just one example to show how little thought is commonly given to these matters. An otherwise sensible book on ancient shipping contains the following wildly misleading passage about Selinus: 'Corinthian ships,' it says, 'arrived loaded with fine pottery, oil, and perfume: and heavy loads of marble; the local rock was too soft for first-rate building stone.'[9] In fact, all the great temples at Selinus are of the local stone; and as for bringing by ship marble for building – no Greek city, however rich, which was so distant from the quarries, could have afforded a whole temple of this or any other size in marble.

It is true that Aegina, a generation before, could afford two pediments entirely of marble. The reason? She was, if sheer output of coinage is the criterion, one of the wealthiest of Greek states; secondly, she was only a hundred miles north-west of Paros, where the marble was quarried; and, thirdly, the figures were all under life size and comparatively light.

Anyhow, at Olympia the decision was made to use marble for the sculptures, and the question was, what marble? Here we can quickly see that there was not much choice. Pentelic marble was only just coming into free use even in Athens, and the quarries on Pentelicus were in an awkward position high up on the mountain-side, and fifteen miles from a harbour. Several islands in the Aegean, Thasos and Siphnos for instance, contained marble which was good for building but not entirely suitable for sculpture. Naxos had abundant marble, used widely for sculpture during the sixth century, and some of the quarries were almost on the seashore; but Naxian marble was falling out of favour, partly because its very large crystals made minute detail tricky to carve, and partly perhaps because of a tendency to greyness in colour: it was being superseded by the marble of Paros, which had a finer grain, a colour white but warm, and a perfect lustre caused by the light penetrating a short distance into the stone and then being reflected by the surfaces of the deeper crystals. The quarries were reasonably close to the sea, so that the cost of transport would not be impossibly high.

Accordingly, Parian marble was ordered for Olympia, naturally in blocks of certain sizes. And now we come to a crucial question – what *were* the sizes? The master-sculptor must by now have decided not only the main design of both pediments, and the thickness of the metopes, that is to say what height of relief he intended, but he must also have calculated to within an inch or two the exact dimensions of every figure in each pediment. Otherwise he would not have been able to order the blocks of marble for them. A simple conclusion, but inescapable, surely; and surely of some importance. And I think it is a strong probability that the sculptor was on the spot in Paros to help in choosing the marble.

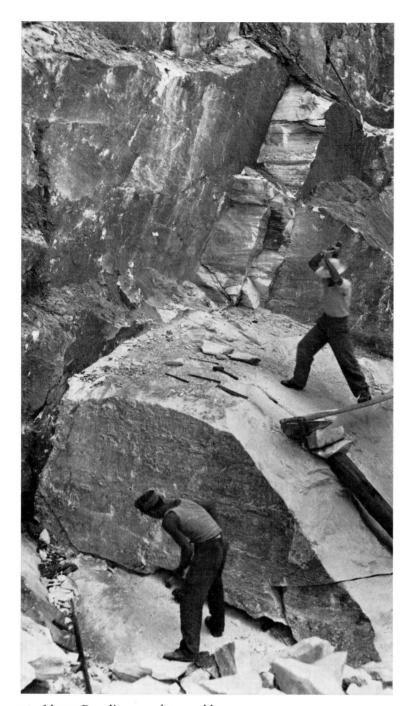

18. Mount Pentelicus, modern marble quarry

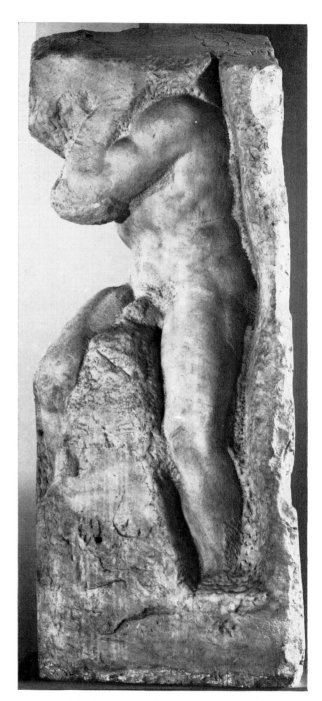

19. Unfinished statue for the tomb of Pope Julius II by Michelangelo. Florence, Accademia.

The quarry shown (Fig. 18) is actually on Mount Pentelicus, but it gives a good idea of how marble is naturally divided by faults. The blocks thus produced are not necessarily usable as complete blocks, they may have other flaws. Finding perfect marble is a far from easy task: you cannot go to the quarry and expect to find immediately a block of any size you want: suitable blocks have to be searched for, usually with the help of the quarry-master, who from long experience of observing

16

the face of the quarry can pick out the areas which are likely to yield them. You may remember that Michelangelo spent many months in 1517 in the quarries of Carrara and Pietrasanta, choosing marble for the façade of San Lorenzo in Florence; in fact he reckoned that altogether he had spent several years of his life in quarries, searching for marble.

Now, in carving a figure from a rectangular block, the sculptor normally cuts away marble at least equivalent in bulk to the finished figure, and what is even more important, equivalent in weight. One of the unfinished statues by Michelangelo intended for the tomb of Pope Julius (Fig. 19) gives a fair idea of how much marble is cut away from the original block in making a statue, and how much remains.[10] Of course if the composition is less free than this, for instance in a Greek archaic statue, there would not be quite so much waste; but, on the average, about as much marble is removed as is left. Notice the Michelangelo monogram of three linked circles, on the top, to show that he has selected the block: it reminds one how difficult it was to find a perfect block, and how, once found, it was important to establish one's ownership.

How critical weight was with ancient means of transport (and how much cheaper it was by sea than by land) can be seen whenever we have any figures for expenditure: one instance often quoted, a century later than Olympia but a valid analogy, is that of the quarrying and transport of four blocks of Corinthian limestone (of unknown weight, unfortunately) from the quarries near Corinth to Delphi, for the new temple of Apollo. These four pieces cost two hundred and forty-four drachmae to quarry. To transport them by sea from Lechaion, the port of Corinth, to Kirrha, the port for Delphi, about forty miles across the Gulf of Corinth, cost eight hundred and ninety-six drachmae; whilst to get them the remaining ten miles up the steep road from Kirrha to Delphi – a climb of two thousand feet, admittedly – cost no less than sixteen hundred and eighty drachmae. Thus the cost of transport was more than ten times the cost of quarrying. No wonder that statue-bases at Delphi were made of local limestone; and no wonder that the Alcmaeonidae gained such prestige by building one façade of the sixth-century temple at Delphi in marble instead of limestone.

Much can be achieved, as I know from long personal experience of moving all kinds of ancient marbles, both architectural and sculptural, with the most simple means, namely the lever, the wedge, and the roller;[11] but even so the loading and unloading of large blocks of marble is always a dangerous business. Into a ship particularly, for marble is a concentrated dead weight: if a block weighing as little as two or three tons were accidentally let fall, even a few inches, it could easily go through the bottom of a ship; and even when safely aboard, a two- or three-ton deadweight is an uncomfortable thing to have on a small ship in a high sea.

20. Olympia: West pediment of the temple of Zeus: Women struggling with centaurs

Take a single example from Olympia. In the west pediment there are two groups of a centaur seizing a woman (Fig. 20): each block originally must have been about three metres high, three wide and nearly one metre thick: a cubic metre of marble weighs two and a half tons, and a simple calculation will show that each of these blocks, before carving, must have weighed between fifteen and twenty tons. I reckon that for all the sculpture of the temple at Olympia the total amount of finest statuary marble needed – and none but the finest would do – must have been in the region of one hundred and sixty tons: one hundred and thirty for the pediments, and thirty for the metopes. Roughing out the statues on Paros would have saved transporting, unnecessarily, at least fifty tons of marble the great distance from Paros to Olympia, and it seems to me that this would have been a strong argument for doing at least some of the carving at the quarry.

There is a point that arises here, which may or may not be relevant, but is worth mentioning: it has been shown by those who have studied the archaic buildings at Delphi, that it was the regular thing for the masons to come with the material (I am talking now of masonry marble, not statuary): this is proved by the shape of the cramps for joining the blocks, which have local peculiarities.[12]

The Siphnian treasury at Delphi was constructed by Siphnian masons, for they knew how Siphnian marble behaved: it was dangerous to cut except at right angles to the strata – a careless blow along the natural bed could split a block from end to end. Where Parian marble was used, Parian masons were employed, even apparently for the Athenian treasury there.

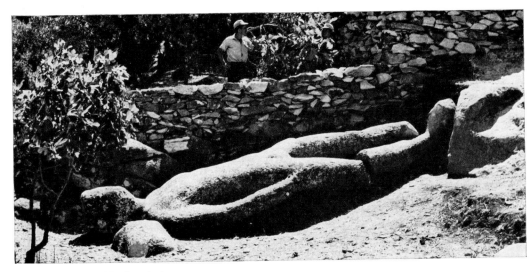

21. Naxos: Unfinished archaic statue

Centuries later, under the Roman empire, Greek sarcophagi were roughed out in or near the quarries, but were accompanied to their destination in other countries by a Greek sculptor or sculptors, who finished the carving after they had arrived.[13]

How far can one apply this principle to Olympia? I do not mean to say that no one except a Parian carved a statue in Parian marble; only that, when a whole series of statuary blocks were to be quarried, it must have been essential to use local quarry-men, and it might have been convenient to employ local craftsmen to carry the shaping of the blocks a stage further, under the sculptor's supervision.

Another relevant factor is the possible existence of a major flaw in a block of marble already being carved. This must have been a constant source of worry to the sculptor.[14] Even a small flaw in an important place, for instance in that part which was to be carved into the features of a person, could be serious: in an unimportant place it might be smoothed or carved down so as to minimize it, but in a vital place it could ruin the whole block. How serious this hazard was in early times can be seen from the unfinished statues that have survived. In ancient quarries a number of archaic statues lie abandoned (Fig. 21), and in all of them the shape of the figure is already clear. The most famous is perhaps the huge statue on Naxos which is some thirty feet long (Fig. 22). This is a draped figure, and has been usually spoken

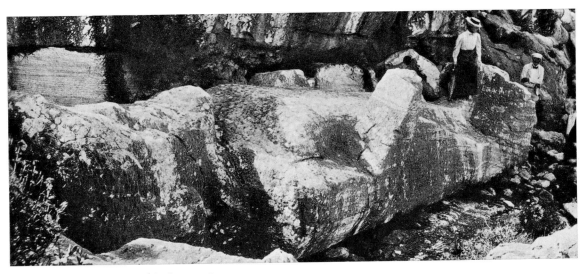

22. Naxos: Colossal unfinished statue in a quarry

of as archaic, but it is just about contemporary with Olympia, and here certainly a good deal of the shaping of the statue was done in the quarry. It used to be thought that it was still part of the living rock, but in fact it has been moved a little from its bed, and it was, probably, then that the flaw or flaws appeared and caused its abandonment. This, then, is evidence that the practice of roughing out the statue in the quarry went on as late as Olympia.

I have stressed this point because of the size of the blocks of marble needed for the temple of Zeus. The larger the block the more likelihood of there being a flaw somewhere, and the greater the catastrophe, the cost, and the delay in replacement, if, having transported it some hundreds of miles, the sculptor should find, whilst carving, that it was irremediably flawed. One further argument: marble is less hard when it is quarried than it becomes after a few weeks, and this is one of the reasons why in Italy today much of the carving of tomb-figures, for instance, is done in Carrara itself.

There would have been one advantage, admittedly a most important one, in doing at least the final carving at Olympia, and that was avoiding the risk of damage in transporting a fully-finished statue.

On balance, I believe that the statues were at least roughed out before leaving Paros.

This question of the supply of marble affects directly the problem of who the sculptors were. Lately there has been a tendency to talk of a local, Elean, school of sculptors having carved the sculptures of the temple at Olympia. This seems to me quite impossible. There was no marble at Elis or anywhere within a couple of hundred miles: one cannot become a marble-sculptor without marble, and it is not an art that can be learnt in a few weeks or months. I should guess that there was not a single man in the western Peloponnese who could carve a life-size statue in marble.

Whether the blocks of marble remained exactly as they had been quarried or whether they were roughed out, there now came the task of transporting them to Olympia. Road transport was out of the question: you have only to look at a map of the Peloponnese to see why (Fig. 2) Anyone who has travelled by road or rail along the southern shore of the Gulf of Corinth, with its dozens of inlets, will know that to take really heavy loads on such roads as existed then would have been quite impossible. So it had to be by sea, and the blocks had anyhow to be loaded on ship-board to get them away from Paros. There were then two possibilities. One was to take them round the south of the Peloponnese, rounding Cape Malea and up the west coast to Pheia; but Malea, where the waves and winds of two seas meet, had a very evil reputation in antiquity, so much so that there was a sailors' proverb 'When you round Malea, forget your home.'[15] If they did go round the

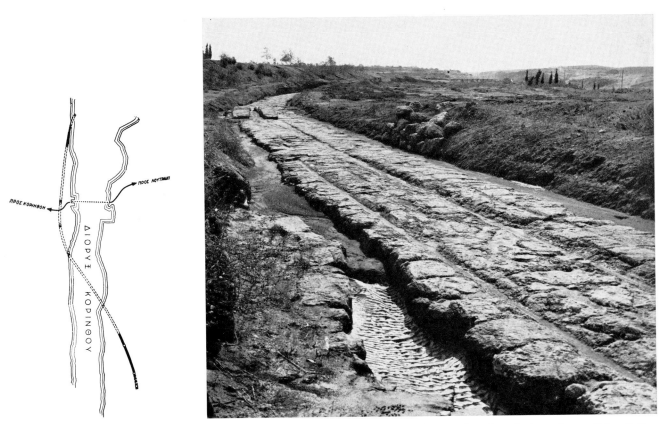

23–24. Diolkos across the isthmus of Corinth (from N. M. Verdelis, *Athenische Mitteilungen*) and view of part of the diolkos

south and came to harbour in Pheia, it would be a journey of about three hundred miles. There was, however, an alternative. One of the most impressive discoveries of modern times has been that of a section of the diolkos, the great portage road, probably built by Periander, the sixth-century tyrant of Corinth, which runs three and three-quarter miles across the narrowest part of the isthmus of Corinth, surmounting a saddle of land nearly three hundred feet high.[16] Only small sections of the diolkos have been uncovered, but enough to show what its course was: this was not the same as that of the modern canal, which naturally cuts straight through, because the diolkos is designed in great sweeping curves in order to make the gradients as gentle as possible (Fig. 23). It consists of a roadway nearly twelve feet wide (in places sixteen feet or more) constructed of thick blocks of limestone. Down the middle of this roadway are cut two parallel grooves, about five feet apart, forming a kind of tram-line, in which a wheeled trolley must have run. Ancient writers tell us that ships were taken across. How they were hauled we do not know, but if empty they might have been pulled and pushed by their own crews, with the help perhaps of teams of Corinthian slaves stationed there. Not apparently by oxen, since there are no marks of heavy wear on the pavement. A massive stone structure uncovered in one place may have supported some kind of machine, perhaps a great capstan to assist haulage (Fig. 24).

The point that interests us at the moment is what was done with the cargoes. It seems that usually they were taken out and moved across separately by another route, the normal land route, Kenchreae to Lechaion, in order not to cause traffic-jams on the diolkos; and were re-loaded at the other end, in the harbour of Lechaion. This method would be quite feasible for ordinary cargoes consisting of small units – sacks of grain or figs, skins of wine, batches of pottery – but a very different matter for large blocks of marble, since, apart from the difficulties of loading and unloading the ship, they would have needed special vehicles and many teams of oxen to haul them along the normal roads across the isthmus. Again, this would have been easier if the blocks had been roughed out.

The Gulf of Corinth does afford a much more sheltered course, though not much shorter than round the south, and it is conceivable that the Corinthians, in view of the purpose for which the marble was to be used, may have quoted cut-prices for the use of the diolkos – no doubt the charges were heavy, as they are with the great canals today; hence the immense wealth of Corinth – but it is hardly likely that they let them go through free. Taking everything into consideration, I should guess that the southern route was used, round Cape Malea; but it is only a guess.

Now we see the importance of the Eleans having control of the harbour of Pheia and of the country between it and Olympia, and if the blocks were unloaded at Pheia there remained the twenty-odd mile journey to Olympia. This is a long haul, but it is comparatively easy going in the valley round the foot-hills of Erymanthus: Elis had plenty of cattle for haulage, and provided it was summer-time when there was no mud, the journey need not have presented great difficulties. It is possible that instead of unloading at Pheia the blocks were floated part of or all the way up to Olympia. Pliny says that in his day the Alpheios was navigable for six miles from its mouth; but Olympia is three times as far as that, the Alpheios has many shallows, and there is no evidence that it was ever navigated so high.

By some such methods as we have tried to indicate the temple and its sculptures were finally produced, and dominated the site for close on a thousand years (Fig. 25). Perhaps we can begin to realize what an achievement it was, even when we con-sider the sculptures only. There were twelve metopes, each about five feet square, and two pediments, each about eighty feet long (Figs. 26–28): these were about eleven feet high in the centre, and each contained about twenty figures well over the size of life—the central ones nearly twice the height of a man, that is to say four times as large. If a life-size statue takes one sculptor a year to carve, working full time, or as long as he can at a stretch, these sculptures would represent roughly the complete life-work of two sculptors. Since there was not even one life-time in which to do the work – there were only ten or a dozen years, from about 468 to 456 B.C. – we must postulate more sculptors. Let us say for the sake of argument that there were

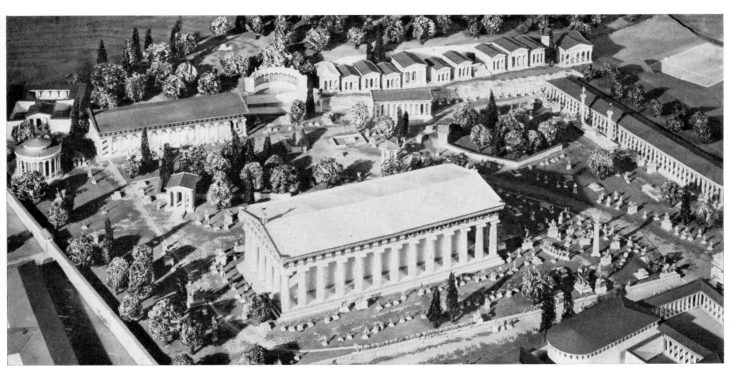

25. Olympia: Conjectural restoration of the sanctuary in the second century A.D. from the South-west

two master-sculptors, which is what Pausanias was told at Olympia, and a team of ten assistants. They might have done it in the time. If there were more workers it could have been finished more quickly: that is a matter of simple arithmetic; but whereas the size and make-up of the team of sculptors is guess-work, what is not guess-work is the amount of carving that had to be done, was done, and was done punctually.

Wherever the sculptors worked, whether at Paros or at Olympia or at both, they had to work either by measurement or by trial on the ground, until the moment came for setting the sculptures in place: nothing could be tried on the temple itself until the building had reached triglyph level, and then the metopes had to go in as speedily as possible in order to avoid disrupting the time-table. As for the pedi-mental figures, they could not go in until all the structural stonework was finished.

The colouring of the sculptures had also to be carefully timed, since the architect would not want them to be lying about for long fully coloured, at the builders' mercy. Hoisting them into position when coloured must have been difficult, and it is possible that the finishing touches were added only when they were finally in position.

Lastly, the choice of subjects: one would dearly like to know how this had been organized, who chose them, at what stage the master-sculptors had been called in to consultation; and especially where the brains and the education came from. For, whatever method was used, somewhere in the background there was a highly intelligent and well-informed person or persons, with a wide knowledge not only of general mythology but also of local history. No reference libraries in those days;

23

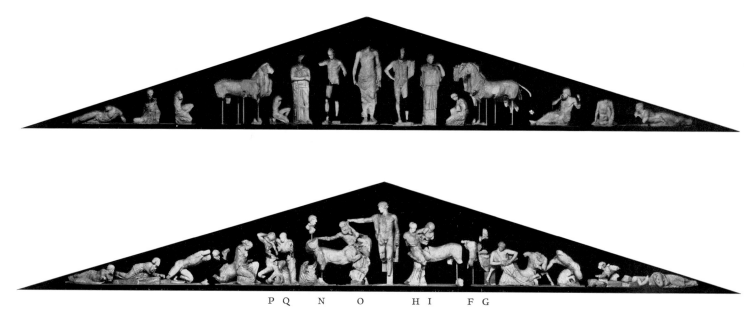

P Q N O H I F G

26. Olympia: The pedimental sculptures of the temple of Zeus as set up in the museum in 1965

no convenient handbooks on mythology.[17] The managing committee of Eleans must have chosen, or at least have approved, the subjects, and the architect and master-sculptors may well have been members of this committee, or have been constantly consulted.

It was evidently decided that the theme of Zeus and his children was to run through the whole series. As the visitor approached, the focal point of the only sculptural group visible, the East pediment, was a figure of Zeus larger than those around him (Figs. 14, 26, 27). It was Zeus presiding over a contest which was the prototype of the chariot-races now taking place periodically in the sanctuary, the tense, silent preparation for the cruel contest devised by Oenomaus, king of Pisa, in order to secure his own rule undisputed. Any suitor for his daughter's hand had to race in his chariot from Olympia to the Isthmus of Corinth, pursued by Oenomaus, whose chariot was drawn by immortal and invincible horses, and who speared the suitor in the back when he overtook him. Pelops, the last suitor to arrive, when no less than thirteen had perished in this way, bribed the charioteer of Oenomaus, Myrtilus, to substitute linch-pins of wax for the metal linch-pins of the wheels of the chariot: the wheels came off at full speed, when the hubs heated up, and Oenomaus was thrown and killed. Afterwards Pelops made away with Myrtilus by drowning him.

At the other end of the temple, in the centre of the west pediment, was Apollo the son of Zeus, aiding humanity in its fight against barbarism (Figs. 26, 28),

24

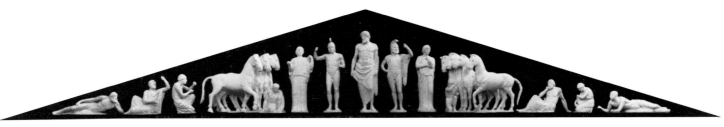

27. Olympia: Conjectural arrangement of the East pediment of the temple of Zeus

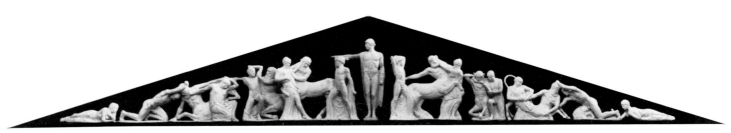

28. Olympia: Conjectural arrangement of the West pediment of the temple of Zeus

typified by what Euripides called 'the four-legged wantonness' of the centaurs.[18] On the twelve metopes were Athena and Hermes, also children of Zeus, helping Heracles, another son, and, incidentally, the founder of the Olympic Games, to fulfil those twelve tasks which were to make him a god on Olympus (Fig. 71).

The scene in the east pediment was almost motionless, that in the west one of riotous movement, and this may well have been because it was appropriate for the calm scene to be in view as the visitor approached the doorway, through which could be seen the colossal statue by Pheidias, embodiment of divine majesty.

There was, however, also a more subtle contrast between the two, for the calm scene in the east pediment, outwardly more civilized, concealed purposes more deadly and more cunning than the mere animal lust of the centaurs. And the irony went deeper still. The cruel conditions laid down by Oenomaus for the chariot-race were to be circumvented by Pelops, but his apparent success was won only at the cost of violating an oath to his fellow-conspirator. A few yards to the south of the temple were the precinct and statue of Zeus Horkios, god of the oath; and the subsequent history of the house of Pelops offered a terrifying example of the consequences of this oath dishonoured. For Pelops was the father of Atreus and of Thyestes – Atreus, who gave his brother the flesh of his own children to eat; Thyestes, who seduced his own daughter and became thus the father of Aegisthus, paramour of Clytemnestra, and with her the murderer of Agamemnon.

The ordinary visitor, or the charioteer who glanced up at the sculptures from the

race-course whilst trying to bring a fiery team to the starting-point, may not have grasped these implications to the full; but we must surely suppose that the master-sculptors had all these things in mind, and that this is what gives the sculptures their great power and their deep significance, both of which must have been en-hanced by the colouring. All the sculptures were fully coloured, not in imitation of, but by analogy with nature, the colours bolder and simpler; and the figures stood out sharp and clear, in a way that we can hardly imagine, against a coloured back-ground.[19] Realistic, yet stylized, and therefore making a more forcible impact: life-like – living, you might easily imagine, a life of their own – and yet not of this earth. Imagine these coloured, and with the eyes painted in, and how startlingly alive they would have been: the more so because now, for the first time in Greek sculpture, there is an attempt to show, not only the character of the figures, but their mood at the moment.[20] In the West pediment Apollo, calm but stern. In the east pediment, the seer gazing anxiously into the future at the doom that is coming on his master's house. In the metopes, Athena, not simply accepting a gift but accept-ing it with kindly grace: or Heracles strained to the utmost, bearing the burden of Atlas steadfastly.

No doubt a sophisticated Athenian would have judged all these as works of art – except that that unhappy term 'work of art,' with all its gruesome implications, had not yet been invented. But what of the peasant from deepest Arcadia? Would he not believe these towering figures to be the gods and heroes themselves? Much in the same way, I suspect, as you may see even today in some church in Naples a peasant woman appealing to the statue of a saint as if it were not stone or wood, but the saint himself, alive and listening. And how much we lose with the loss of the ancient colour – lose not so much sculptural quality, but credibility; the sense that these are no longer images, but people. And surely that, not mere adornment, was their main purpose.

II

The Temple of Zeus at Olympia

THE PEDIMENTS:
A REVOLUTIONARY PHASE IN SCULPTURE

In my first lecture I tried to reconstruct the conditions under which the temple of Zeus at Olympia was built, and to envisage the various problems involved, such as finding the money; appointing the architect – who seems to have been available in Elis itself; choosing the master-sculptor – who had to be brought in from a distance; and securing and transporting the materials for the sculptures. In the next two lectures I want to deal with the finished products, the two pediments and the twelve metopes. In this lecture, the pediments.

In the east pediment was displayed the preparation for a chariot-race, unique in its conditions. It was for the hand of Hippodameia, the daughter of Oenomaus, who was son of the war-god Ares, and King of Pisa. The king had been given a prophecy that he would be killed by his son-in-law, and was therefore reluctant to have his daughter married. In order to prevent it, he had decreed that anyone seeking her hand should first race against him, in chariots, from the river Cladeos at Olympia to the Isthmus of Corinth. The suitor started first, taking Hippodameia with him. Oenomaus waited to sacrifice to Zeus (warlike Zeus, Zeus Areios incidentally, a sidelight on that helmeted Zeus in the temple of Hera)[21] and then started in pursuit. If he overtook the couple he thrust the suitor through the back with his spear. Since Oenomaus possessed invincible horses given him by his father Ares, the odds in his favour could hardly be better, and he had already killed thirteen suitors in this way. As a further deterrent, he had the unpleasant custom of fastening the heads of the unsuccessful suitors on the roof of his palace.

Then Pelops arrived, coming from somewhere in Asia Minor, probably Lydia. He solved the problem of the invincible horses by tampering with the chariot, so that it broke up at full speed; and that of an awkward accomplice by drowning him.[22]

Pausanias, in his journey through the Peloponnese in the second century A.D., came across a good many traces of Oenomaus, enough to make it clear that he was a real person.[23] So too was Pelops real; and there may well have been a primitive chariot-race involving the death of one of the contestants, possibly also a horse-

sacrifice, since the legend had it that Oenomaus killed the horses of the first suitor as well as the suitor himself, and, to quote Pausanias, 'granted them the privilege of burial'.[24] Among the earliest bronzes from Olympia are armed persons in chariots, which surely indicates that chariot-races were an early feature of the Olympic Games, perhaps the one original feature; and in the middle of the Altis – the sacred precinct – someone digging beside a wooden pillar traditionally supposed to be a part of the House of Oenomaus, found remains of armour, and bridles and harness. This must have been about A.D. 174, because, says Pausanias, 'I saw them excavated myself'.[25]

These are the antecedents that lend colour and substance to the scene in the east pediment, which had its basis in legend, but also had an up-to-date application, for it symbolized the defeat of Pisa by the Eleans which had just taken place; and the legend embodied a convenient atrocity-story, about the suitors' heads, calculated to enlist sympathy on behalf of the none too clean-handed winner, and to make it evident that it really was a good thing that the newcomer had triumphed.

Pausanias, in his guide-book to Greece, describes the pediments, and however brief these descriptions are – that of the west pediment seems to break off suddenly half-way through – they are precious to us because they are all we have. We will avoid becoming involved in the discussion which has been going on for eighty years and is not yet settled, about the exact arrangement and identity of some of the figures, because I think we can get at what we want without doing so; but it would be wrong to ignore the problems.[26]

I can show you in a few seconds what the main difficulty is, simply by giving a literal translation of Pausanias without any explanation, and asking how you interpret it. 'As for what is in the pediments', he says, 'there is the contest with horses between Pelops and Oenomaus about to begin, and preparation for the race is being made by both. There is a statue of Zeus right in the middle of the pediment. Oenomaus is on the right of Zeus with a helmet on his head, and by him his wife Sterope, one of the daughters of Atlas. Myrtilus too, who drove the chariot of Oenomaus, sits in front of the horses; the horses are four in number. After him are two men: they have no names, but they too must have been ordered by Oenomaus to look after the horses. Right in the corner lies Cladeos: after Alpheios he is the most honoured by the Eleans of all rivers. On the left from Zeus is Pelops, and Hippodameia and the charioteer of Pelops, and horses, and two men, and they also are grooms for Pelops. And again the pediment narrows down and here Alpheios is represented in it.'

The difficulty is obvious, is it not? There are two ambiguous phrases ἐν δεξιᾷ τοῦ Διός 'on the right of Zeus', and ἐς ἀριστερὰ ἀπὸ τοῦ Διός 'to the left from Zeus', and the ambiguity is similar in both. Does ἐν δεξιᾷ mean on the spectator's

right or Zeus's right? Does ἐς ἀριστερά mean on the spectator's left or on that of Zeus? I am assuming that when he says on the right he means the spectator's right, and so for the left: and in this reconstruction the figures are arranged on that assumption.

This is how I identify them (Fig. 27). Zeus in the centre. On our left of him (Zeus's right, the side of good omen) Pelops and his retinue. First his bride, Hippodameia, with her hand to her veil (in ancient times, as now, the symbol of the bride): then the chariot-team of Pelops, with the boy who has led them in sitting at their heads. Behind them the charioteer of Pelops holding the reins, and ready to hand them over to Pelops. Then the seer of Pelops, and finally a touch of local colour, the river-god Alpheios.

On our right of Zeus is Oenomaus, his wife Sterope in an attitude of anxiety, his chariot-team with the treacherous charioteer Myrtilus at their heads; the seer belonging to the house of Oenomaus, and the handmaid of Sterope and Hippodameia, whose task it had been to dress the bride. Finally, the river-god Cladeos, tributary of Alpheios.

Zeus, with Pelops and his bride on one side, and Oenomaus and his wife on the other, are the protagonists: their five heavy verticals proclaim this fact, and incidentally provide a stabilizing element in the centre of the composition. The designer realizes that this is architectural sculpture, that it should pay respect to the architecture it decorates and even echo its forms.

Notice too the very great skill with which he has managed the relative scale of the figures, and has made a transition between the centre and the wings by introducing the chariot-horses with their long horizontal bodies. Difference of scale is one of the major problems for the designer of a pediment, and some of the archaic pediments which fail to solve it are little short of grotesque.[27] Here there is only one great discrepancy of size, that between the god in the centre and the humans round him: and it is a discrepancy that can be tolerated, especially if the god can be thought of as invisible to the humans; or as a statue, which was what Pausanias took it to be. Among the humans themselves there is a satisfying uniformity, or apparent uniformity, of scale.

The figures are motionless: the immobility is deliberate, and designed to enhance the feeling of tension. Anyone who has taken part in a race knows this feeling, and knows that it is intensified by the fact that, at the last moment, there is nothing to do, no physical action to keep one's mind off the emotional strain: all one's hopes and fears are screwed up to the highest pitch in that silent moment, that strange hush, before the fury of the start.

This is trying enough in an ordinary race, and of those ordinary races many of the visitors who came to look up at the temple-sculptures during the Festival had

had experience. Here was no ordinary race: the prize was a princess for bride, with a rich kingdom for dowry: defeat was death.

I now want to consider with you some of the features which make these sculptures truly revolutionary in that they attempt things which had never been attempted before in Europe. In order to do this we will ignore the problems of the exact arrangement of the figures in the pediments, and will arbitrarily select a few figures from each of them for study in detail. From the east pediment the boy, the river-god Cladeos, the river-god Alpheios, the seer of Oenomaus, and the horses of Oenomaus.[28]

The features to which I want to draw attention can be given a rough kind of analysis, although they are to some extent interdependent. I would analyse them somewhat in this way. First, the sculptors have detected, and tried to represent, the differences in the character of the body caused by age and by sex. They have deliberately contrasted extreme youth with youth, with maturity, with old age. They have contrasted the tenderness of the female body with the muscularity of the male.

Second, they have contrasted the substance and texture of the drapery with the nude, and have used this contrast to set off the body.

Third, they have studied the effects of movement: how the whole organism of the body works, and how its various elements – limbs, muscles and flesh – react to a movement. They have also studied and tried to represent momentary positions, not only in the interlocking of limbs in complicated groups, but also in the movement of drapery – how it swings, and folds, and twists.

Fourth, there is more feeling than hitherto for the third dimension, and a good deal more movement in depth.

And lastly, the faces. Here, apart from the indications of age, there are attempts to show the essential character of the person. Nor is that all, there are also attempts to show, in the poise of the head, and in the features, the mood of the moment; and this is something which, it seems, was hardly tried again for several generations.

Begin then with the sculptors' representation of boyhood (Figs. 29, 30, 32). It has been suggested by Dr Yalouris that this young boy may be Arcas, the founder-hero of Arcadia, who appears as a boy in a rather similar position (with his name inscribed against him) on coins of Arcadia, a century later than this. Ever since its discovery the statue has been admired for the skill with which this most difficult of poses (difficult I mean sculpturally, though not perhaps easy for some of us physically) has been made into a satisfactory sculptural composition without undue distortion of the anatomy. One can admire the boldness with which the legs are designed to be seen in a strongly foreshortened view; and the compactness which results from uniting the left leg with the left arm, although the sculptor was careful not to mask the contours of the bare right arm, which serves as a foil to the draped arm on

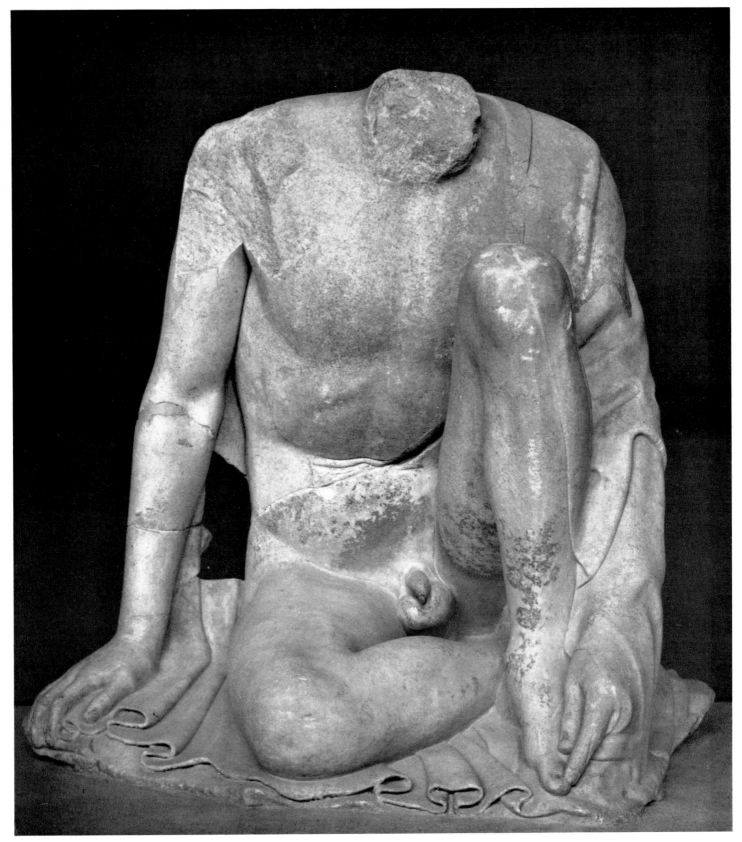

29. Olympia, East pediment of the temple of Zeus: Seated boy

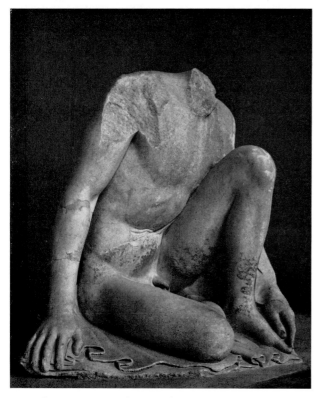

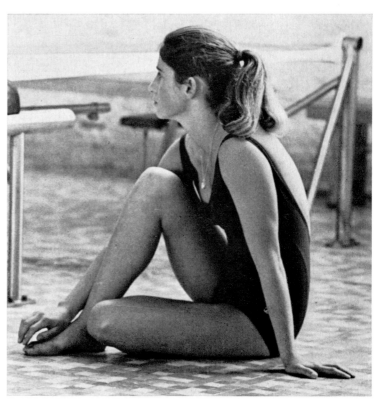

30. Olympia, East pediment of the temple of Zeus: Seated boy

31. Girl diver (Miss G. Lea) resting (from *The Times*, September 1967)

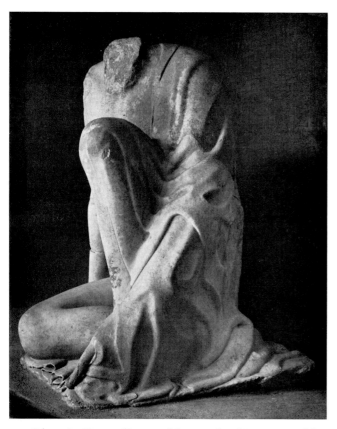

32. Olympia, East pediment of the temple of Zeus: Seated boy

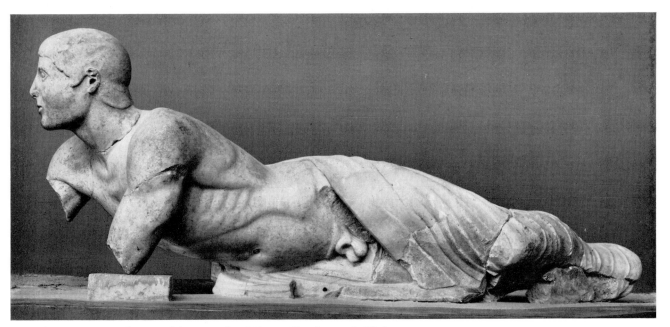

33. Olympia, East pediment of the Temple of Zeus: The river-god Cladeos

the other side. Yet as a demonstration of how natural these poses in the east pediment are, and how these sculptors solved the most formidable artistic problems without apparently realizing that they existed, simply by making a direct approach to nature and reproducing in sculptural terms what they saw, look at a photograph which appeared in *The Times* when I was preparing these lectures (Fig. 31). It is a girl competitor in a diving contest, between turns, and she is sitting in precisely the same relaxed pose as this boy in the east pediment: it is reversed, but otherwise exact, even to the hand against the foot. Before the fragment under the right arm was missing, which breaks the continuity, the body was set off by the shell of drapery: it emerges rather in the manner of a fruit from its skin. The piece of carving over the left hand is a puzzle. I do not think it is intended to be some object under the cloak, such as a halter or a harness-strap, or some attachment of the cloak itself – a strap or loop. One could perhaps take it in conjunction with a rather strange passage higher up over the elbow and say that the man carving it had not quite understood the model he was copying. Or again one might imagine that it was unfinished, that the sculptor had intended to soften down the edges, and make it look more like normal folds of drapery; but that when the time came to colour the statue, and put it up in the pediment, he found that he had never got round to doing it.[29]

See how the rich folds on the ground form a base for the right leg, almost – to change the metaphor – as if it were being served up on a platter. The sculptor has an extraordinary perception of how a limb that is relaxed does look; and in a general way he is deliberately displaying the soft, unmuscular forms, and the smooth, supple skin of childhood. There is no flabbiness, but equally there is no emphasis on the framework of bone beneath. This becomes more clearly apparent, by contrast, when we look at the next example, that of youth. For this we take the figure from the

33

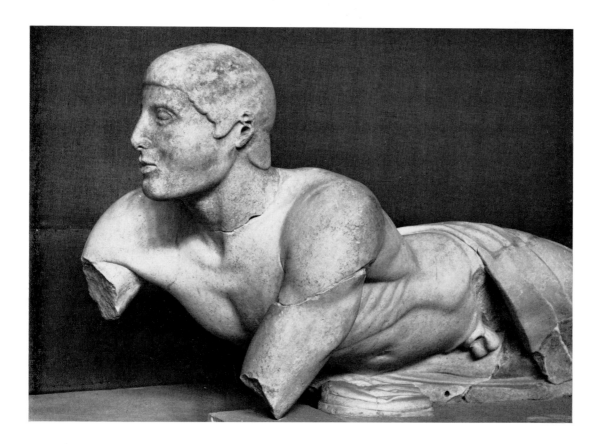

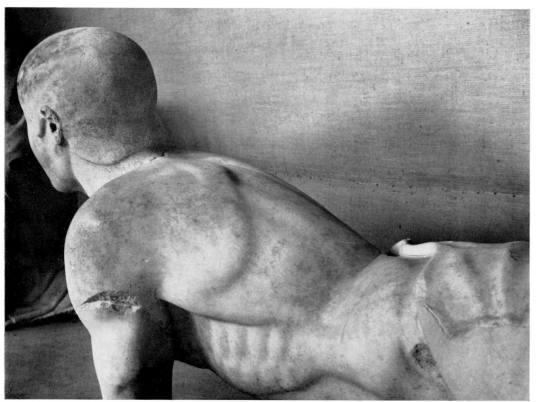

34-35. Olympia, East pediment of the temple of Zeus: The river-god Cladeos

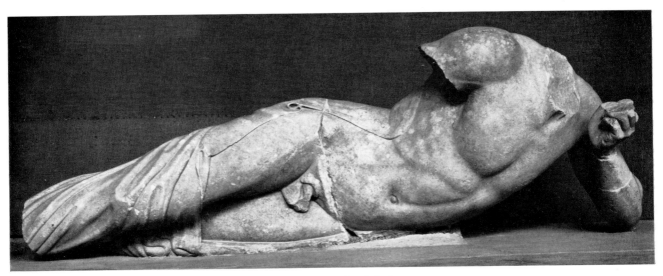

36. Olympia, East pediment of the temple of Zeus: The river-god Alpheios

northern corner of the east pediment (Figs. 33–35). I see no reason to doubt Pausanias's identification of him as a river-god, and two things confirm that he is the Cladeos. First his position on the temple, because the tributary Cladeos flows in from the north, whereas the Alpheios flows along the south side of the site; and thus there is roughly a topographical correspondence between the rivers and the figures personifying them. Second, the youthfulness of the figure as compared with the figure in the south angle, who is clearly older. The Alpheios was the most revered of the rivers in Elis, and must have been shown as the elder of the two: a river can hardly be younger than its tributary. So then, Cladeos.

As compared with the boy there is another difference here beside that of age, namely difference of posture. The boy is in an attitude of complete relaxation: this youth had been lying down, but now turns and raises himself upon his elbows: it is a fairly sharp movement, and it sets many muscles in action.

Nor is there only a contrast with the tenderness of the boy, in that this is a robust young man, evidently, from his leanness, trained to the last ounce. There is also a triple contrast within the figure itself, between the broad, flattish muscles, especially those of the shoulders; the sharper contours, indicating the underlying bony structure of the ribs and hips; and the softness and heaviness of the internal organs, held in firmly by the abdominal muscles, but with no covering of bone. All this is observed from the outside, and it is a matter for admiration how the sculptor, without any knowledge gained from anatomical dissection, has understood the differing natures of the various parts, and the effects of movement on these diverse elements.

And just as the boy was contrasted with the youth, so the youth is contrasted with the man (Fig. 36). The Alpheios is of heavier build, and the forms are more mature. The body is less twisted, and he rests on one elbow with his chin in his hand: he is also more at ease, as being older and less impulsive: he must have been watching calmly. This is neither complete relaxation, as in the boy, nor tension, as

in the youth, but a monumental stability. See how easily the torso is suspended between the elbow and the hip, as compared with the way in which that of Cladeos is stretched and taut.

One must always be careful not to read into a work of art what the artist did not intend, but conversely we must not be deterred by respect for what the text-books tell us – for instance that such and such a thing could not appear in Greek art before a certain date – from recognizing the intention when it is there. More specifi-cally, there is this question of what one may call poetic or mimetic sculpture. How soon did Greek sculptors echo, in the forms of the body or drapery, the physical characteristics of the natural phenomenon, in this case a river, which it was intended to personify? When one considers the wealth of vivid comparisons with nature that occur quite early in Greek poetry – for instance in Homer – I cannot see any reason why Greek sculptors should not have attempted something analogous, as soon as they realized that they had the means and the capacity to do so. In short, was it the designer's intention to allegorize on the one hand the vigorous mountain stream, on the other the broad, powerful flood of the river?

One more point before we pass on – the use of drapery to frame and set off the body. We saw it in the so-called Arcas and we see it in both Cladeos and Alpheios. The drapery forms a calyx from which the body emerges, but in the Alpheios, particularly, the sheathlike effect is enhanced by this delicately drawn edge lying along the right side and thigh, with an almost calligraphic flourish at the hip, which clings to, and with the finest of touches explains, the contours of the body (Fig. 37).

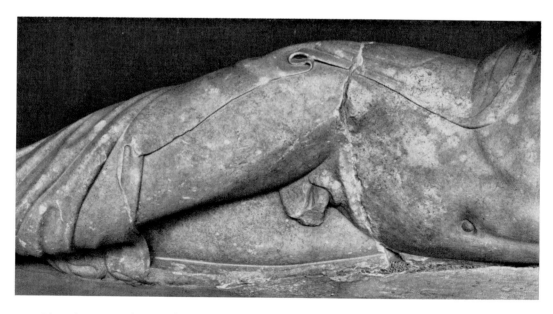

37. Olympia, East pediment of the temple of Zeus: The river-god Alpheios

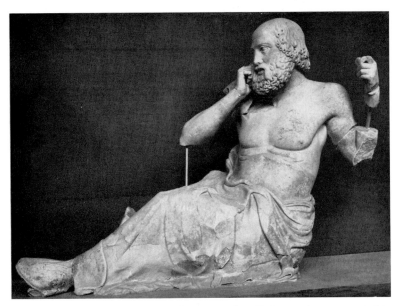

38. Olympia, East pediment of the temple of Zeus: A seer, probably Iamos.

39. The seer Halimedes lamenting the departure of Amphiaraos. Corinthian vase-painting, c. 550 B.C. Formerly Berlin, now destroyed

The two river-gods, by the movement of the body, by the turn of the head (if we restore mentally the head of Alpheios), and by the direction of the eyes, draw our attention to the central group. They show not emotion, but the lively interest that local inhabitants might be expected to show at some unusual happening. We have to look at another figure to see what is really afoot, and to realize that the happening is not merely unusual but momentous. This is the figure now generally recognized as a seer in the household of Oenomaus, perhaps Iamos, the father of the clan of Iamidae, who, as seers, continued to be attached to the sanctuary of Olympia into historical times (Fig. 38). As family seer his emotions would be deeply involved in the outcome of the race, which he can in fact foresee. And the family seer was a traditional character: a century before, on a Corinthian vase in which Amphiaraus is depicted setting out to his death through the treachery of his wife, the seer sits in the dust at the entrance to the palace, and his forlorn attitude shows that he foresees the end of the journey (Fig. 39). Nor were seers just people of myth: they were by no means obsolete at the time the temple was built. Read Herodotus, for instance, about the preparations for the battle of Plataea, fought only ten years before this, and see what a decisive part the seers played on both sides.[30]

To return to the statue of Iamos: it is not composed completely in the round, and this simplifies the sculptor's task, for it enables him to concentrate his effort on producing a figure that will tell best from the front. This has not led him to make it flat or superficial, merely to displace the head: a displacement apparent only in an aspect from which, once in the pediment, it would never be seen (Fig. 40).

The effect of the composition is impaired by the loss of the right upper-arm and of the right knee, which was raised, with the elbow resting upon it. There is also

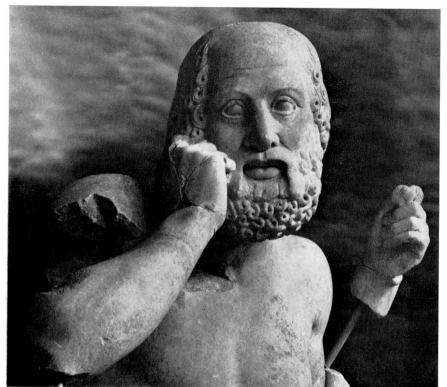
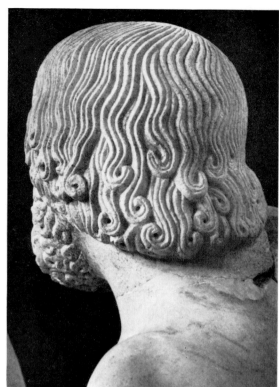

40-41. Olympia, East pediment of the temple of Zeus: A seer, probably Iamos

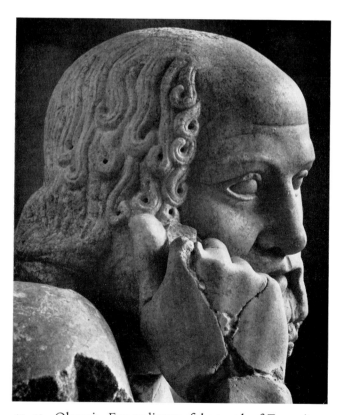
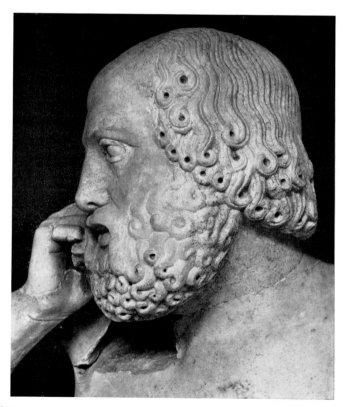

42-43. Olympia, East pediment of the temple of Zeus: A seer, probably Iamos

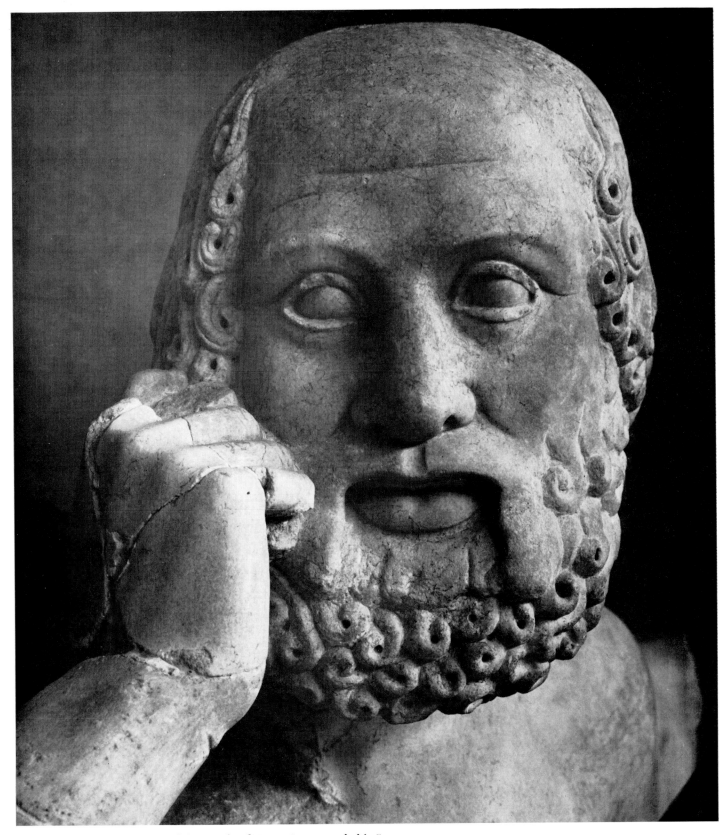

44. Olympia, East pediment of the temple of Zeus: A seer, probably Iamos

some loss in the left arm, which was supported on a staff. These losses make the design less compact than it should be, give the right arm a less natural and more artificially contrived look, and leave the left side out of balance (Fig. 38). This is a body aged but sound, a man who keeps himself in good condition: the flesh is full and heavy but not slack, and the sculptor has appreciated the sculptural quality of those broad, flat contours of the chest which are well calculated to tell at a distance and to contrast with the wrinkled calyx of drapery from which the body rises. Perhaps in his desire to simplify he has produced something a little inorganic here and there, but there can be no doubt of its sculptural effectiveness.

The same feeling for sculptural quality can be seen in the head (Fig. 42). The total shape of the head is wonderfully rendered, and, for the indication of what there is beneath the surface, notice the suggestion of the hard structure of the skull telling through the skin of the scalp. Contrasted again is the rather lank hair (Fig. 41), each lock of which is followed from its root to its end with an almost medieval delight in its individual character; and in order that the effect shall not be too linear, the lower ends of these locks, where they curl round and form a fuller mass, are given an almost colouristic effect by the drill-hole with which each curling end is termi‑ nated. Strange there should be a belief that early Greek sculptors were not inter‑ ested in texture.

The whole pose, and especially the movement of the hand to the mouth, bespeaks anxiety; but to the modern eye, which is accustomed to judge by the face rather than by the body, it is in the face that the emotion is more clearly expressed. This is the first time such expression has been attempted in Greek sculpture, and it is worth analysing how it is done.

There is an interesting peculiarity in the technique here. The sculptor knows the important part which sharp, emphatic detail plays in giving expression to the face, and in order that this detail shall not be lost in a mass of hair, he has deliberately left unsculptured – to be painted only – the surfaces of the moustache, of the upper part of the beard, and of the part below the lower lip (Fig. 44). This allows four im‑ portant accents to be clearly seen, namely the lower lip, the centre of the upper lip, the nostril, and these highly effective lines from behind the nostril down the lower part of the cheek. There is also the carefully modelled forehead with its extreme economy of incident, and that slight sagging of the lower eyelids which is another of the marks of old age.

Boyhood, youth, maturity and age. The range of perception, and the ability to embody it in marble, are quite astonishing only a few years after the end of the archaic.

Before we leave the east pediment, a single example of the great skill which the designer has shown in suggesting depth in space. As we have already remarked, the

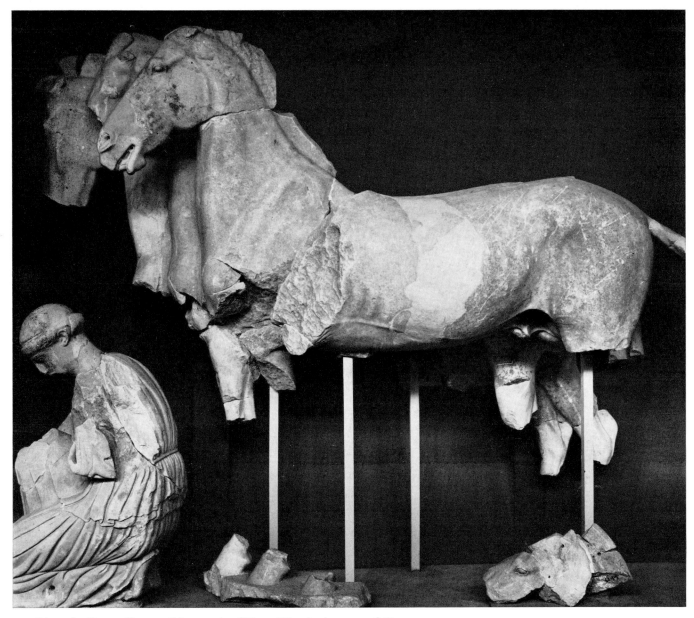

45. Olympia, East pediment of the temple of Zeus: The chariot team of Oenomaus

horse, with its long body, upstanding neck and head at one end, and down-curving tail at the other, is the ideal shape for fitting into the pediment, because it conforms to the raking angle of the pediment-roof. A horse, however, is one thing; a complete team of four horses is quite a different matter, and all four had to be accommodated in the three-foot space between the back wall of the pediment and its front edge: yet they are full size, and look almost as if they are in the round. In this group the front of the near horse is missing (Fig. 45). Each horse is set slightly in the rear of the horse next to him, which has the advantage that it gives the designer a little more space to work in: it displays (or did display) the four separate heads of the team, and it enhances the appearance of recession into the background. The

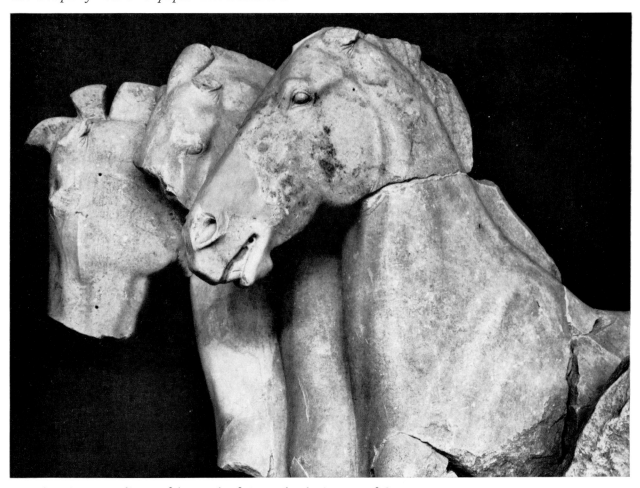

46. Olympia, East pediment of the temple of Zeus: The chariot team of Oenomaus

near horse is in fairly high relief; but look at the extraordinary skill with which the three other horses, all carved in comparatively low relief from a single block of marble, have been made to appear fully corporeal when seen from the front (Figs. 46, 47).

Pausanias describes the west pediment thus: 'The figures are by Alcamenes, a man of the same age as Pheidias and adjudged second to him in skill in the making of statues. His work in the pediments is the fight of Lapiths against centaurs at the wedding of Peirithous. In the middle of the pediment is Peirithous; beside him on the one side is Eurytion, who has seized the wife of Peirithous, and Kaineus defending Peirithous: on the other side Theseus defending himself against the centaurs with an axe: one centaur has seized a girl, the other a beautiful boy. Alcamenes I think created this because he had learnt from Homer's poems that Peirithous was the son of Zeus, and knowing that Theseus was great-grandson of Pelops.'

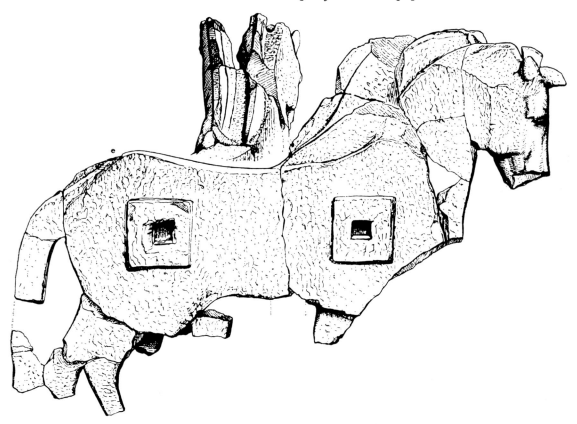

47. Olympia, East pediment of the temple of Zeus: The chariot team of Oenomaus
(from Curtius‑Adler, *Olympia*)

This story was far more generally familiar in Greece than the local myth of the east pediment. It was becoming popular in vase‑painting about this time, but it had not, so far as we know, appeared in architectural sculpture before. The fight at the wedding feast of Peirithous, when the centaur guests, after too much wine, suddenly turned on the women and boys, had been in Thessaly: but there were centaurs nearer Olympia than that. On Mount Pholoe, north of the Alpheios, they lived, and they too had come to grief for the same reason – too much to drink – when Pholos, the centaur, was entertaining Heracles. This feeling that Olympia was in centaur‑country must have made what was something of an Attic and Thessalian legend more acceptable here. I do not think these are local centaurs in the west pediment, although an ingenious scholar has tried to prove that they are. It is, however, surprising that the most picturesque incident of the fight is not included, when the centaurs, unable to deal in any other way with Kaineus, who was invul‑ nerable, had piled rocks on him and buried him alive. It may have been the absence of this scene which led Pausanias to make his extraordinary suggestion that the central

43

figure of the west pediment was Peirithous, for this enabled him to identify one of the figures beside him as Kaineus, though even so not in the usual uncomfortable situation.[31]

The arrangement in the museum at Olympia is now generally supposed not to be quite correct, and that which is generally accepted today omits one of the figures from each corner, assuming that they are additions made in Hellenistic times, and interchanges the four groups, HI with NO, FG with PQ. Our arrangement (Fig. 28) shows Apollo in the centre. On his right (our left) the bridegroom Peirithous, king of the Lapiths, striking at the centaur Eurytion, who is attacking his bride Deidameia. On our right of Apollo, Theseus of Athens, the friend of Peirithous, strikes with an axe at the centaur who is assaulting the bride's companion.

Then come two pendant groups, of two figures each, on our left a centaur trying to carry off a young boy, on our right a centaur locked in struggle with a youth. Moving further out from the centre still, again two pendant groups, this time of three figures each, a centaur attacking a girl and at the same time himself being attacked by a Lapith.

In this scene of violence, there is naturally more opportunity than in the east pediment for showing the body in movement, and the sculptors have taken full advantage of it. In a general way there are three distinctive kinds of action: the thunderous attack of the drunken centaurs, who, with the enormous weight of their two bodies, hurl themselves on the women, using both hands and legs to seize them. Counterpart to this is the resistance of the women, defensive but by no means feeble, aimed at loosening the hands that grasp them and thrusting away the heads of their assailants. Third, the Lapiths, who attack and attack vigorously, not wasting their time in trying to pull the women free, but out to kill.

Within this general picture there are a number of momentary incidents which have been studied by the sculptors with much careful observation, and we must look at some of these, for this is where the new spirit of the early classical period is most evident.

We will look first at the central figure. Then at the bride and her attacker. After that at what is left of Theseus (Peirithous, alas, exists only as a head and a few fragments): then at the youth struggling with the centaur, and finally at the two three-figure groups.

First, then, the central figure (Fig. 48). Despite the curious statement of Pausanias that it is Peirithous, and the gallant attempts of certain scholars to uphold him,[32] this is undoubtedly Apollo. He is not taking part in the fight: the movement of the arm is symbolic, and he must be thought of as invisible to the combatants, but swaying the conflict by his commanding gesture. The expression of the face is deliberately impassive: stern but calm.

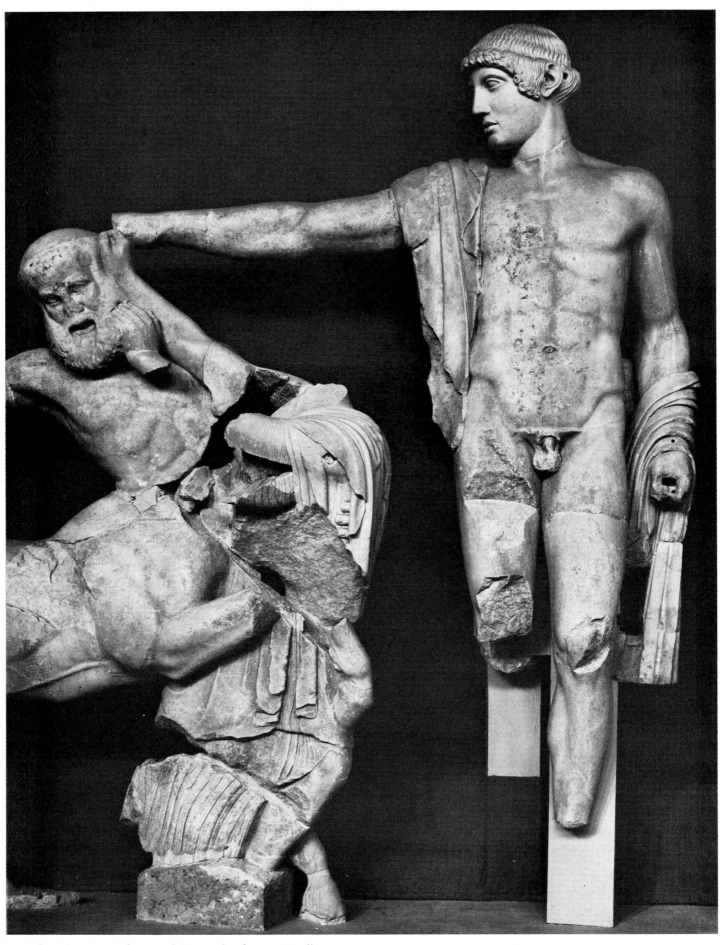

48. Olympia, West pediment of the temple of Zeus: Apollo

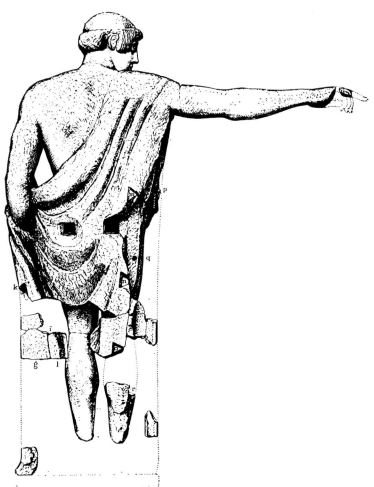

49. Olympia, West pediment of the temple of Zeus: Apollo
(from Curtius-Adler, *Olympia*)

50. Apollo. Roman copy of a Greek statue of the fourth century
B.C., perhaps by Leochares. Rome, Belvedere of the Vatican

One curious point about the composition of this statue. At one stage, presumably
at the beginning, the sculptor had intended that the cloak should pass between the
left arm and the body (Fig. 49), but he then changed his mind so that the swathe
of drapery now appears to come from outside the forearm and to fall between it and
the hip. Believing, as I am inclined to do, that the carving was in two main stages,
one before the statue left the quarries on Paros, and the other before it was hoisted
into the pediment, I should like to use this as an argument in favour of that belief:
yet it is not a strong argument, because the sculptor's change of mind could equally
well have been made if all the carving had been done at Olympia.[33] The reason for
the change may have been that there was a moment at which he realized that the
drapery coming very close to the hip would obscure the contours of the torso. Or,
of course, there may have been an accident.

The next time you look at the Apollo Belvedere (Fig. 50), consider if there is
not a possibility that it owes something, not at second or third hand, but directly,
to the Apollo of the west pediment at Olympia. The Apollo Belvedere is not a
Greek original, but is copied from a lost Greek bronze of the fourth century B.C.,

51. Horsemen. Athenian vase-painting, sixth century B.C. (from De la Coste Messelière, *Au musée de Delphes*)

52. Chariot. Athenian vase-painting, late sixth century B.C. London, British Museum

a bronze usually ascribed to the Athenian sculptor Leochares. Now we know that Leochares worked at Olympia: he made the portraits of the Macedonian royal family for the Philippeion there.[34] And whilst at Olympia, how could he have failed to study the sculptures of the temple? I think it quite possible that Leochares was a little puzzled about the gesture of Apollo's extended arm, which has no obvious purpose, and that the idea suddenly came to him, either consciously or subconsciously, that it might be rationalized. This is not so far-fetched as it may look at first sight. Sculpture, unlike painting, has a limited repertory, and it seems to me that an adaptation and rationalization of the earlier pose might very well have occurred to a fourth-century sculptor. The Olympian Apollo had both bow and arrows in one hand. It only needed to reverse the pose and place the bow where it belongs when in use, in the outstretched left hand, and the thing was done.

Another field of experiment, in which at least one of the designers of the figures in the pediments was active, is that of the third dimension; and this is seen at its clearest in the group of the bride and her attacker. In archaic art bold frontal poses are not unknown, especially on vases, but these bold effects are achieved by presenting the main view of a figure or group in a persuasive aspect, and letting what is behind take care of itself, without any attempt at foreshortening. On vases, delightful views of a horse and its rider often appear: only the front of the horse is seen, but the viewer knows that the remainder must be there, because there is its tail (Fig. 51). Chariots are often treated in this way on Athenian archaic vases: their grouping is highly effective and often complicated, but with no true foreshortening, merely a combination of expressive silhouettes (Fig. 52). Though less common,

53. Delphi: Metope of a Sicyonian building: The ship Argo

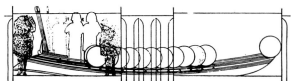

54. Delphi: Two metopes of a Sicyonian building conjecturally restored: The ship Argo (from De la Coste Messelière, *Au musée de Delphes*)

such devices are not unknown in sculpture, for instance on one of the little metopes of the Sicyonian peristyle in Delphi about a hundred years before Olympia (Figs. 53–4), in which the Dioscuri, the divine horsemen Castor and Polydeuces, are mounted on their horses, aboard the ship Argo among the other Argonauts. More surprising, because not much more than a generation before Olympia, and because of its greater size, was the east pediment of the temple erected by the Alcmaeonidae at Delphi, which seems to have had as its centrepiece an almost life-size chariot-team and chariot, facing the front, although the depth of the pediment was certainly not more than three feet.[35]

At Olympia, difficult compositions of great depth are attempted, but there is a growing consciousness that something has to be done about rendering the third dimension instead of simply suggesting it, and this confirms the belief that pre-liminary models for the pedimental figures were prepared in clay or wax, a method that invites greater freedom of composition than does either a preliminary drawing or a direct attack on a block of marble.[36] In this group of Deidameia and Eurytion (Fig. 55) the body of Deidameia turns freely in space: her head and chest are in three-quarter view: her left elbow is thrust out towards the right: the right thigh is in profile, but the left lower leg is drawn back so that the heel – an odd little touch of realism, clearly intended by the sculptor to prove that the leg did really come as far back as that – parts the hem of the dress right at the back of the plinth. Another matter-of-fact touch is the way in which the edge of drapery demurely laps over the foreleg of the centaur which encircles her (Fig. 56). This is, however, sculpture in relief, and not sculpture fully in the round, and if you look at the back of the group, which was not meant to be seen, you will observe that the shoulders of Eurytion have suffered a grievous distortion (Fig. 57).

48

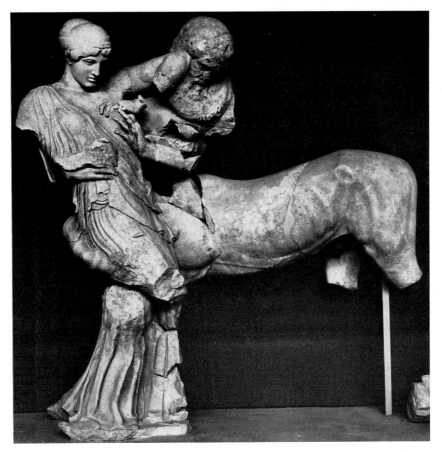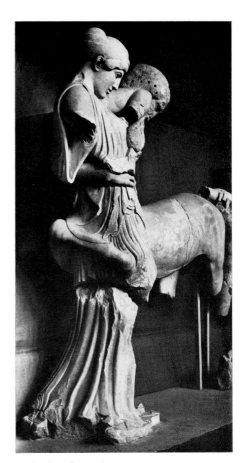

55–56. Olympia, West pediment of the temple of Zeus: The centaur Eurytion seizing the bride of Peirithous

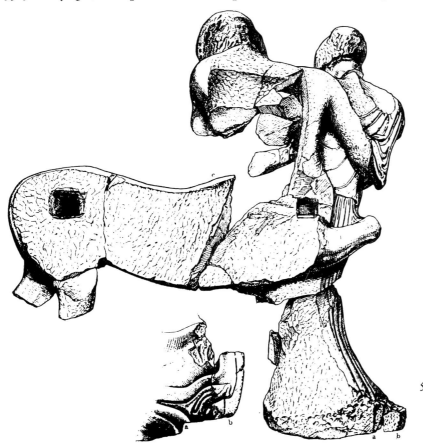

57. Olympia, West pediment of the temple of Zeus: The centaur Eurytion seizing the bride of Peirithous (from Curtius–Adler, *Olympia*)

What is left of Theseus deserves a moment's notice (Fig. 58), for here too there was evidently something of this feeling for the third dimension. The drapery swathed round the legs and feet suggests the speed with which the guest has leapt from the couch on which he was reclining at table. There is a close parallel to this figure on a vase, in New York, made about this time (Fig. 60). It is the same subject, but it is an Athenian vase, and the Athenian Theseus occupies the centre of the stage, wielding an axe against a centaur who has snatched up a cushion to defend himself: the cloak of Theseus swirls round his legs in a fashion similar to that of the sculpture, suggesting that either the vase was inspired by the sculpture, or that both were inspired by some other original, perhaps a great wall-painting.

Another incident on the vase suggests some sort of connection with the sculpture – a centaur and a youth locked in a struggle, with their heads close together and the centaur apparently trying to bite: though not by any means identical, it inevitably recalls this two-figure group at Olympia (Fig. 59).[37] This, more obviously than most of the others, is a piece of relief-sculpture, since the centaur consists only of a façade – head, arms, human chest, horse's chest, and two forelegs – the remainder of his horse's body existing only in the imagination. Without any doubt there must have been a preliminary wax or clay model here, not necessarily of large scale, if only to determine how much could be included without the group projecting over the edge of the pediment, and to work out the extremely complicated pose. It is indeed so complicated that, with a large piece missing in the middle, it is not at all easy now to make out exactly what is happening.

The youth must have seized the centaur round the neck with his right arm and the centaur must have reacted by holding the arm with his right hand, gripping its hand with his left hand, and savagely biting at the forearm. The youth's left arm must have crossed his own body at the midriff, trying to detach the centaur's left hand, and the youth's right leg came boldly out to the front, almost without foreshortening. Something, however, went wrong with his left leg (Fig. 61): the designer's intention clearly was to show this sharply bent at the knee and the lower leg going straight back away from us; but the model may not have been precise here, and the carver has failed to show where the knee comes, or what its relation is to the drapery swathed round it. One can well understand that, having carved to a certain depth with marked lack of success, he did not dare to undercut the mass of marble more deeply. Nor is it clear exactly what he could have done in order to make the relationship of limb and drapery more convincing. He evidently felt this too, and decided to leave it alone.

When the marbles of Olympia were excavated, the head of this youth came as a great surprise (Fig. 62). Archaic sculpture was well known from the marbles of Aegina: classical sculpture from the marbles of the Parthenon. In neither did the

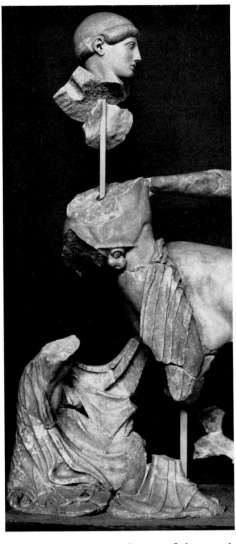

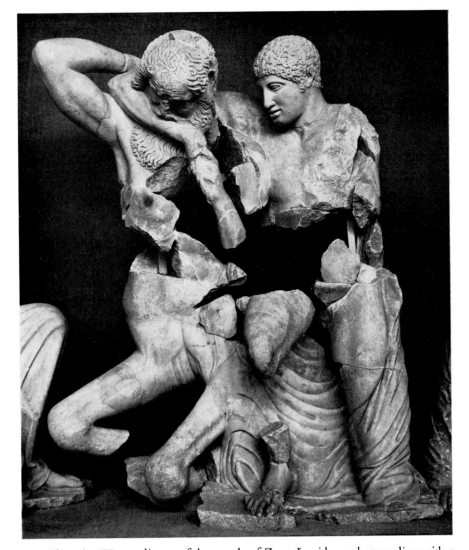

58. Olympia, West pediment of the temple of Zeus: Theseus

59. Olympia, West pediment of the temple of Zeus: Lapith youth struggling with a centaur

60. Lapiths and centaurs fighting. Athenian vase-painting, c. 450 B.C. New York, Metropolitan Museum of Art

61. Olympia, West pediment of the temple of Zeus: Lapith youth struggling with a centaur

faces of people show any emotion. Such a bold piece of realism as this was therefore almost shocking, and it has taken us some years to realize that this was a genuinely experimental phase of sculpture, by a particular group of sculptors; perhaps a little outside the regular evolution elsewhere, and fitting rather uneasily into the text-books – which do like things to develop tidily – a phase which might have led to something even more great and powerful had not the concentration of Greek talent taken place so shortly afterwards at Athens in the building-schemes of Pericles, and produced through the overwhelming influence of Pheidias and his circle – to say nothing of Polycleitus, the arch-standardizer, with his system of proportions – a kind of classic conformity which has affected art ever since. I do not think that Pheidias was classical in this sense – so far as we can judge he was highly original – but his followers certainly were.

The means by which emotion is expressed in this head are parallel to those used in the seer of the east pediment – great economy of modelling, concentration on a few simple themes, and elimination of inessentials. If you have seen anyone suffer-ing an intense spasm of pain you will recognize the acuteness of the sculptor's observation – the half-snarl which the shock causes, the curl of the nostril drawing up the ends of the mouth and opening the lips – the telling accuracy of the deeply-cut line by the nostril, and of the two sharp-cut furrows on the forehead.

One other feature adds considerably to the effect. In the early days of the cinema, when films were mostly light-hearted, a not uncommon incident was for a character to receive a sudden, though never in those days lethal, blow on the top of the head; and it could be observed that this caused the victim to goggle and to squint. There is a similar effect here: the sculptor has made the eyeballs prominent, and by his modelling of them has shown that the two axes of sight are in fact converging.

We come now to the two groups, each consisting of three figures, which balance one another on opposite sides of the pediment and fit into it fairly far out towards the corners (Figs. 63, 67). The compositions are two variations on a similar theme – a girl attacked by a centaur, who in turn is attacked by a Lapith youth. Both the girls are shown to be young by the forms of the body, and they wear the dress worn commonly but not exclusively by young girls, the simple Doric peplos without an undergarment.

In the group on our left of the pediment (Fig. 63) the centaur has dislodged the dress from the girl's breast with his near hind leg, which she seems to have been pushing away with her left hand, now missing. He has also grasped her by the hair with his left hand, and she is thrusting away his head with her right, seizing him by his ear, which is a sensitive organ: their arms must have run more or less parallel with one another. The centaur's nostrils contract (Fig. 64): it is a snarl not of anger or because he is naturally ugly, but of intense pain. Apart from the extraordinary

52

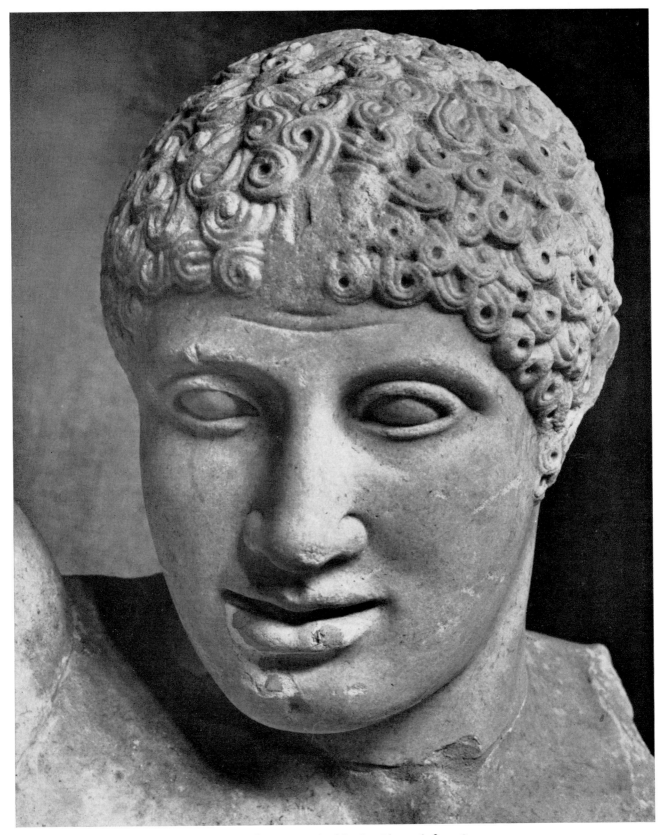

62. Olympia, West pediment of the temple of Zeus: Head of the Lapith youth from fig. 59

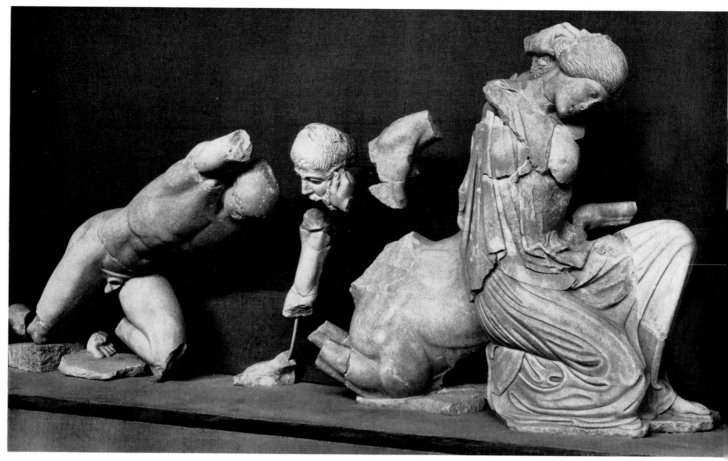

63. Olympia, West pediment of the temple of Zeus: Centaur attacking a girl is attacked by a Lapith youth

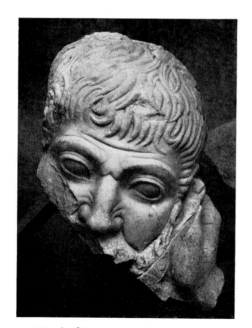

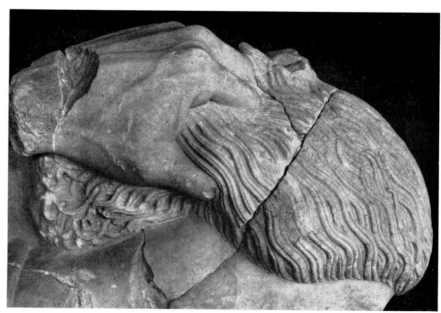

64. Head of the centaur from fig. 63 65. Head of the girl from fig. 63

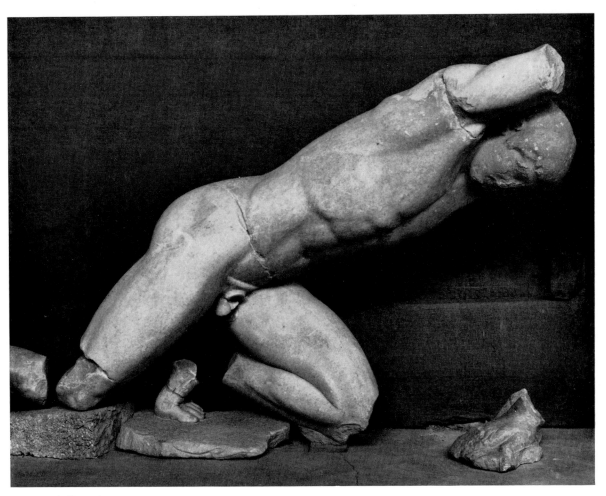

66. Youth from fig. 63

complexity of the group, the sculptor has made two bold experiments which have not been quite successful, and have failed, in so far as they have failed, in a rather similar way. One is the tucking in and re-emergence of the dress between the under-side of the thigh and the back of the calf: it is just a little too flat, and the contour of the calf a little too level to be consistent with the degree of realism seen elsewhere in the figure. The second is the hair (Fig. 65). It is not clear exactly what has gone wrong, until one understands what was being attempted. The sculptor was trying to give the impression of the hair being pulled violently back: he realized that hair pulled back would come sharply off the scalp, and he has given it a sharp line of demarcation, but he has not flattened it as much as the action demands. Nevertheless, the total effect is exquisite, whether it be in the beauty of the strands of hair, the contrast with the tense hand that grips them, or the contours of the cheek and fore-head. The Lapith youth who comes to her rescue (Fig. 66) charges straight in, putting all the weight of his body into the thrust.

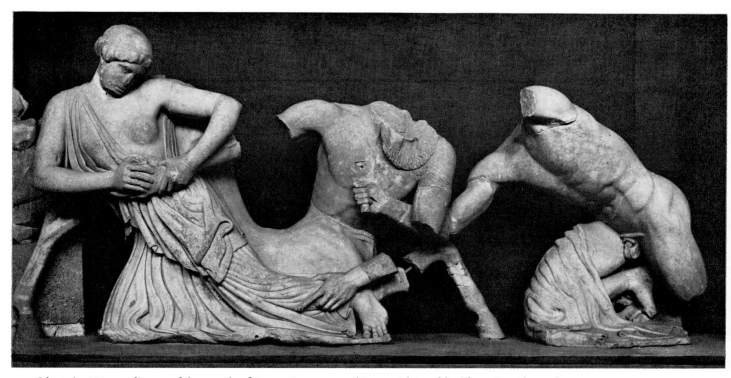

67. Olympia, West pediment of the temple of Zeus: Centaur attacking a girl is stabbed by a Lapith youth

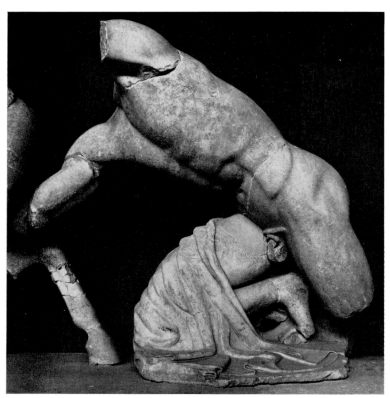

68. Youth from the group in fig. 67

69. Hand of the centaur
from fig. 67

In the corresponding group on the other side of the pediment, the centaur has seized the girl with both hands (Fig. 67). His right hand tears her dress from her body and his left grasps her by the ankle, forcing her to her knees. The sculptor has carefully studied every part of the dress in order to reproduce a momentary effect. As the girl goes down on her right knee the cloth round it collapses in a series of concertina-like folds: the edge of a theatre-curtain as it strikes the stage (one of those old-fashioned theatre-curtains that swing in from the sides) produces just such a series of folds. In the middle of the body the drapery has bunched into a mass with one layer over another, the upper layer enriched by the loose end which has been torn from the shoulder. The folds on each side frame – and frame intentionally – the young and tender breast; and there is youth too in the lean forearms, the soft hands and the pathetic poise of the head. The foot is contrasted with the centaur's hand – foot with hand, female with male. A pity the centaur's foreleg is broken, because there was certainly intended to be another contrast here between the human forearm and the equine foreleg: the whole complex forming an extended whirligig with four elements. The centaur's hand has been studied not only down to the veins, but even down to the wrinkles over the joint of the thumb: an extraordinary piece of realism straight from the living model, perhaps the sculptor's own thumb (Fig. 69).

Then comes the rescue: a young Lapith charges in with a tremendous thrust of his powerful body, and plunges a knife into the centaur's breast (Fig. 68). The Lapith's right leg is fastened down – not in fact, of course, but in appearance – by the cloak, which flows over the knee, stressing that this is the fulcrum on which the action turns: a subtle contrast with the similar figure in the pendant group, where the youth throws himself headlong at his opponent with nothing to check him. This one has rushed in, but checks himself as he stabs upward with a knife, and the cloak, anchoring the knee, indicates the difference of the action.

70. The group in fig. 67 seen from the back (from Curtius-Adler, *Olympia*)

Here then we have the ageing, rather slack, body of the centaur in the middle, flanked on the one side by the slim, delicate body of the girl and on the other by the hard, robust torso of the youth.

A study of the back shows not only how complex the group is (Fig. 70), but also how concerned either the architect or the master-sculptor was with the problem of weight. He must have told the sculptors to make everything as light as they reasonably could, and they saved perhaps a hundredweight or so here by hollowing out the centaur's human body. When was this done? Could it have been done before the marble was shipped in order to economize weight on the voyage, or could it have been done just before the group was hoisted into position, in order to avoid the risk of over-weighting the pediment floor? The last seems unlikely, for the pediment floor had far greater weight than this to bear in the central groups.

If you think over the composition of the various figures we have been discussing, you will agree that these, the groups especially, must have needed a great deal of preliminary planning. Drawings would not have been adequate, because this is a construction in three dimensions, and before the invention of paper, drawings were not the natural way for a sculptor to express himself. There may have been sketches on whitened boards, or on clay tablets, but the finished prototype must have been in some other form. There must in short have been a three-dimensional model, not necessarily very large – even quarter-scale might have been excessive – but a fairly detailed one, in order that the complexities of the group could be worked out exactly; and an accurate one, a scale-model, in order that blocks of exactly the right size could be quarried, and also that the finished group might fit exactly into the space allotted to it in the rapidly contracting field of the pediment, where it had to fit from ceiling to floor, from side to side, and also from front to back.

Whilst we have been studying these various details you may have thought that the distinctions made are too subtle, that the contrasts between various textures and surfaces, between soft and hard, young and old, drapery and nude, male and female, were not intended. Yet these differences are certainly there; and if there, how can they be other than intentional?

Another question that naturally then arises is: 'Why were they not attempted before?' I think we can assume that sculptors, and not only sculptors, must, some time before this, have noticed the different contours of the male and female body, the difference between maturity and childhood, and those other subtleties some of which we have observed: and that they might have been interested enough in these differences to see their sculptural possibilities.

Why then did this happen at this particular time? Why was there apparently this sudden awareness of certain phenomena in the form and mechanism of the human body, the emotions of the human mind, and the pathos of the human situation; and this apparently sudden ability to present these in sculpture?

Perhaps that is best answered by an analogy. If Shakespeare, with the same natural gifts, had been born a hundred years earlier, he could not possibly have produced the poems and plays he did, partly because the English language had not reached an adequate stage of development, and partly because the surroundings in which he would have lived, and the knowledge to which he would have had access, could not have given him the stimulus he needed. Genius is to some extent at the mercy of its environment and of its technical equipment, and grows with what it feeds on. The kind of advance that we see at Olympia is the result of a happy conjunction between genius and opportunity.

III

The Temple of Zeus at Olympia

THE METOPES:
NEW ASPECTS OF OLD LEGENDS

ECAUSE of the method of constructing a Doric frieze, the metopes of the temple of Zeus at Olympia had to be inserted before the roof was put on. It would have been difficult, though not impossible, to do much carving on them once they were in place, and thus it is likely that the metopes were given priority by the master-sculptor, the architect having insisted that they must be ready by a certain time, so as not to delay the construction of the roof. Is there any confirmation of this from the metopes themselves? They do give the impression of all having been carved about the same time. Whether there was one designer or more than one, the series is conceived as a whole; the use of colour instead of carved detail for the larger areas is much the same in all of them; and the style is homogeneous, although certain differences can be detected which might well arise from two different master-sculptors having been at work. The same kind of spirit, calm but by no means weak, seems to inform them all. It may be partly the smaller scale, partly the general softness of the contours and a touch slightly less coarse, partly the freer use of paint instead of carving for details, that seem to set them apart a little from the pediments; but one cannot maintain that they are necessarily earlier, in fact in some ways they seem later. At a guess I should call them more Cycladic, and should suppose that a closely-knit team of island sculptors worked upon them.

Were figures for the pediments being carved at the same time, although they could not be placed in position until the building was finished? We cannot be certain, but the quarrying of the marble must have gone on steadily, and if the marble was available, there would be no reason for delaying a start on the pediments, provided there were sculptors free to carve them: in any case the finishing of the metopes would have released a number of craftsmen for the more laborious task of carving the pedimental figures.

The architect had, then, so planned the building as to produce twelve metopes, one row of six over the portico in front of the only door of the temple, that on the east, the other row over the similar portico at the back. Into these twelve metopes

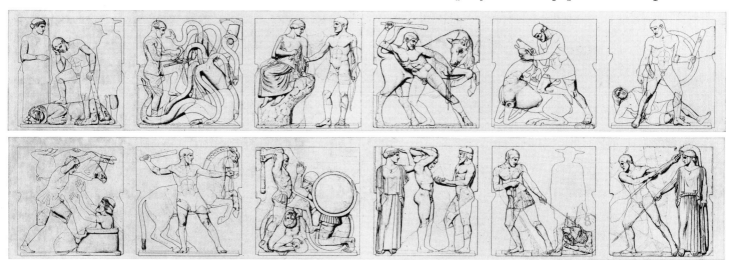

71. Olympia, temple of Zeus: Conjectural restorations of the twelve metopes. Restored parts are in outline. (M. Kühnert in Curtius-Adler, *Olympia*)

spaces, each about five feet square, were fitted twelve sculptured panels depicting the labours of Heracles (Figs. 15, 71).

Apart from the neat way in which the twelve metopes had been designed to accommodate the twelve labours, the choice of the exploits of Heracles to decorate this particular temple was a singularly happy one. Heracles was the greatest of all the Greek heroes, he was known to everyone, especially here, because he had spent much of his life in the Peloponnese, and performed half his famous labours there. He was the patron of athletes, and had actually established the first Olympic Games on this very spot. He was the son of Zeus, and this was the temple of Zeus: but he also typified the life of man on earth, who battles on against seemingly impossible odds, endures sudden and terrible calamities – how like real life this must have been to many Greeks – yet by sheer determination, and, one may add, very hard work, wins through in the end, and, with the help of Athena, is received by Zeus into Olympus.

He had a sympathetic personality too, with a strong taste for ordinary human pleasures, and not without a share of ordinary human failings, which made him both more lovable and more credible. He had numerous sons in many parts of the world – he was a great traveller – but, and this would appeal especially to Greeks, no daughters.

By the time the Olympian temple was built the exploits of Heracles had been a favourite subject among artists for a couple of centuries, especially in vase-painting. There must also have been poems about him, and at this very time a Carian poet, Panyasis, produced a long epic, of which nothing survives, apparently about his major achievements apart from the labours. In general, however, his adventures had

a strong earthy flavour, not particularly suitable for high epic, but rather for tales told or sung round the fire in humble places. As is the way with such things, many stories tended to accumulate round a celebrity, and a striking or amusing incident which occurred independently would become attached to a famous name. There are plenty of modern instances of this: a good story goes the rounds, and to make it easier to tell and more acceptable to the listener it is attributed to a well-known public character. In England the Duke of Wellington in the nineteenth century or Winston Churchill in the twentieth are obvious examples.

So, by the end of the seventh century, and even before, a number of adventures, far more than twelve, had clustered round the name of Heracles. Then someone with a passion for tidiness came along and the stories were neatly divided into three classes: first the major exploits, those which the Greeks called Athloi and which we call rather clumsily, after the Latin, 'Labours'; these were tasks which had been imposed upon him. Then there were the Deeds which he had performed of his own free-will and which were called Praxeis – Deeds: and finally there were the Parerga – the incidents that happened to him when he was engaged in his other tasks.

It is the twelve main labours with which we are now concerned, and it is on this temple that the twelve first appear in art all together, and alone.[38] It was generally agreed that these were performed in the service of Eurystheus, King of Argos. It may be that here there is an echo of actual history. Heracles is mentioned by Homer as a princely ruler, and it is possible that he was a real person, a prince, ruler of Tiryns perhaps, and that Eurystheus was a more powerful ruler of Argos, to whom somehow Heracles became subject for a time. In the legend, twelve years' servitude was commanded by the Oracle at Delphi as a penance (penance for what is not certain) and it was accompanied by the promise of immortality when the labours were ended.[39]

Imagine yourself for a moment to be the sculptor confronted with the task of designing the metopes. A little thought will show that it is possible to introduce into the design of each panel only one, two or at most three human figures. The reason is that the scale has to be large enough for them to hold their own with the architectural frame, and indeed large enough to be seen at all. Alternatively or additionally an animal or monster may be introduced if essential to the story, but this, as we shall see, raises another problem of scale. Further, there is a limit to the number of ways in which three human figures can be composed within a square panel. The three stock designs are two standing, three in a row standing, or one standing at each side and one lower – sitting or stooping – in the middle. These are vertical compositions: if diagonals are used other variants can be introduced. In the Olympian metopes the designer has shown great ingenuity in devising various compositions: they are not elaborate in themselves, and he has not troubled to disguise

the skeleton of the design, thinking no doubt that in this way they would harmonize better with their architectural frame. Accordingly it is an interesting exercise to see exactly how he has done it in each, and how it accords with the subject that is represented.

We must now put ourselves in the position of the visitor who had stepped inside the main colonnade and who looked up and saw above him for the first time six of the metopes. I do not know whether there is an exhibition of waxworks in the United States, but in London we have the collection started in the time of the French Revolution by Madame Tussaud. The figures now shown have nothing like the life-like quality of the earlier ones by Madame Tussaud herself, which were destroyed by a fire not so long ago, and yet they exert an extraordinary fascination on people, who see in them far more than just a dummy: the figures seem to take on a living personality – to *be* in some way the persons represented. This is a deep-seated human feeling, reflected in the magical practices of many people, including the Greeks, where an image, even a small one, has something of the very essence of the person it portrays. If only we could capture something of this feeling it would, I think, help us a little to understand what the visitor in antiquity felt when he first saw these sculptures. Naturally the more simple-minded felt it more deeply or accepted it more readily, and I reminded you in my first lecture of a modern parallel to this, in the churches of Southern Italy. We ourselves have become so accustomed to regard sculpture as something to put in a museum and, quite apart from the loss of colour and the blank, sightless eyes, we so rarely have a statue complete, that we tend to think in fragments, and of the details rather than the whole. We delight, and rightly so, in exquisite minutiae. But that kind of delight was not the purpose for which these sculptures were carved. They were not regarded primarily as works of art, although many Greeks would have appreciated their fine craftsmanship: the scenes were re-creations, so life-like that you never questioned their veracity, of things that had really happened – not in what would today be called history, because simple people do not use dates, and do not distinguish readily between past and present: nor in religion, which also had a different meaning in antiquity. These were events in the lives of gods and heroes, who all belonged to the Greeks, were still part of them, events brought to life and making a more forcible impact on the mind by reason of the sculptural forms and by the bold, simple and therefore emphatic colour-scheme. Think of the visitor, then, as seeing alive before him Heracles himself, engaged in those very exploits he had heard sung at the banquet or narrated at the fireside.

Heracles, naturally, must be present in every one, and there will sometimes be an animal or monster, because the legend demands it; but at Olympia two deities also appear, Athena and Hermes: Athena four times, Hermes twice. Both are appro-

priate. Both were children of Zeus. Athena was the sponsor of Heracles, who eventually introduced him into Olympus: as early as the *Iliad* she accepts the same mission, though ungraciously, complaining that because of Zeus's insistence on behalf of his son she has often had to go down to earth and help him with the tasks set him by Eurystheus. This querulous tone is quite out of character with the Athena of the metopes – a good index of how far thought had moved since the time of the poet, whoever he may have been. The second deity, Hermes, is often associated with Heracles as the patron of athletes, but here he is introduced rather in his special function of guide: he appears at the beginning of the series to imply that he will be a helper throughout, and then on a special occasion later when his unique knowledge of the way to the underworld is needed.

Pausanias saw the metopes in position on the temple about A.D. 174, and he gives a list of them. 'Most of the labours of Heracles' he says 'are in Olympia. Above the doors of the temple is represented the hunting of the boar from Arcadia and the exploit against Diomedes the Thracian and in Erytheia against Geryon, and Heracles about to receive the burden of Atlas, and cleansing the land of dung for the Eleans. Above the doors of the room at the back is Heracles taking the girdle of the Amazon, and the affair with the hind, and the bull in Knossos, and the birds on Stymphalos and the hydra and the lion in the land of Argos.' There is no doubt that this is the order in which Pausanias saw the metopes: by mistake he omits one, that of Cerberus. Its fragments were found in such a position as to indicate that it came on the east front, last but one from the north.

Just a word about Stucchi's ingenious suggestion that at some date after the building of the temple and before Pausanias saw them (perhaps after damage by an earthquake) the metopes had been rearranged, and that the original order grouped the labours performed at or near home on the west side and those performed elsewhere, often at the ends of the earth, on the east.[40] I do not think he is right, and one of the reasons for not thinking so is that the present arrangement, which we know Pausanias saw, introduces Athena at four symmetrical points, namely in the first metope, the third, the tenth and the twelfth.

In the series of drawings made by Max Kuehnert for the German excavators of Olympia in 1882, the parts of the sculptures drawn in heavy lines still exist, and the parts drawn in lighter lines are conjectural restorations (Fig. 71). A good many fragments have been added to the metopes since,[41] but the drawings are still the best there are, and it is convenient to go on using them as a guide. Some of the metopes are far less complete than others, and I shall not discuss them all, but select three from each side, the Nemean lion, the Stymphalian birds and the Cretan bull from the west: the Augean stables, Cerberus and the apples of the Hesperides from the east. We will start on the west with the labour which everyone agrees is the

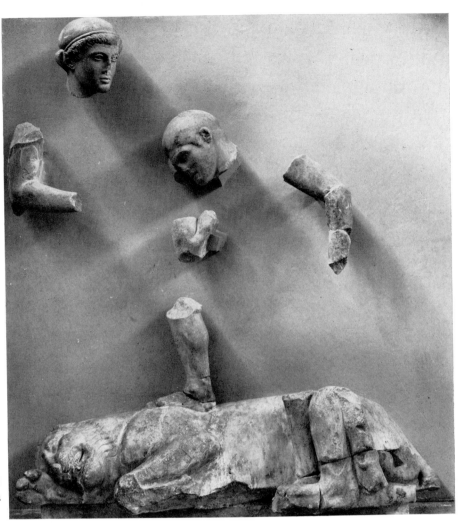

72. Olympia, temple of Zeus:
Metope of the Nemean lion

first, that of the lion of Nemea, or, as Pausanias calls it, the lion in the land of Argos (Fig. 72).

The Nemean lion had, in art, a long and chequered career. In archaic art Heracles overcomes it in a number of ways: in a painting on a cup in Munich he disembowels it – an enchanting presentation of a disgusting process – and after that he wears its skin. Indeed, in classical and later art the skin is better known than the lion, and becomes simply a convenient identity-mark for the hero.

The story is simple. The lion was ravaging the land of Argos and Heracles was ordered to kill it: but it was invulnerable; it could not be wounded. Heracles solved the problem by knocking it senseless with his club and then strangling it, and archaic artists delight to show him doing this, although they tend to forget about the preliminary clubbing, and the lion is usually putting up a stout resistance.

Sad that this metope is so fragmentary as to be almost grotesque, and so much is missing that we cannot be certain of the details; but the general composition is clear (Fig. 72). Athena is standing on the left looking down towards Heracles, and Hermes on the right, probably also looking inwards.

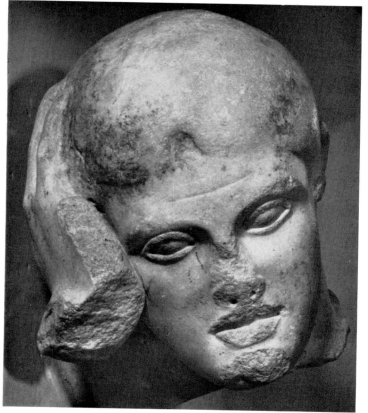

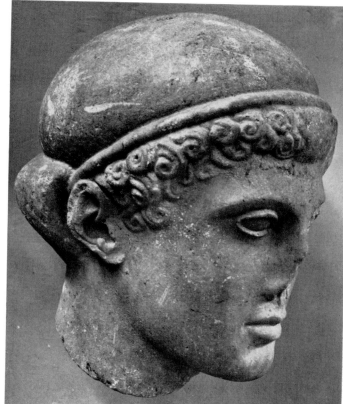

73. Heracles from the metope fig. 72

74. Athena from the metope fig. 72

It was a tendency in this early classical period to choose subjects rather less simple than the mere successful feats of strength which had appealed so much to archaic artists, and it is therefore not surprising that the fight is not shown at all. The lion is dead, and the hero stands with one foot on his victim, not in the complacent attitude of the big-game hunter, but as an exhausted youth, beardless, and little more than a boy; exhausted by the struggle and daunted by the prospect of many years of toil ahead of him (Fig. 73).

At the outset of his labours both his helpers are with him, but it is not clear whether he knows this or not, since he is taking no notice of them. Hermes is here specifically in his capacity of patron of travellers and divine herald, for this is the beginning of a series of journeys where the way will often be arduous and difficult to find. Athena too is present because this is the beginning of the labours. On vases, both black-figured and red-figured, Athena is often shown standing by Heracles, but vase-painters so far have had no means of indicating any emotional relationship between them, except by the fact of her being there and by her gestures. Here for

75. Lion from the metope fig. 72

76. Olympia, temple of Zeus: Lion's head water-spout

the first time a sculptor is able to give some indication of her character, and of her present mood, through the expression of her features; an expression firm yet sympathetic, which seems to commend what has been achieved and to encourage further effort (Fig. 74). The lion is a curiosity. So plump, so mild, and so carefully resting his head on one paw – it is a stage death, and almost a property lion (Fig. 75). The sculptors of Olympia could do better than this, if we judge from the original lion's-head water-spouts on the building (Fig. 76). There is, however, a good reason for the strange Nemean beast. The designer naturally wanted to produce something particularly monstrous, and that would account for the rather unusual type of animal he depicted. Then, apparently about a century after the temple was completed, there was a catastrophe of some kind – a fire, or an earthquake – and the metope was so much damaged that the original lion had to be replaced. The new sculptor did his best to copy the damaged animal, but failed to catch its essential spirit – certainly any ferocity it may have had seems to have evaporated.

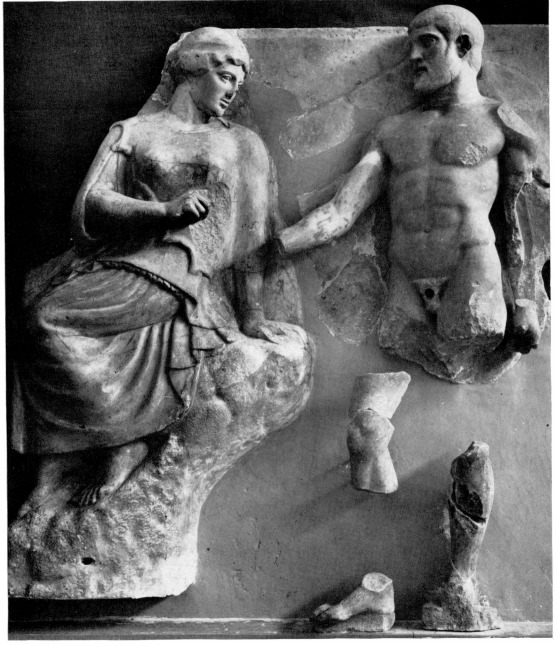

77. Olympia, temple of Zeus: Metope of the Stymphalian birds

The next labour we have chosen is that of the Stymphalian birds (Fig. 77). There were differences of opinion as to why the birds in the marches of Stymphalos in Arcadia had to be exterminated. The reasons given by ancient authors range from eating the crops, or having poisonous feathers, to eating people. Pausanias not only saw models of the birds at Stymphalos itself (he was uncertain whether they were made of wood or plaster), he was also informed that such birds still existed, no longer in Arcadia but in the Arabian desert, and he surmised that they were native in Arabia and that a flight of them had settled on Stymphalos.[42]

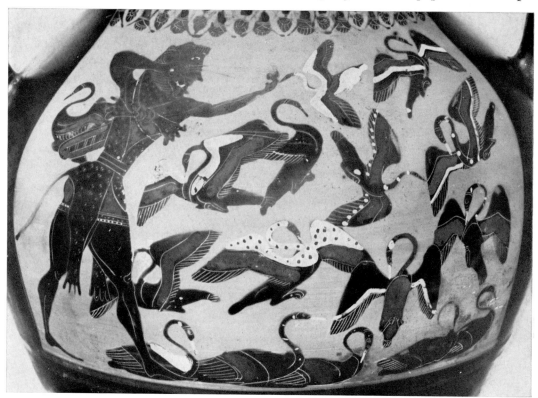

78. The Stymphalian birds. Athenian vase-painting about 520 B.C. London, British Museum

The Arabian specimens were the size of a crane, but as dangerous as lions or leopards, since they had beaks which could pierce armour of bronze or iron. The natives, he says, had an ingenious way of dealing with them. They wore thick garments of plaited bark, and the birds' beaks stuck in them just as small birds do in birdlime. On lake Stymphalos, they lived deep in the reeds, and the problem was how to get at them. Heracles is said to have borrowed a bronze rattle from Athena (how she came to possess such a rattle is not stated), to have frightened them out of the reeds with this, and then to have killed them with stones from his sling. A vase in the British Museum shows him in action (Fig. 78), and it makes a gay picture, because although it is an ordinary archaic vase, red, with the picture in black on it, the painter has enlivened it with a great many touches of white and purple, and has given the birds stripes and spots.

In the metope at Olympia – and it is a characteristic change of emphasis – the slaughter is over, and Heracles, now bearded, has brought a pair of the birds to his patroness Athena for her approval. Athena is turning, and with an almost shy gesture, is about to accept them: she has to turn, because she is sitting on a high rock, and has been facing away from him. This is a most surprising design, and nothing

quite like it was known in Greek art before this was discovered.[43] There are, how‑
ever, good reasons for both the nature and the height of the seat, and for the action
of turning round (Fig. 79). Athena is pre‑eminently the goddess of the citadel,
especially of course of the Acropolis at Athens, but also of acropolis rocks every‑
where. That is what the rock symbolizes, and that is why it is a lofty one. She is
seated on it because she is guarding it, and although at the moment she is not wear‑
ing a helmet, she does wear an exceptionally thick, warm dress, as is shown by the
way it folds; and over it the heavy leather aegis, the formidable thunder‑producing
cloak, fringed with serpents, which she took over from her father Zeus. She is in

80. The feet of Athena, from the metope fig. 77. Paris, Louvre

fact on guard, but she spares a moment from her guard-duties to turn round and look down graciously at the tribute her protégé has brought her. Only the mass of the hair is indicated; there is no attempt to carve on the surface of this mass either the strands of hair, or locks, or curls. This leaving of large areas to be indicated by painting instead of carving occurs often, though not with absolute consistency, in these metopes: the sculptor must have realized that in the diffused light under the colonnade of the temple, finely-carved detail would have told no better than plain colour.

One should always be careful of attributing to an artist intentions that he did not have, but one thing is certain: in sculpture no feature is introduced by accident, or because of a passing whim. Unlike the painter, who can insert a detail with the touch of a brush, or omit something by a moment's inattention, everything a sculptor puts in is the result probably of careful thought and certainly of weeks of exhausting work, and he will have satisfied himself of the desirability and the meaning of that feature before introducing it, anyhow in this early classical period, when sculptors are obviously thinking for themselves. What I have in mind is these bare feet (Fig. 80). Athena wears an exceptionally heavy peplos and aegis: she has been wearing or is about to wear a helmet. Why should her feet be bare? I think that it is because she is goddess of the rock, and by a normal magical mode of thought, direct contact with it reinforces both her strength and her identity.[44] The idea of going with one or both feet bare, in order to be in contact with the powers of earth, was certainly familiar in Greece: it seems for instance to have been recognized in

71

the ritual at Eleusis. These simple, magical ideas occur to most of us, especially when young. In that sensitive book on memories of childhood, Edmund Gosse's *Father and Son*, the boy recalls how the family moved from the town to the country: when he had his first sight of the sea, he knelt down on the beach and tasted the salt water. 'I recollect', he says 'that I thought I might secure some power of walking on the sea if I drank of it – a perfectly irrational movement of the mind, like those of savages.' Irrational, yes, but magically valid.

Surely there is in this head a touch of gentleness (Fig. 81), and surely it differs from the head of Athena on the Nemean metope (Fig. 74). It differs a little in style, but it differs also in feeling. Both are noble, but the one is more godlike, more remote, this more human, more gracious. Could one fairly say too that there is rather more emphasis here on youth? The sculptors at Olympia were not alone in taking a new interest in the personality of Athena: it seems a special mark of this generation. Theoretically, if the gods do not ever grow old they can never be younger than they are, but sculptors of this period very sensibly ignore theology, and show Athena younger than she could have been when she sprang fully armed and fully grown from the head of Zeus. The most obvious disregard of orthodoxy is in the young Athena of Myron (Figs. 83, 86).[45] The group of which she formed part must have caused a sensation when it was set up on the Acropolis at Athens, perhaps a few years later than Olympia but still in the fifties of the century; for here she is manifestly little more than a girl, with a slim, undeveloped figure; and with a girlish impulse she has flung away the pipes she had invented, because they dis-torted her face. The satyr Marsyas was on the point of picking them up, with the dreadful consequence that we all know, his death by flaying. The subject must have been chosen for some special reason, and because it was topical; a question well worth investigating, but outside our scope at the moment.

It may have seemed fanciful to say the group caused a sensation; but soon after there was an issue of coins, not in Athens but in Corinth, which attests its fame (Fig. 84). The coin is not a slavish copy of the statue – coin-dies of this period never are – but it is fairly obvious that the Corinthian die-engraver had studied and made detailed sketches of the statue at Athens, even to the arrangement of the hair which falls below the helmet at the back. An archaic coin of Corinth, only a generation or so earlier, is an index to the profound change in this period: the same subject, brilliantly executed, and as empty of human feeling as it conceivably could be (Fig. 85). And from what we know of the Athena Parthenos of Pheidias, by 438 Athena had again become conventional: but there was a stage between, illustrated by what I judge to have been one of the most marvellous statues ever produced, the bronze Athena Lemnia by Pheidias (Fig. 87), in which there is such a blend of the divine with the human, of majesty with beauty, as has never been surpassed.[46]

81. Head of Athena, from the metope fig. 77

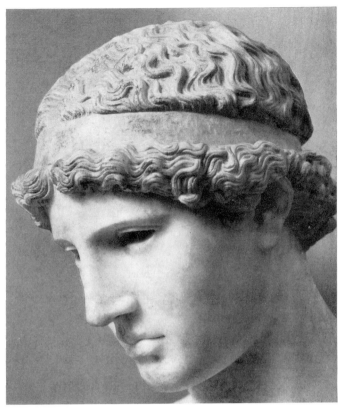

82. Head of Athena. Marble copy of a bronze of about 450 B.C., probably the Lemnia of Pheidias. Bologna, Museo Civico

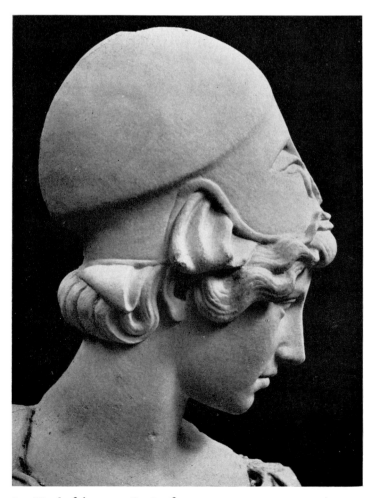

83. Head of the statue fig. 86, from a cast

84. Athena on a coin of Corinth, 450-400 B.C. Berlin, Museum

85. Athena on a coin of Corinth, about 500 B.C. London, British Museum

We may seem to be wandering a little far from the Stymphalian metope, but I think not. The Lemnian Athena was so called because she was dedicated on the Acropolis at Athens by Athenians who were sent as colonists to Lemnos about 450 B.C.; and, presumably to mark it as being a peaceful expedition, Athena was shown in peaceful guise, without her helmet. She held it, however, still in her hand, and she had her hair done in a rather unusual way with a broad, close-fitting band, which produces a rich fringe below (Fig. 82). I assume that the hair was dressed in this way in order that the helmet might fit comfortably upon it. Now the hair of Athena in the Stymphalian metope is dressed in the same way, except that there is no carved detail – everything was left to the painter. She had, then, been wearing a helmet, and perhaps had just laid it aside at the approach of Heracles. It is not at all improbable that Pheidias knew this metope. He was already a leading sculptor, and was engaged at this time, about 460, in making, from the Persian weapons captured at Marathon, the colossal bronze Athena to be set up in the open on the Acropolis at Athens. We can hardly suppose that he had never been to Olympia, in order to see what was up to that time the most important temple in Greece, especially since, either at this very moment or within a few years, he was to receive the commission for making the great gold-and-ivory statue of Zeus to go inside it. He is likely to have gone to Olympia soon after the temple was finished, or even while it was still being built, and, as a sculptor, his chief interest would naturally be in the sculptures. He may have seen some of them still on the ground. If they were already in position, the scaffolding may still have been up; or failing that, the maintenance-gang could surely have produced a forty-foot ladder so that he could have a closer look at the metopes. It would not, then, be fantastic to suggest that this Athena of the Stymphalian metope was one of the elements which con-tributed something to that supreme creation, the Athena Lemnia. The young Athena by Myron was certainly another.

We have looked at the Nemean lion and the Stymphalian birds: the third metope we have chosen from the west side is that of the Bull of Knossos (Fig. 88). The animal was at large, and was ravaging Crete. Here again there were differences of opinion, this time about his origin; but, whatever his pedigree, he had become a nuisance and Heracles was given the task of capturing him and bringing him to Eurystheus. There were some special problems for the sculptor here. He had to show that the creature was of monstrous size, but he had only his five-foot-square metope to accommodate it. He could not make Heracles small so that the bull should look large in proportion, because all the human figures on the metopes obviously had to be of about the same scale, and as large as possible in order to be visible at that height from the ground. So he very ingeniously sets the bull diagonally across the metope – it is just going up on its hind legs as it feels the strain of the rope

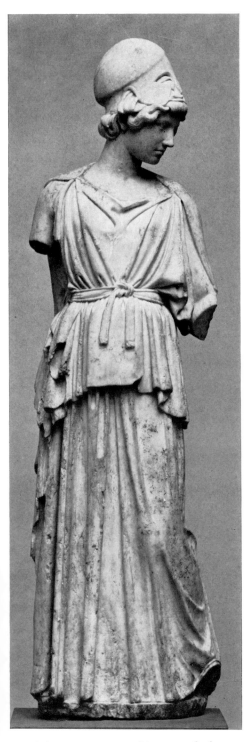

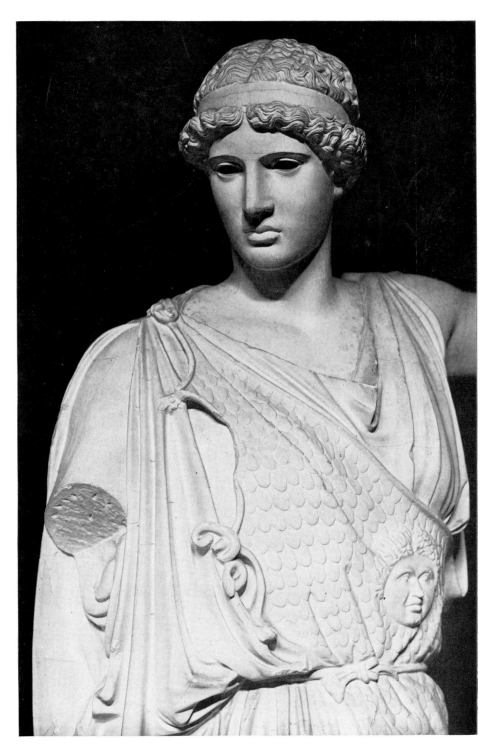

86. Athena. Roman marble copy of a bronze statue by Myron about 450 B.C. Frankfurt, Liebighaus

87. Athena, probably after the bronze by Pheidias dedicated about 450 B.C. in Athens by the Athenian colonists on Lemnos. From a cast made up from two Roman marble copies, a head in Bologna and a body in Dresden

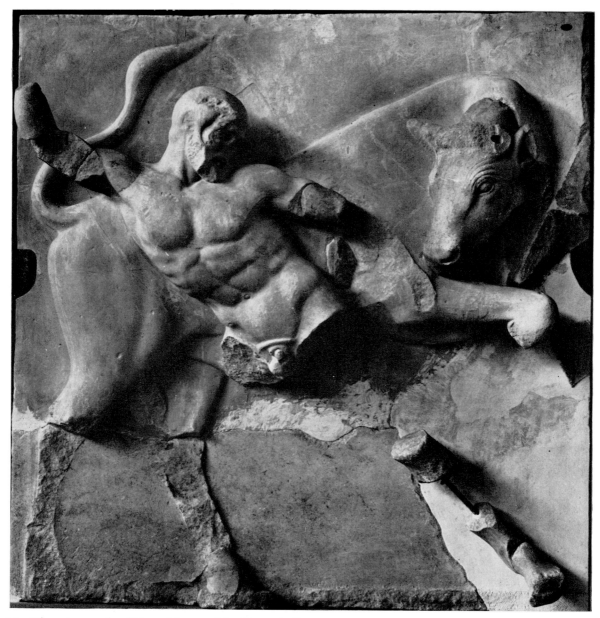

88. Olympia, temple of Zeus: Metope of the Cretan bull

– and at the same time he turns its head back. This has a double result. It enables him to increase the size of the animal, because he does not have to show it at full length; and he has increased the space to put it in, because the diagonal of a square is longer than its side. Then by a daring piece of design he has set the body of Heracles X-wise across it. This has the dramatic result of bringing the man and beast face to face; and because the hero has his rope round the animal's muzzle and is throwing his whole weight backwards to control it, there is a fine effect of tension and balance. This is, so far as we know, the first time that this X-shaped design, with the two bars of the X suspended exactly one against the other, has been used in sculpture. It becomes popular after this, not only because of its satisfying

76

89. Heracles and the Nemean lion.
Bronze relief about 600 B.C.
(from E. Kunze, *Archaische Schildbänder*)

self-contained scheme of two bodies in equilibrium, but also because one of them can be displayed against the other. Here the rather rugged torso of Heracles is contrasted with the flank of the bull, which is broad and smooth because covered with heavy skin: in a metope of the Parthenon ten or twenty years later (Fig. 114) the contrast is made more subtle by setting off the human torso not only against the horse-body of the centaur but also against the splendid folds of the cloak.

Perhaps it is a little strange that no one had hit on this design before, of the crossing bodies pulling against one another. Earlier artists had come very near it, but just missed the idea, for instance even as early as about 600 B.C. in a tiny bronze relief (Fig. 89). In relief sculpture of large size in marble, the technical problem is quite a formidable one. The sculptor has only a certain depth of marble (the metope slabs were fourteen or fifteen inches thick before carving started), and within it he has to carve two bodies one in front of the other. Here he has the human being in front, and has gone out of his way to make the torso as bold as possible, not only because he wanted to produce that contrast with the smooth flank of the bull, but also because he wanted to avoid any appearance of shallowness at a place where there was not much depth of marble to spare. The technical difficulty is not simply concealed, it is defied and exploited. The human torso being in such high relief, there was then the danger that the bull, because of its necessarily low relief where the bodies crossed, might seem insubstantial: this the sculptor avoided partly by the strong contrast of colour (the bull was red and the background deep blue), but chiefly by rendering its hindquarters in fairly high relief and its head almost in the round, with a finely foreshortened neck – a foreshortening bold, unique so far (except on coins) and highly successful.

Something of the similarities, and the differences, between the metopes and pediments, can be understood by comparing this torso of Heracles with that of Cladeos in the east pediment (Fig. 33), both powerful and both tense. Although the general style is clearly the same, in Cladeos there is a little more emphasis on the skeleton, a little more difference between soft and hard: whereas here, and elsewhere in the metopes, the contours are softened, and tend to slide off into one another without sharp transitions.

We now move round on to the eastern side of the building, and from the metopes there we select those of the Augean stables, of Cerberus and of the Golden Apples.

The story of the Augean stables had a strong local interest for the inhabitants of Elis in general, and for the people who lived near Olympia in particular: it also had a special interest for athletes. The story was that Augeias, king of Elis, had vast herds of cattle, which could be stalled for safety not in what we should normally call stables, but in a walled cattle-yard. Unfortunately Augeias was a bad farmer, and the yard was never cleaned. Matters finally became so critical that the whole land of Elis seemed likely to be swamped by the overflowing dung. Augeias had offered a reward – not in money, but naturally enough in cattle – if the stables were cleaned out in one day. The story is unusual – not to say unique – but its pattern is very much that of the regular fairy-tale, with its seemingly impossible problem, which the hero somehow manages to solve. It is also just the kind of story to appeal to an audience of cattle-farmers, and that was what many Eleans were.

Heracles accepted the challenge. To clean the stables by hand with a pitchfork was obviously impossible, although when this metope was first discovered it was thought that Heracles was actually doing something of the kind; but it is now clear that the instrument he is using is a crowbar. Athena is pointing with her spear, (which was made separately of bronze), to the spot low down on the stable-wall where he can drive the point of it in and lever out the stones. Through the breach will flood the waters of the Alpheios (some writers for good measure added the Peneios, thirty miles away, on which Elis stood – perhaps a little piece of Elean propaganda), and will carry away the dung.

The special interest of the story for the local inhabitants was that the deed was performed by the banks of their own river, and actually on the site of Olympia. Its special interest for athletes was that, after he had cleaned out the stables, Heracles marked out on that very spot the boundaries of the sanctuary, and founded the Olympic Games.

The composition (Fig. 90) is particularly interesting. Only in this metope is Athena helmeted, and this caused a little problem of its own. Here, as in the pedi-ments, the helmet is of the so-called Attic type (which might give us some clue as to where the sculptors did not come from[47]), and a helmet of this type must have a crest: but a crest takes up room, and the head of the wearer must therefore be at a lower level than it otherwise would be. In a word, Athena would have to be shorter. The designer cleverly evades the difficulty: by making Heracles bend forward as he strikes, he brings his head to a level below that of the goddess.

The composition – a beautiful piece of animated geometry – consists of the power-ful vertical formed by the goddess, whose body faces the front, and this is broadened and reinforced by the vertical arm apparently rigid (it is not really so, when seen

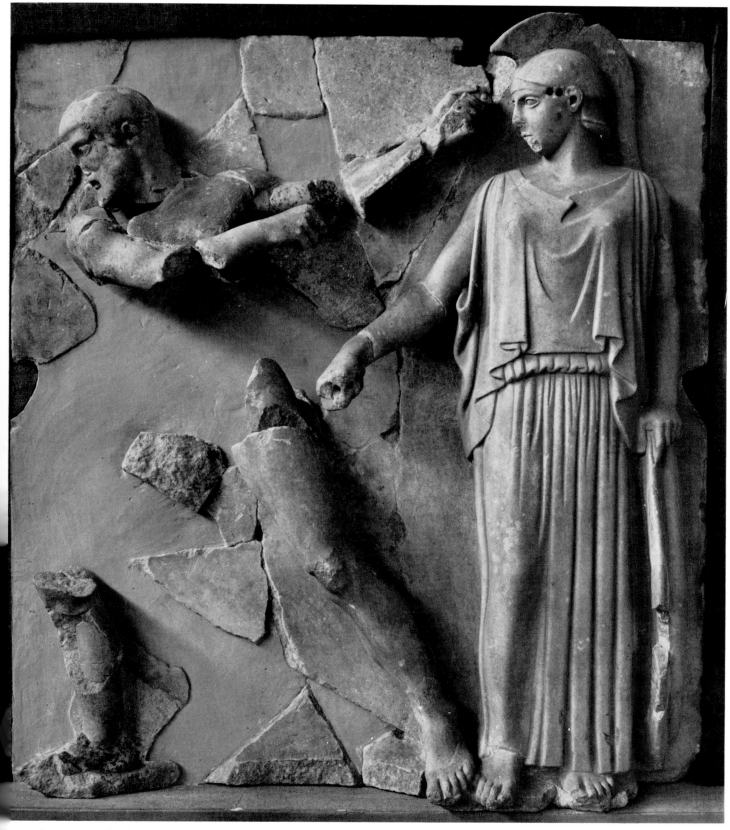

o. Olympia, temple of Zeus: Metope of the Augean stables

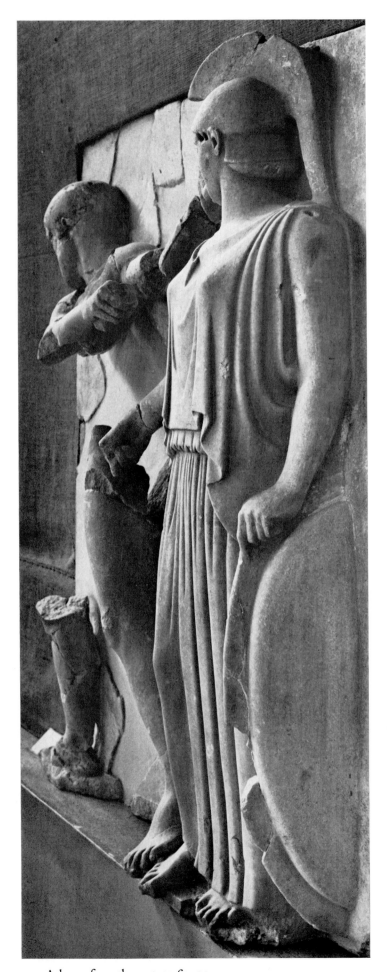

91. Athena, from the metope fig. 90

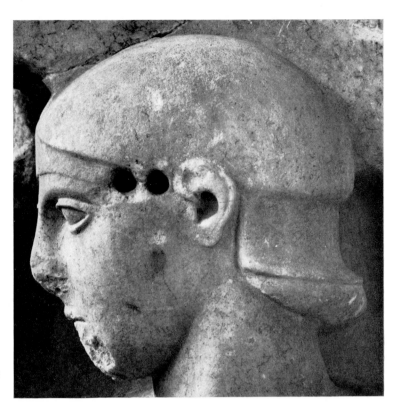

92. Athena
from the metope fig. 90

sideways it is relaxed, and tenderly modelled (Fig. 91)) and by the vertical accent of the shield seen edgeways. Springing from the vertical body of Athena are two oblique lines, one formed by her right arm with its spear, the other by the two arms of Heracles and his crowbar. Then, cutting across these obliques in the fashion of a cross is the line formed by Heracles' head, torso and left leg: and the whole design was supported by the vertical of his right lower leg. An oblique view shows how skilfully the sculptor had managed his carving in depth, in order to allow for the height and angle at which it was to be seen. The heads are almost in the round and the middle area of the metope projects boldly: towards the base, although three of the feet are frontal, the relief becomes shallower.

The head of Athena (Fig. 92), which was masked by a heavy cheek-piece, is the least sensitive of the four heads of Athena on the metopes and seems barely finished: some details of the drapery, too, are sketchy, but the total effect is one of power.

The adventure with Cerberus, the hound of Hades, seems to be a milder version of an older tale, known to Homer, in which Heracles entered hell and overcame Hades himself. Cerberus is, basically, a monstrous dog; usually he has more than one head, and although no one would dare to joke about so terrible a god as Hades, a many-headed dog is fair game; so that we have a whole series of more or less comic pictures on vases, ranging from the burlesque painted half a century before by an Ionian settled in Etruria, in one of his more wildly Etruscan moments, of a hound

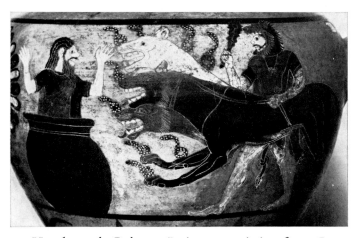

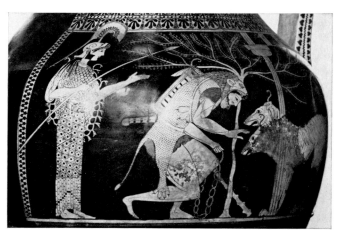

93. Heracles and Cerberus. Ionian vase-painting from Caere, about 530 B.C. Paris, Louvre

94. Heracles and Cerberus. Athenian vase-painting by the Andokides Painter, about 510 B.C. Paris, Louvre

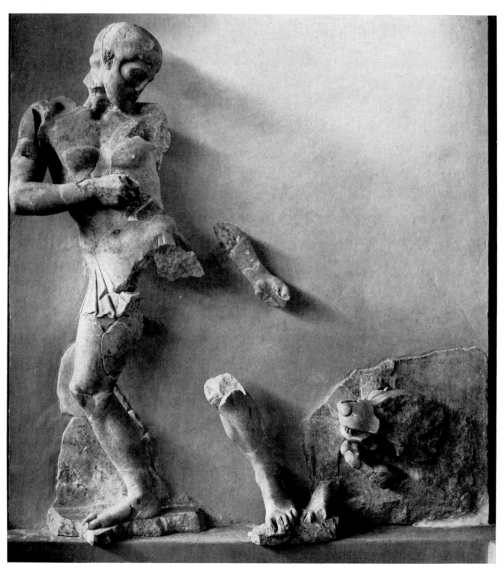

95. Olympia, temple of Zeus: Metope of Heracles and Cerberus

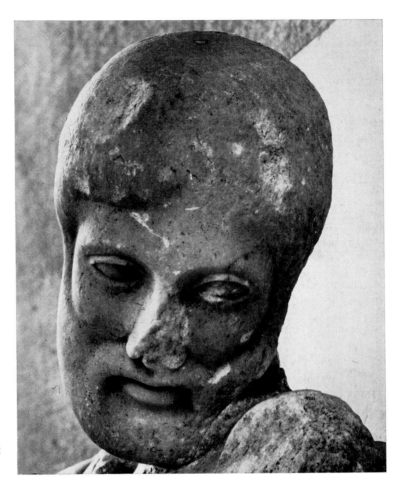

96. Heracles
from the metope fig. 95

of enormous size with bodies of three different colours, black, white and red, and erupting into snakes at every joint (Fig. 93), down to the more refined humour of the Andokides Painter, on a vase in the Louvre, who reduces the heads to two, each with a modest snake as crest, and shows Heracles coaxing the suspicious animal into accepting a chain (Fig. 94). The designer of the metope, again characteristically, minimizes the monstrous element (Fig. 95), and shows Cerberus as just an extremely large and surly hound: only his head and shoulders protrude from the mouth of hell, and this conveniently leaves more room on the metope. The composition is again self-contained by internal tension – Heracles had a chain on the dog and was trying to drag him out. His wary eyes and intent expression show that he is gauging the animal's temper and judging every movement, awaiting the moment when he can increase the pull and drag the monster clear (Fig. 96). Hermes stood behind Cerberus: only part of his legs survive. He is here not simply because he is normally a friend and helper of Heracles, but because as a god of fertility he was associated with the underworld: he was god of roads, patron of travellers, and all this fitted him to be the divine herald whose task it was to conduct the dead to the under‑ world. That is why he knows exactly how to lead Heracles to the mouth of hell, and it is to be assumed that it was he who ensured that Cerberus, after being shown to Eurystheus, was returned safely to his post.

We come now to the last of the labours, the getting of the apples of the tree of life, which are the golden apples of immortality (Fig. 97). These grew in the garden of the Hesperides, which, to judge from the name, should be in the far West. This is confirmed by one of the leading characters in the story being the giant Atlas, who supported the heavens upon his shoulders. He was early identified by the Greeks with the great Atlas mountains, which still bear his name, on the southern shore of the Mediterranean, near the straits of Gibraltar; and it is a natural fancy, especially to the Greeks, who personified so much, to imagine that a mountain whose summit was constantly wrapped in clouds was a giant supporting the skies. Somewhere nearby was hidden the garden of the Hesperides, where, guarded by a dragon, grew the tree bearing the golden apples; only Atlas knew its whereabouts.

In one version of the legend Heracles asks Atlas the way, and then himself goes to get the apples, which he succeeds in doing with the connivance of the Hesperid nymphs, or of one of them who fell in love with him. This version, with its romantic undertone, naturally appeals to later artists, and is particularly popular at the end of the fifth century; but in the equally well-known version used here, Heracles persuaded the giant to go and fetch the apples, offering meanwhile to carry the burden of the skies for him. Atlas agreed, but some ancient writers say, and some vase-painters show, that when Atlas came back with the apples and saw that Heracles was trapped, he had the idea of leaving him there for good. The designer of this metope has rejected that somewhat unseemly version of the story; but here, as elsewhere in the metopes, treating the problem as a practical one however fantastic the main story may be, he realizes that this is inevitably an awkward moment; and – whether an invention of his own or some otherwise unknown version of the legend – he has brought Athena on to the scene to solve the problem of the transfer. She is specially qualified to help in this way, because she is the daughter of Zeus, and Zeus is god of the sky. You may perhaps think of her as having been helping Heracles to support the weight whilst Atlas has been away, although I do not think that is so; but you must now certainly think of her as gently easing the weight off his shoulders and supporting the whole sky herself for a moment whilst he disengages himself and Atlas resumes the burden.

The whole composition must be restored in the mind's eye, because the parts missing detract from the effect originally intended; and then it can be seen how the composition corresponds with and emphasizes this situation (Fig. 98). On the left are two heavy verticals. First the body of Athena, every vertical line within it stressed, including the muscle down the neck; and reinforced at the left edge of the metope by her upright spear, now lost. No helmet: because the goddess must be as large as possible to balance the giant Atlas. Second, the rigid line of the body of Heracles, with legs close together. These two verticals are linked at the top by the

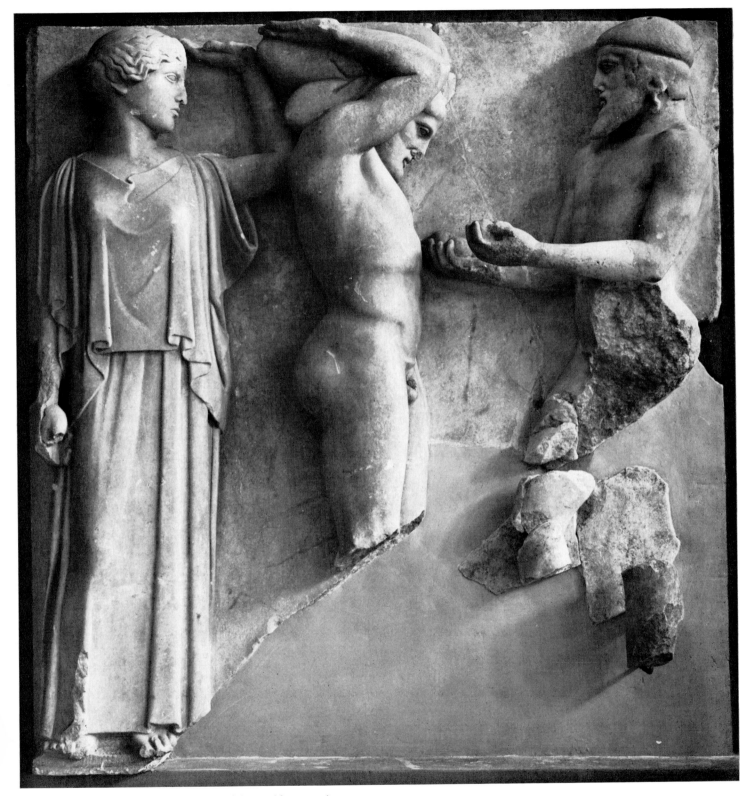

97. Olympia, temple of Zeus: Metope of the Golden Apples

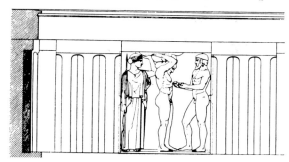

98. Olympia, temple of Zeus: The metope of the Golden Apples in position (from Curtius-Adler, *Olympia*)

left arm of Athena, the line of whose hand picks up the line of the top of the cushion; her elbow the line of Heracles's shoulder, her upper arm the line of his upper arm. By means of this link the two together form a rigid double support, implying a heavy mass above, and upholding it by means of what one may call a hinge or a spring-lid, in shape like an arrow-head, namely the bent arm of Heracles, echoed by a similar shape in the cushion, and even, in a minor key, by the creases in the cushion (Fig. 99). The designer is a practical man, and he provides a cushion not only to distribute the weight but also to give Heracles the extra height he needs for the task, because Atlas is a giant. He leaves you in no doubt that this complex of two verticals linked at the top, an almost architectural complex, is firmly fixed in that position. Towards this immovable mass comes Atlas. His stance, with all the weight on the left leg and the right ostentatiously free, emphasizes by contrast the rigidity of Heracles. The designer creates a deliberate division between the two-thirds of the metope on the left, and the third on the right, focussing attention on the apples, which are the motive of the story, and which are held out almost provokingly, by arms perfectly free, towards Heracles, whose arms are hopelessly engaged, and who is immovably fastened by the weight above him. It seems a deadlock, and I have no doubt that the designer intended it to seem so in order that he might intro-duce Athena at this moment to resolve it.

One of the unluckiest blows ever struck was that which mutilated the nose of Athena so as to produce a hideous form which one cannot ignore (Fig. 100). If it were not for this there is no doubt that the whole figure would be the embodiment of majesty, the final epiphany of the all-powerful daughter of Zeus. For surely on the four occasions where she appears on these metopes she is displaying four of her characteristic activities: as the giver of wise counsel at the outset of the labours in the metope of the lion; as the guardian-goddess of citadels in the metope of the birds; in the Augean stables as the mistress of all kinds of crafts – what we should call a technologist; and whom better could one have at one's elbow when faced with a problem of hydraulic engineering? – finally, as the daughter of the supreme god of the sky.

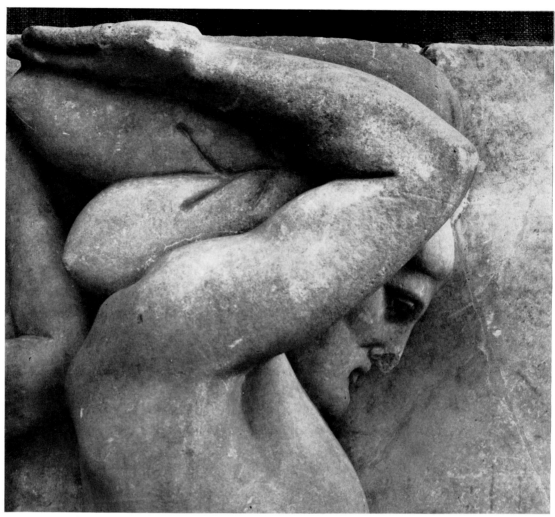

99. Heracles from the metope fig. 97

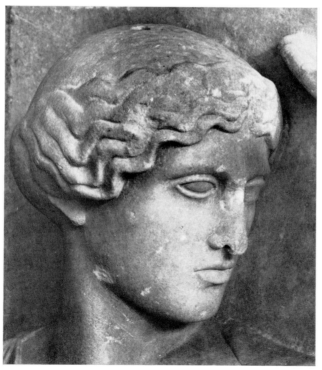

100. Athena
from the metope fig. 97

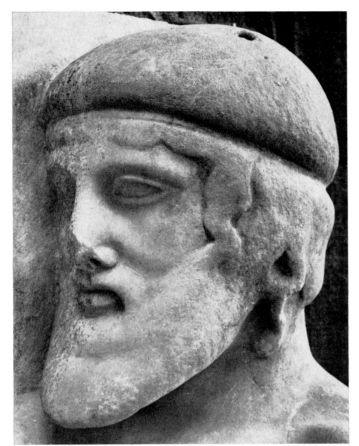 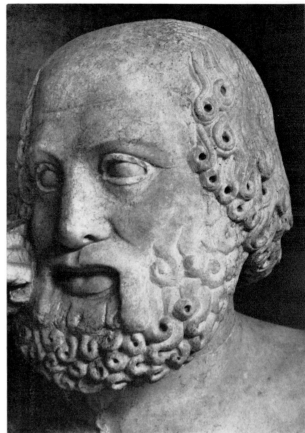

101. Atlas from the metope fig. 97

102. The seer from the East pediment of the temple of Zeus, Olympia

Then Atlas: the gravity of age and its resignation have never been more nobly expressed. All passion spent (Fig. 101). The general contours of the head are remarkably soft because the hair and beard are long and full, and the hair is not drawn tightly into the hair-band: I think they must have been painted white, and if this is thought to suggest the soft contours of snow I see no objection: poetic perhaps, but factual, not romantic. Even the internal modelling of both head and body has no sharp transitions, but this in no way diminishes its great strength: there is rock beneath.

It is interesting to take a comparison from the pediments again, the seer of the east pediment (Fig. 38), in order to judge the differences of touch within the same general style, the difference of characterization between man and god; and the difference of mood – the man anxious (Fig. 102), the god impassive.

And then to Heracles, for whom this is the final task (Fig. 103). He is no longer so young as he was, and his years of toil have told on him, but his courage is un-dimmed, and the determination to endure to the end; and I seem to detect also the gleam of a smile of satisfaction, of triumph.

All this is done with the most subtle of touches – the steady eyes, the line of the lips with set teeth, and again that most sensitive index, the oblique line from the

88

103. Heracles from the
metope fig. 97

nostril: its dominant influence on the expression can be seen by comparing it with
the same line in the head of Atlas.

The whole design of the metope, with its almost architectural solidity, contrives
to suggest calm after struggle, and there is a feeling of impending release, perhaps
something of the same feeling as at the end of a tragic drama, when a god intervenes
to resolve the problems of troubled humanity.

One cannot want better sculpture than this. We are on the threshold of the
classical age, but the full classical never surpassed this for character-drawing: and
when you think what later writers in derision made of the character of Heracles –
that was deliberate, and one might say legitimate – but when you think what later
sculptors, in all sincerity, made of him, you can understand the claim of this moment,
just before the Parthenon, to be the greatest in the history of Greek sculpture.

IV

The Parthenon

THE METOPES AND PEDIMENTS:
PROBLEMS PRACTICAL AND ARTISTIC

IN the first of the next two lectures, which are on the Parthenon, I want to begin by asking the same general questions about ways and means that we applied to Olympia – where the money and materials came from, and how the work was organized; and then go on to discuss the placing and character of the sculpture, especially the cult-statue, the metopes and pediments. In the second lecture the placing, the carving and the subject of the frieze.

I fear that both these lectures will be rather shapeless, because the points I want to raise are miscellaneous; but they are, I hope, worth thinking about, and the excuse for not making the lectures a straightforward discussion of the style and subjects of all the surviving sculptures is that this has been done so well several times already.[48]

We know much more about the building of the Parthenon than we do about that of the temple of Zeus at Olympia. The decision to build it, and the way in which it was financed, have been discussed not only in modern times but in antiquity; in the pages of Thucydides we have one or two almost contemporary references to the project, and the old controversies still echo in Plutarch, where there is an elaborate account of the whole policy of Pericles and the motives underlying it. Plutarch was writing about A.D. 100, five and a half centuries after the event. Of course he had access to earlier sources, but we cannot be certain how far he embroidered them, or indeed how far they had already been embroidered: certainly some passages look as if some orator or other had tampered with them, so exquisitely balanced are they and so highly coloured.

All the same, the main lines of the story to be inferred from Thucydides and Plutarch can hardly be in doubt: they are these.[49] On the defeat of the Persians in 479, there was a general agreement among the Greek cities which had suffered destruction, that they would not rebuild the temples destroyed by the Persians, but leave them as memorials of barbarian sacrilege. Very little building seems to have been done for thirty years, with two notable exceptions, the Hall of the Mysteries at Eleusis, for the obvious reason that the Mysteries had to go on and that this was

the only place in which they could be enacted; the other the temple of Zeus at Olympia, where too the circumstances were exceptional. Elsewhere little was built. But in armaments there was great activity, and a naval league was formed among the Ionian cities and other maritime states, with Athens at its head, and its centre at Delos. The prime purpose of the league was to maintain a navy at sea as a defence against Persia; but because it was difficult for some of the smaller members of the league to supply even one ship, and inconvenient for some of the larger ones to have many of their citizens permanently afloat, a contribution in money was permitted instead, and the league thus had two classes of members, one of whom supplied ships, the other money. Athens assessed the contributions, and Athenian treasurers administered them, although the money itself was kept on Delos. This Delian League Athens gradually transformed into an Athenian Empire by subjugating any members who attempted to secede; and in 454 she transferred the treasury to Athens.

This was the situation when the great building programmes of Pericles began, and it was with the treasure of the Delian League that they were financed. The Parthenon was part only of a far larger scheme, which included the Propylaea, the Odeon, which was a covered concert-hall, yet another Hall of the Mysteries at Eleusis, and the Long Walls between Athens and Piraeus. The schemes were fiercely criticized, and in a famous passage of Plutarch the arguments used by some of the Athenians themselves against them can still be read.[50] 'Greece,' they say, 'is clearly the victim of a monstrous Tyranny; she sees us using what she is forced to contribute for the war, in order to gild and bedizen our city like a wanton woman hung round with costly stones and statues and thousand-talent temples.' Pericles, in reply, claimed that, having supplied everything that was necessary for defence, Athens was entitled to use the surplus, not only to beautify the city, but to provide full employment for her citizens. He then describes the ways in which work is created by the building of temples and colossal statues, and, whether they are the words of Pericles or not that Plutarch quotes, we are given a very good idea of what an enormous undertaking temple-building was, even for so large a city as Athens: 'the materials to be used' he is quoted as saying, 'are marble, bronze, ivory, gold, ebony and cypress wood: the crafts required to work such materials are those of the carpenter, moulder, bronze-worker, mason and sculptor, dyer, worker in gold and ivory, painter, embroiderer, metal-inlayer; and the providers and transporters of these – merchants, sailors and pilots by sea; and, by land, waggon-makers, cattle-breeders and drovers. There are also rope-makers, weavers, leather-workers, road-builders and miners. And since each craft has its own body of unskilled labourers attached to it, practically every able-bodied man is employed, and is receiving pay for his work.'

It was in 450 that the proposal by Pericles to use the 5,000 talents of accumulated tribute for the building of the Parthenon was carried. Commissioners were appointed to keep account of the expenditure, and to inscribe each year, on a marble slab, the total sum, and how it had been spent. Fragments of this slab have survived, and the information they give us is of great interest.[51] Their first year's account was not until 447, which suggests a good deal of preliminary planning, clearing of the site and organizing the supply of materials before building started. The accounts run for fifteen years, and the year 432 is almost certainly the last. In addition to the commissioners, someone had to be in charge of the whole work, and we are lucky to know from Plutarch who it was. It was Pheidias, and Plutarch says 'he controlled and directed everything.' For the Parthenon, two architects were appointed, Iktinos, who seems to have been the main designer, what we should call the architect; and second, Callicrates, who must have been a master-builder, because we know that he built part of the Long Walls to the Piraeus and other fortifications.

What did the architects find when they surveyed the Acropolis before beginning work? They found, on the site afterwards used for the Parthenon, the remains of a temple which had been half-finished when the Persians burnt it thirty years before – the extremely massive substructures, and a number of unfinished columns and column-drums, mostly spoiled by the burning of the scaffolding round them. Much of this material could be re-used, but mainly where it could not be seen: the column-drums were not of suitable size, and even the substructure was of the rather narrow proportions common in archaic temples; Iktinos needed a broader and slightly shorter foundation. Accordingly he used almost all the other foundations except at the east end, and where he needed the extra breadth, he obtained it by wisely extending the foundations to the north, away from the dangerous made-up southern slope (Figs. 104–7).

A vast temple of Zeus, started under the tyrants in the sixth century, lay down in the plain to the east of the Acropolis. Democracy demanded that the new building, the Parthenon, as it was later called, should be in the heart of Athens, on the Acropolis itself, and dedicated to Athena. It was not pure Doric, but had certain Ionic elements, and it was to make up for what it lacked in size[52] by its material, solid white marble throughout, without stucco; by the refinement of its proportions and details; and by the richness of its decoration.

Let us go back for a moment, put ourselves in the place of Pheidias as director of the whole project and see what his problems were. He must have discussed them with Iktinos the architect and Callicrates the master-builder, since architectural, structural and sculptural matters were all involved, and a whole army of sculptors, masons and other craftsmen had to be assembled and organized, no doubt from all over the Greek world.

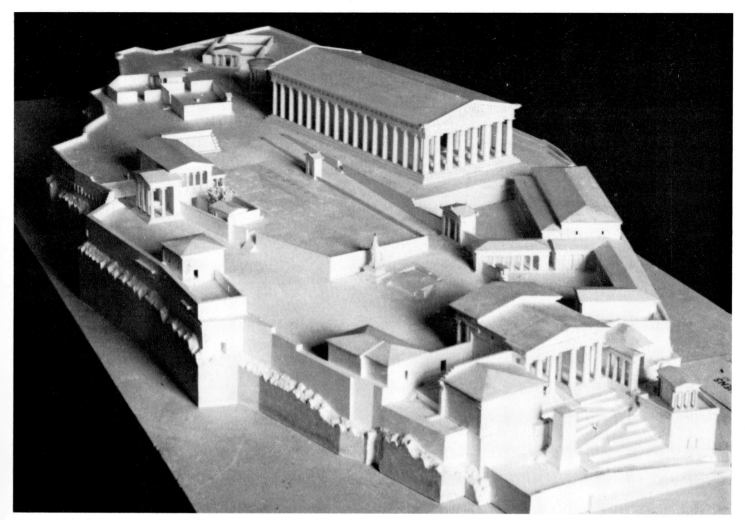

104. Model of the Acropolis at Athens (from G. P. Stevens, in *Hesperia*)

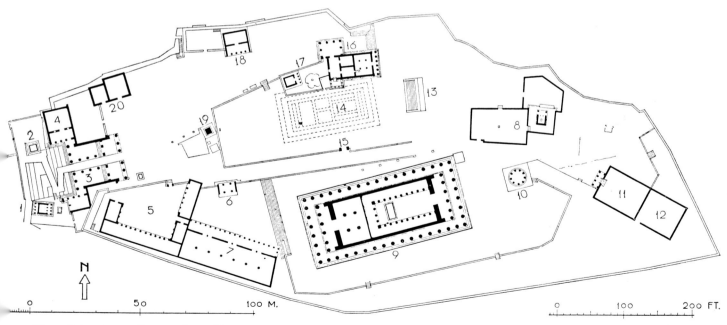

N

105. Plan of the Acropolis at Athens (from G. P. Stevens, in *Hesperia*). Key: 1. Nike Temple. 2. So-called Monument of Agrippa. 3. Propylaea. 4. Picture Gallery. 5. Sanctuary of Artemis Brauronia. 6. Propylon. 7. Chalkotheke. 8. Precinct of Zeus Polieus and Boukoleion. 9. Parthenon. 10. Temple of Roma. 11. Heroon of Pandion. 12. Service. 13. Great Altar of Athena. 14. Old Temple of Athena. 15. Propylon. 16. Erechtheum. 17. Temple of Pandrosos, Sacred olive tree, Cecropium. 18. Dwelling of the Arrephoroi. 19. Promachos. 20. Service Building.

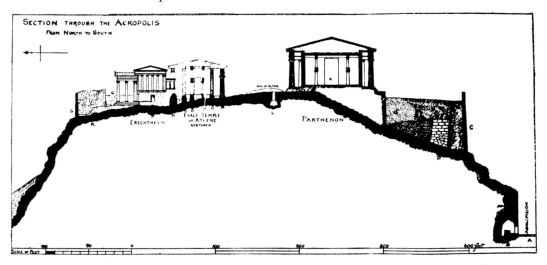

106. Section of the Acropolis at Athens, North to South, showing original rock and later filling (from J. H. Middleton, in *Journal of Hellenic Studies*)

They must have discussed the present condition of the site, how the platform could be broadened to take the broader plan that Iktinos proposed, and how far the earlier foundations could be utilized. They must have discussed the supply of material and, after having decided, if practicable, to build entirely in marble, they must have surveyed the quarries of Mount Pentelicus in order to judge whether there was in fact a sufficient supply of sound, pure white marble in blocks large enough for a building of this size; and they must have organized a special system of transport from those quarries which they did eventually decide to use. About a third of the way up the mountain there is a vast cavern from which it is believed that most of the marble for the Parthenon came; and by the time the temple was complete no less than twenty-two thousand tons of marble had been quarried, brought down from Mount Pentelicus, transported ten miles, on carts drawn by teams of oxen, to Athens, and then hauled up the difficult slope on to the Acropolis. Each block, as we know from the terms of a later contract that has survived, had to pass three tests on delivery: it had to be of uniform colour, free from natural flaws, and free from accidental damage.[53]

Within the quarry, the mechanical means were simple but effective – levers, rollers and wedges. Down the mountainside special paved slipways were built, on which the blocks were lowered on sledges, again controlled by simple means, and not without accidents, as is shown by blocks that have been abandoned. Once down the mountain the usual problems of cartage arose, inevitable when, before the invention of roller- or ball-bearings, great weight was concentrated on the axle of a vehicle. These, however, are at the moment outside our scope.[54]

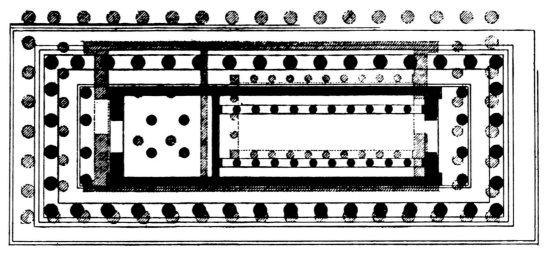

107. Plans of the earlier and the later Parthenon (from W. B. Dinsmoor, in *American Journal of Archaeology*)

Pheidias and his colleagues must have discussed the time-schedule of the work on the temple very carefully, since the five major elements in it had to be accurately co-ordinated on the Acropolis itself, where space for workshops, for building materials, and for all the litter of a construction-site, was none too plentiful.

These five major elements were, one, the construction of the temple; two, three and four, the various kinds of sculpture on it, namely, metopes, frieze and pediments; and five, the great gold and ivory statue of Athena Parthenos inside it.

If the unfinished temple at Segesta is a trustworthy guide, the external colonnade would be erected first. The joints between drum and drum had to be perfect, but the flutes were not cut until later, in several finely calculated phases. The nucleus of the temple itself, that is, the walls forming the two rooms back to back, one facing east for the cult-statue, the other a treasury facing west; with porticoes at each end, must have been erected either at the same time as or immediately after the columns, because all these were necessary to support the immensely heavy marble roof, as were the four Ionic columns in the western chamber, and also the rows of super-imposed internal columns, which eventually served as a frame for the cult-statue in the eastern.

Of the sculptures,[55] the metopes were the most urgent, since these had to be inserted as the building went up, and before the roof was on (Fig. 108). They could not be moved or changed once the entablature was in place above them, and it is doubtful if much work on them was possible once they were in position. Conversely, they could not go in before the building was ready for them: this seems to have been not before 442, when there is an item in the accounts which suggests

108. Disposition
of the sculptures
on the Parthenon

that the column-capitals were now in place: after that, when the architrave was on, the builder would be ready to accept the metopes. This implies that the metopes were carved on the ground between 447 and 442. If any were not ready by 442, they would have to be built in as blanks and carved on the building, however awkward that might be. The metopes themselves – or such as have survived – would agree well with the supposition that here was a raw and not too well co-ordinated team of sculptors, some of the highest, some of mediocre ability: and that there were mis-calculations, corrections and breakages, as if there had been something of a scramble to finish them in time.

Next was the frieze, and we shall have something to say about the timing of this in the next lecture.

Finally the pediments. There was no special urgency about these, except that, consisting as they did of nearly fifty figures, all over life-size and some colossal, they involved an enormous amount of carving. Their carving, however, need not in any way interfere with the building, and the figures could not anyhow be hoisted into position until after the structure was finished.

96

109. The armature
of the Athena Parthenos
(from G. P. Stevens, in *Hesperia*)

Pheidias himself must have been preoccupied by the cult-statue, for this was of over-riding importance, and since we know that it was dedicated in 438, a dozen years from the inception of the whole scheme, he must have started on it immediately, making sketches and models, calculating the mechanism of the armature that supported it, and planning its exact setting within the temple, because this would have to be decided almost at once in close consultation with the architect. Then there was the supply of material. Gold presents few problems, provided you can get enough of it, and the Athenians now probably obtained theirs from Ionia and Thrace; but the ivory must have needed negotiation for a supply sufficient in quantity and suitable in quality. This came probably from Africa by way of Egypt, the ancient trade-route down the Nile.

The model for the head of the statue, perhaps made of wood, must almost certainly have been of full scale, in order that the plates of ivory could be fitted together: they could not be joined to one another without support; and it may well be that this wooden backing remained as part of the statue. A limited amount of softening and bending of ivory is possible, but the basis of the whole technique is that no elephant has a tusk more than six inches in diameter, so we have to imagine a face about seven feet high with a skin pieced together from a number of comparatively small strips of ivory.

The whole colossal statue, standing on a base about twenty-six feet wide and thirteen deep, was constructed on a great armature of timber (Fig. 109), the central shaft of which went down through the base deep into the pavement, as we can see from the aperture to receive it that still remains.[56] We know that this wooden framework was the regular system with these great gold and ivory statues, from an irreverent remark by the satirist Lucian, who speaks of the families of rats disporting themselves in the hollow interior.[57] The gold, the ivory and the other materials for various inlays on the statue were precious, and had in the meantime to be kept in some secure place. This place might have been expected to leave some remains; so let us begin with that.

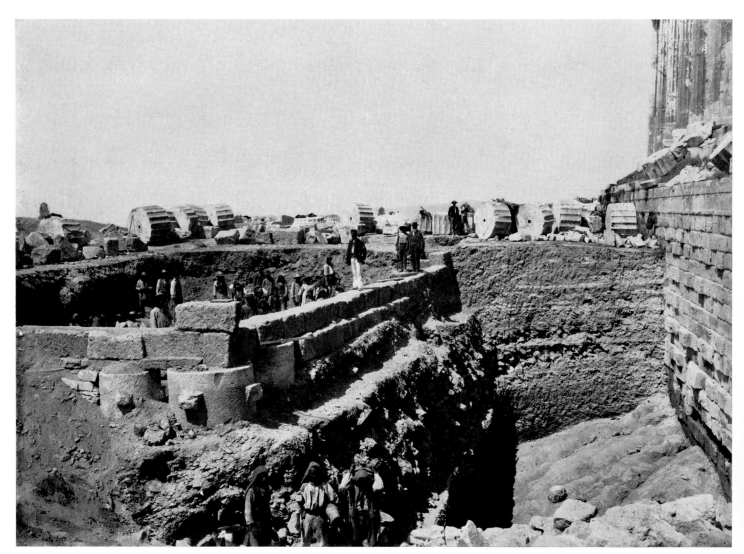

110. A building on the South of the Acropolis: view towards the West during the excavations of 1885–91. The Parthenon is on the right

When Greek archaeologists excavated the Acropolis between 1885 and 1891 it was found that some of the blocks intended for column-drums and for other parts of the temple which was being built on the site at the time of the Persian invasion, had been brought together to the south side and laid in such a way as to form the walls of a building (Fig. 110). They were convenient to lay, since they already had their upper and lower beds cut flat; but the structure was evidently made for temporary use only, because the blocks were of irregular shapes and sizes. It would be a fair guess that a building of this massive construction was one in which precious materials were to be handled. At Olympia the building called in antiquity the Workshop of Pheidias, and shown by recent excavation to be one in which a gold and ivory colossus, no doubt the statue of Zeus, had been made (Fig. 3), is also of massive construction, and for the same reason.[58] It is wise to take precautions when you have a million dollars' worth of solid gold to look after: I

think we can assume that this strange building on the Acropolis at Athens, conveniently placed within a few yards of the Parthenon, must have been the workshop in which the Athena Parthenos was made.

As soon as there are locked doors there is malicious gossip. This is not peculiar to our own day, and the tone is familiar. 'Pericles was taking women into the workshops on the Acropolis, on the pretence of showing them the works of art': 'Pheidias was stealing the gold.' Even the usual disgruntled employee, one named Menon, was found to play the informer. Fortunately Pericles had foreseen some such trouble, and had advised Pheidias to make the gold of the statue, plates about a millimetre thick, removable, so that it could be weighed. The charges were refuted; but the story shows that the statue under the gold was really a statue, not just a framework; and when Lachares, tyrant of Athens in 296 B.C., stripped the gold from it in order to pay his troops, what he left must still have looked complete enough to do duty as a cult-statue.[59]

Now for the sculptures made for the decoration of the building; and first the metopes. There was no suitable place for carving in the quarries on the mountain, and since a regular system of carting the blocks of marble had been devised, it was probably decided to bring them all the way to Athens in the rough state. Because they could hardly be carved in position, although the finishing touches and some of the colour may have been applied then, we have to assume that they were made in workshops, not necessarily substantial structures, either on the Acropolis itself or somewhere near.

The decision to fill all the ninety-two metopes of the outer colonnade with sculpture was a curious one. With the example of Olympia fresh in mind (Figs. 14, 15), you would have thought the advantage was obvious of not bringing two sets of high relief, metopes and pediments, into direct competition of scale and subject with one another (see p. 96). And the Parthenon was anyhow less well suited to this form of decoration than Olympia, because in the Parthenon the metopes are not only more distant from the eye, they are also smaller, about four feet instead of about five feet square, so that the figures are well under life size instead of being, as at Olympia, almost the size of life. At Olympia, too, the sculptors of the metopes were careful to keep the main lines of their designs simple and the masses bold, partly by omitting finely carved detail and relying on paint instead.

Whether rightly or wrongly, the ninety-two sculptured metopes were decided upon, and it seems that, in order to counteract the disadvantages of their small scale and their distance from the eye, instructions must have been given to make the figures as large as possible and to make them project as boldly as possible from the background. Even among the few that have survived, the results are very mixed, as one would expect with a new and large team of sculptors of varying ability.

111. Parthenon: Head of the centaur on metope no. 4 South. Copenhagen, Ny Carlsberg Glyptotek

112. Parthenon: Head of the centaur on metope no. 31 South. London, British Museum

There are some obvious differences between one metope and another, both in style and in subject. One which has often been pointed out is the contrast between two metopes on the south side, each showing a fight between a Lapith and a cen‚ taur (Figs. 111–12). One centaur has a completely human face with so mild and sensible an expression that it could easily be a portrait of one of the sculptor's friends; the other is so grotesque both in its strongly stylized forms and in its savage expression as to make one think that it is taken direct from some dramatic mask.

From the technical point of view the metopes are of two kinds: one kind has a band of marble left projecting at the bottom to form a ground line, and to give support to the figures: the other kind is without it. This base‚line seems an elementary precaution which would make the carving both easier and safer, but it was perhaps abandoned when it was realized that by neutralizing a strip at the bottom it dimin‚ ished the space available for carving. Or the master‚designers may have had dif‚ ferent opinions on how metopes should be carved, and instructed their teams of carvers accordingly.

Let us look at two, both of high quality, one of which has or had this ground line, the other not. One is the most westerly metope on the south side of the building and is so excellent that it has been attributed to Pheidias himself (Fig. 113). It is certainly remarkable in its style, its composition and – none too common on these metopes – its freedom from accidents. The highest projection of the relief is all in

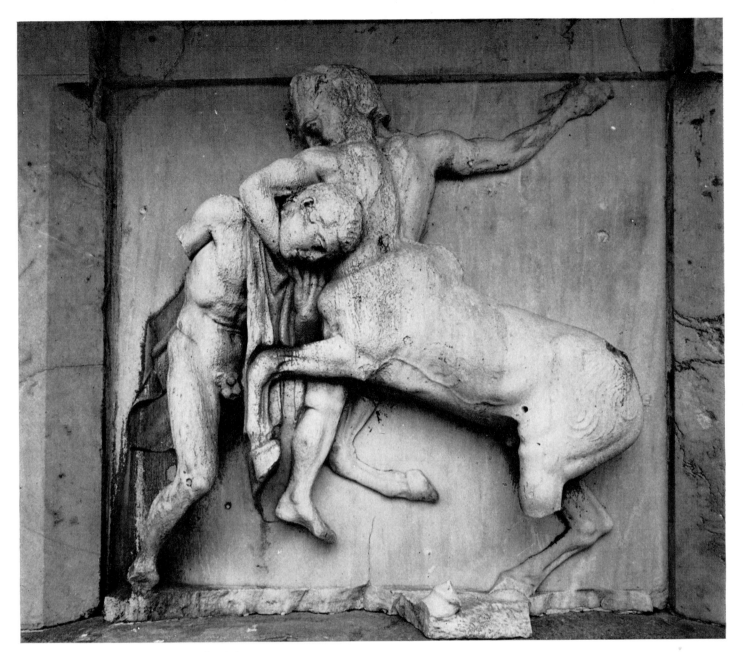

113. Parthenon: Metope no. 1 South. Athens

the middle of the metope, and the elements there are packed close with one another – the Lapith's head, his left leg and his cloak. The further arm of the centaur is safe from accidental breakage because it is in contact with the background along its full length, and so is the Lapith's further leg. The Lapith's near leg is safe too, because it runs right down and is supported by the base: the centaur's near hindleg also had some support from the base. The only accident seems to have been the centaur's tail, which evidently broke off and had to be inserted separately, some coherence being given by carving the loose end in low relief on the rump. As you might imagine, these centaurs' tails gave endless trouble.

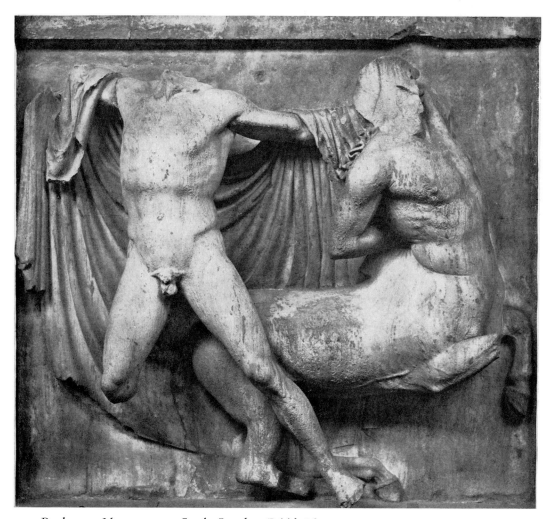

114. Parthenon: Metope no. 27 South. London, British Museum

This second example is one which in spite of having no basis at the bottom, and in spite of the boldest possible relief, has by a miracle succeeded (Fig. 114). It is cut back in places as much as twelve inches from the original face of the block. In composition it is an elaboration of the cross-shaped scheme, with two bodies in equilibrium, which we saw used for the first time in the metope of the Cretan bull at Olympia (Fig. 88), but the sculptor here, besides contrasting the human body with the horse's body, has also contrived to set off the human body against the background formed by his cloak – again an elaboration of the kind of thing we saw in the Olympian pediments (Figs. 36, 67), where drapery worn by a person is used as a foil to the body: here the drapery is free, and forms an independent screen. Both arms are stretched out, and this, expanding the chest, displays the torso to the fullest advantage: it also causes the cloak to be extended, so that it falls in these magnificent folds. The head of the Lapith was completely free of the background, and the body was attached only by the right shoulder and buttock and the left arm. The carver must have had some anxious moments. In the face of so brilliant an idea so bril-

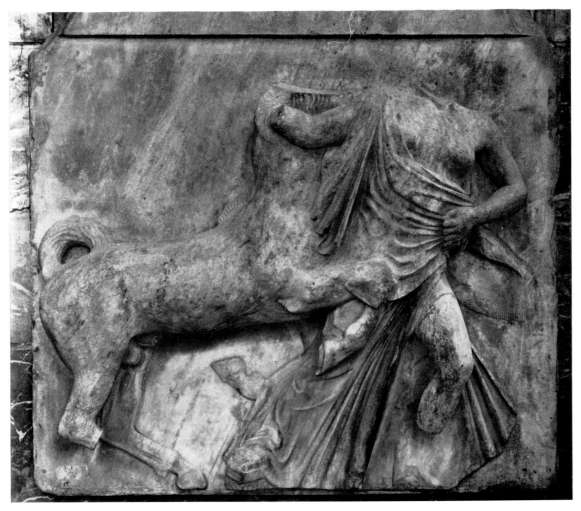

115. Parthenon: Metope no. 10 South. Paris, Louvre

liantly executed, we can hardly complain of the absence of the centaur's tail, which is completely omitted, perhaps through an accidental breakage, perhaps because it did not really matter. The far foreleg of the centaur, also, looks a little inorganic: it would in fact have been masked by the near leg, but even so it seems that there was not quite room on the slab to render it convincingly. This makes one wonder what kind of preliminary study there was. Was it a separate sketch, or model; or was it a drawing on the face of the slab itself?

The same question arises with all the metopes, and some at least seem to have suffered from inadequate preparation. One, for instance, of a centaur attacking a Lapith woman, is little short of a disaster, not apparently by reason of any physical difficulty caused by the high relief, but through sheer incompetence (Fig. 115). The sculptor simply cannot carve: neither the horse's body nor the human body seems to have any coherent structure – even the tail is a miserable object, and the hoof equally. We shall never know the explanation, but it looks like sheer shortage of skilled labour at some moment when haste was essential.

Before turning to the pediments, let us look at the one well preserved metope on the north side – the most westerly (Figs. 116–17). All the other metopes on the north side have been severely defaced, many systematically. Both Christians and Moslems were given to the practice, the Christians because the sculptures were pagan, the Moslem because they were human. To judge from most ancient sites, Moslems were more haphazard, content with the casual blow, and it looks as if this mutilation were Christian, done when the temple was converted to a church, and scaffolding was available. This metope alone escaped mutilation, and the reason was long ago suggested by Rodenwaldt – the scene was taken to be the Annunciation of the Blessed Virgin Mary.[60] The real subject is still a puzzle: a woman, rather heavily built, and dressed in voluminous clothing, is seated on a rock; there approaches her a young woman, of slight build and upright carriage, who holds up one end of her cloak with her left hand whilst the right hand holds its right edge. Wonderful use of drapery again as a background, and a contrast of vertical folds with festooning ones. The action, which is majestic, looks like one of revealing herself. It could be, for instance, the return of Persephone to the mourning Demeter, but no convincing identification has been made.

Clearly this is by a sculptor of the first rank, and the style can be recognized elsewhere; it has obvious affinities with that of Myron, as one sees it in his Athena (Fig. 86).[61] The figure on the left has a similar girlish slenderness and straightness, and the seated figure has the unique, full, almost viscous drapery of which we can see a small specimen in the padding under the helmet of Athena (Fig. 83). One suspects that there may be some direct connection. We have no evidence that Myron could carve marble, though he may have done so: all his recorded free-standing statues were in bronze. He could however, have provided a clay model, and supervised or even shared the carving; and this peculiar drapery does carry with it the suggestion of a plastic origin. To look at it from another angle: here was a demand for every available sculptor: Myron, an Athenian citizen, had recently dedicated a group on the Acropolis, and so was presumably available. Would he not have been employed in some capacity or other?

These two metopes nearest the west end, one on the north side and one on the south (Figs. 113, 117), are of high quality and executed with great care. It is possible that they were carved early in the series, when the need for haste was not so obvious because nothing could be set on the building until the colonnade was up. I hesitate to suggest that they were exemplars, and conspicuously better than the others, because so few of the others are left; but they are certainly magnificent. On the other hand, if more metopes were preserved, it is possible that we should find even wider discrepancies of style than those we have noticed; and if the dates were not established by the inscription, one suspects that far wider limits of date would be given to those

116. Parthenon: Metope no. 32 North, from a cast

we do have. It must have been a matter of older and younger generations, of sculptors from all over Greece, and of varying ability, working together, occasionally against time.

In 438 the great gold and ivory statue of Athena Parthenos was dedicated, and in that same year comes the first record, on the inscribed slab, of payments to sculptors for carving the pediments. The slab is fragmentary, and we are almost, but not quite, certain that it is the first payment. Although the structure of the building

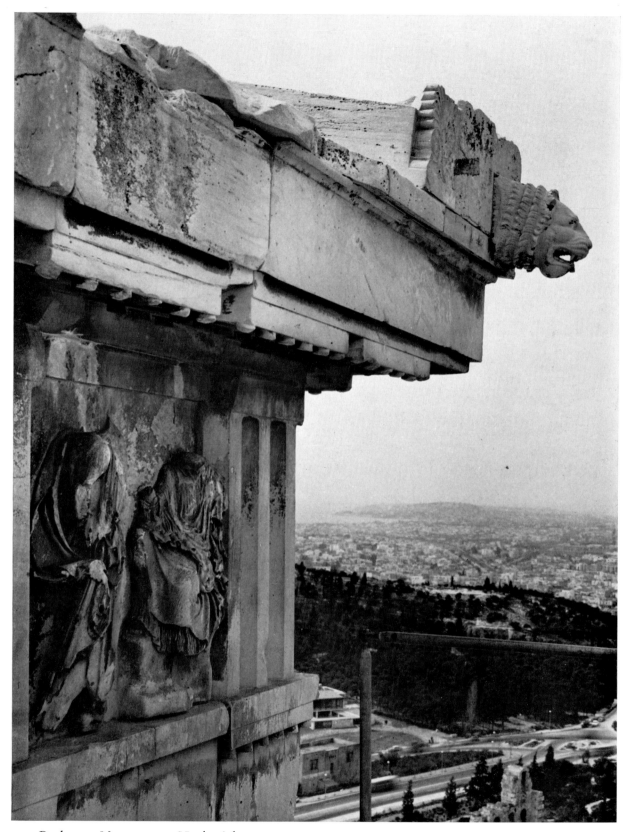

117. Parthenon: Metope no. 32 North. Athens

must have been complete – if only for reasons of security – when the statue was dedicated, both pediments were empty.

The last payments for loading marble at the quarries for transport to Athens were made in 434, and the record on the inscribed slab ended in 432. In any case nothing much could have been done after the outbreak of the Peloponnesian War, within a year. So it looks as if nearly fifty statues in the pediments, all over life size, were carved, painted and placed in position in five or six years. No wonder people were astonished, as Plutarch says in a striking sentence of five words μάλιστα θαυμάσιον ἦν τὸ τάχος 'Most wonderful was the speed.'

Even if the carving of the pediments did not begin until 438, there must have been much preliminary planning and model-making. Master-designs for the complete compositions of both pediments must have been prepared, and at a fairly early stage the individual figures must have been designed in some detail, for, as with the pedimental figures of Olympia, the exact sizes had to be determined so that perfect marble blocks of the exact measurements could be quarried.

Actual carving apart, think of the immense amount of work involved in such preparations. And think of the space needed on that comparatively narrow corner of the Acropolis (Fig. 104-6), both for the models, and for nearly fifty huge blocks of marble spaced out so that the sculptors could get at them: all the excitement in Florence about Michelangelo's David, a single fifteen-foot statue, seems by comparison a little trivial.

As the statues were finished, they were presumably painted and then put into store somewhere on the south or south-east of the Parthenon. Or were they hoisted one by one into the pediments? This must have been a very awkward process, however and whenever it was done, and there is evidence, from the severe cutting away of the backs of some of the statues, that something was found to be wrong at the last moment – either that some would not go in at all, or that they would not fit in the exact position that had been intended.[62]

We can hardly assume that the scaffolding erected for the structure of the building remained in position on both façades for five years after the statue of Athena Parthenos was dedicated, simply in order that the pedimental statues might be raised and placed in position. But what is the alternative? In these days of standardized steel scaffolding we should make nothing of re-erecting the scaffolding for the purpose: but in antiquity scaffolding was of wood; it must have been massive, and cumbrous, since for the sculptures it had to support weights of seven or eight tons at least. Possibly a section was erected at a time, and then moved along: but it was a tricky manoeuvre, since there was a risk of damaging the metopes, which were already in position, or even the building itself – the flutes of a Doric column, for instance, are very vulnerable.

118–119. Parthenon: Cuttings in the floor of the East pediment, South end and North end (from F. Brommer, *Die Skulpturen der Parthenon-Giebel*)

120–121. Parthenon: Cuttings in the floor of the West pediment, South end and North end (from F. Brommer, *Die Skulpturen der Parthenon-Giebel*)

It is just possible that a feature in the pediments that has never been satisfactorily explained may have been connected with this operation. In each corner of each pediment is a mysterious rectangular hollow cut over four inches deep into the pediment floor: all four or them measure much the same – about three feet by two feet, and although they are not identical, they are so similar that we may assume that they were all made at the same time and for the same purpose (Figs. 118–21). Brommer, who knows more about the Parthenon than anyone living, and whose opinion must always be treated with respect, has attempted to show that they were for the insertion of sculpture.[63] I do not see how he can possibly be right, for the following reasons.

First, any sculpture set so far into the corner could hardly be seen. Second, these cuttings would be unnecessarily deep for sculpture: all the other figures rest on the pediment floor and are not inset. Third, the cuttings are rather rough: one comes

very near the edge of a block and one actually comes right to the edge: they were obviously planned and cut after the blocks were in position.

We may safely assume then that they were not for sculpture. They were, however, certainly cut for some purpose, and if not an artistic purpose, then a practical one. What was it? The depth of the cuttings seems to prove that whatever was inserted into them had to withstand a great strain.

My own explanation is that these cuttings were for inserting the base of some sort of bollard – a massive post of stone or wood, or a combination of the two, to which pulleys could be attached, to assist in raising the sculptures from the ground. Or the bollard could have been used simply for getting a fixing on the building out of sight, for any kind of apparatus, scaffolding, hoists or the like, without damaging the architecture or the sculpture.[64]

It is possible that these devices were used at the time of the original building, but it is equally possible that the cuttings were made at some later period, perhaps when the sculptures were being cast, when, for instance, as Homer Thompson has shown, the Poseidon of the west pediment was reproduced for the Odeion in the Agora in the second century A.D.[65]

I have suggested that the filling of the metopes with sculpture was an error of judgement, and one might say the same of the pediments. If so, it was due to the failure to recognize that a large Greek temple is in effect simply a small one made larger, and that to enlarge a building with sculpture on it creates difficulties of scale and, above a certain size, insoluble problems of visibility. Such a failure seems in-credible, in view of the amazing skill and intellectual power that went into the making of the Parthenon: but powerful intellects are not immune from elementary blunders. What justification is there for the carving of so much exquisite detail and then for making much of it invisible by skying it more than fifty feet up, and set tight against the back wall of a pediment? When the figures were in place, on the average only about a third of the total surface of each was visible from the ground. It might be replied that these were made for the honour of the goddess, that artists gladly gave of their best to glorify Athena and Athens; that a sculptor cannot work except by conceiving his statue as a fully three-dimensional object; and that there is satisfaction in doing a thing as well as it can be done, even if no one sees it. All these arguments are valid. Yet artists are seldom quite indifferent to the praise of an enlightened public, and we may suspect that a sculptor, as he put the finishing touches to the back of a statue on which he had spent years of work and which he believed was now to be hidden for ever from human eyes, must, in his heart of hearts, have thought it a very great pity. Nevertheless, there is not the slightest trace of any-thing slipshod, or careless, or sketchy, on any of the pedimental figures that have survived, and the error of judgment, if it was an error, has produced some of the

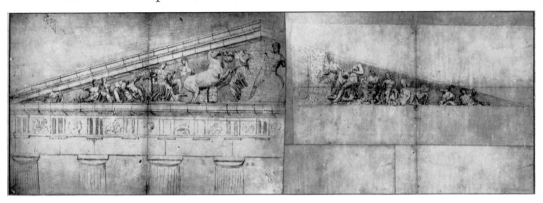

122. Parthenon: Carrey's drawing of the West pediment, made in 1674

greatest sculpture the world possesses. That was in a sense accidental, because they are of far more importance and interest now that they are divorced from the archi-tecture, and can be studied in all their subtlety at close quarters, than they ever were when on the building: perhaps this view had some support in antiquity, for the Propylaea, built during the next few years, was completely innocent of sculpture.

Two or three thoughts soon occur to one when comparing these pediments (so far as we can judge them in their shattered state) with those of Olympia. The first is that there is here much more movement in depth. Despite some remarkable and even revolutionary experiments at Olympia in modelling the individual figures in three dimensions, the general effect of each pediment is two-dimensional (Figs. 26-8). The pattern reads as a flat composition, and gains practically nothing, except a certain solidity, from being in the round. The east pediment at Olympia makes its effect by a balance of separate comparatively simple shapes: the west is more flowing, but still in essence a flat pattern. In both this is largely because the figures either face the front or look sideways: there is very little three-quartering.

In the Parthenon, on the contrary, there is a deliberate attempt to give the im-pression that the events are taking place connectedly in space – I do not mean in the heavens, but in three dimensions – and there is a rhythm of figures turning and half-turning towards or away from the centre (Fig. 122). The effect is enhanced by parts of the sculptures projecting over the edge of the pediment, as if they were moving freely, unaware of the architectural frame. They are in fact no longer sculptures decorating architecture, but a group of living creatures enclosed accident-ally in an architectural container, and spilling over a little at the edges (Fig. 123). This tendency, carried further in the later temple at Ephesus, where figures actually interrupt the architectural moulding, and in the Great Altar at Pergamon, where giants writhe up the great staircase alongside the embarrassed visitor, culminates in seventeenth-century baroque, where the sculptures scream to be noticed.

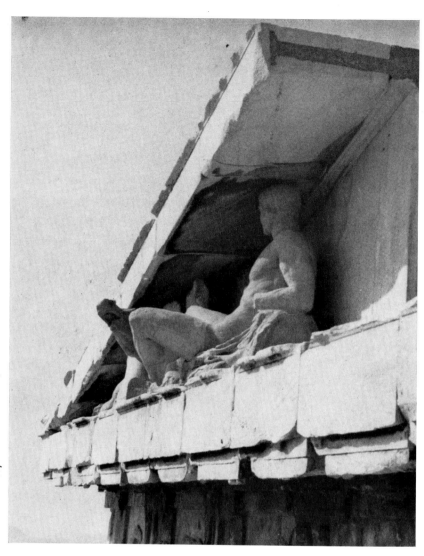

123. Parthenon: South corner of
the East pediment
(from F. Brommer, *Die
Skulpturen der Parthenon-Giebel*)

A second thought that strikes one about the pediments of the Parthenon is their comparative failure to solve the problem of varying scales within the pediment. This does not matter so much where the beings represented are not of the same class. For instance, at Olympia, the mind readily tolerates the difference of scale between the human beings and the single divinity in the centre: but in the Parthenon there is a manifest difference of scale between one divinity and another, and this discrepancy is the more incongruous the more realistic the sculptures are.[66] And in the west pediment there is really rather a clutter of beings of assorted sizes, including a number of children (Fig. 122). Did anyone, even in antiquity, remember who they all were?

A third impression is the greater diversity of styles in the pediments of the Parthenon than in those of Olympia, as if a number of eminent sculptors, each with a strong individuality, had been invited to make their own contribution. Here, however, we must be careful to distinguish between differences that are differences of style and those that are differences of subject. There is for example in the east

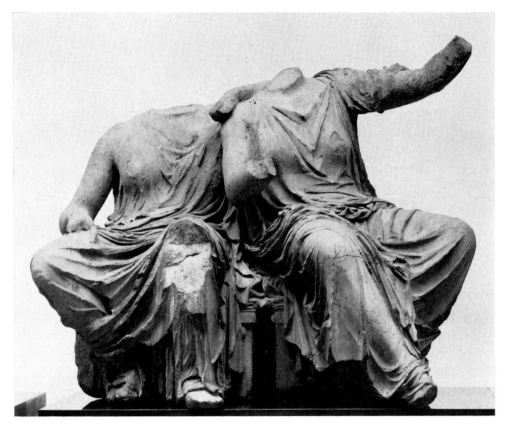

124. Parthenon: Demeter and Persephone, from the East pediment. London, British Museum

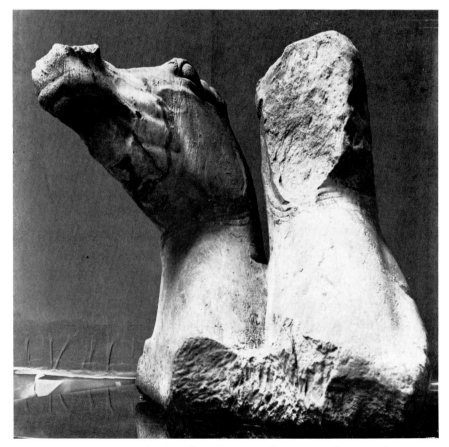

125. Parthenon: Horses of Helios, from the East pediment. London, British Museum

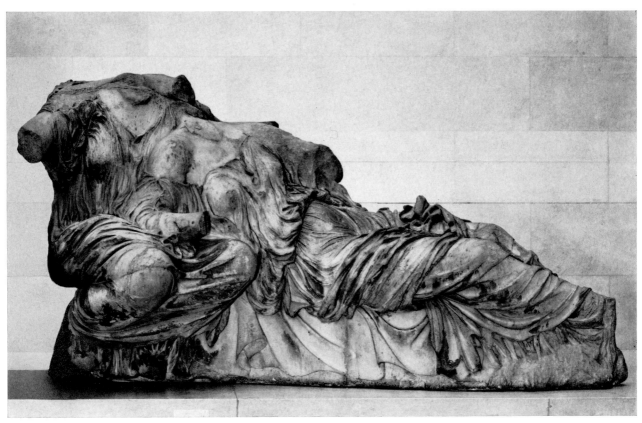

126. Parthenon: Dione and Aphrodite(?), from the East pediment. London, British Museum

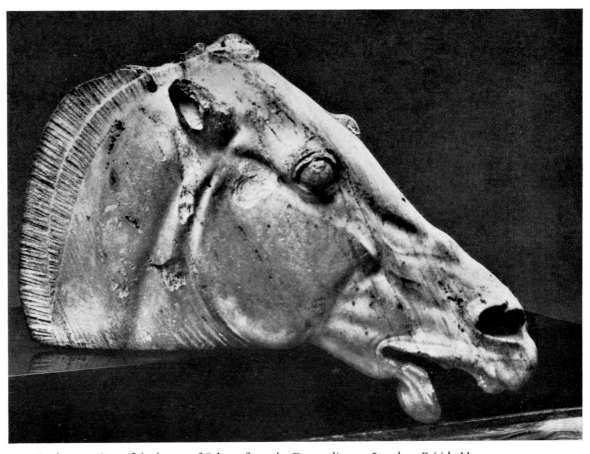

127. Parthenon: One of the horses of Selene, from the East pediment. London, British Museum

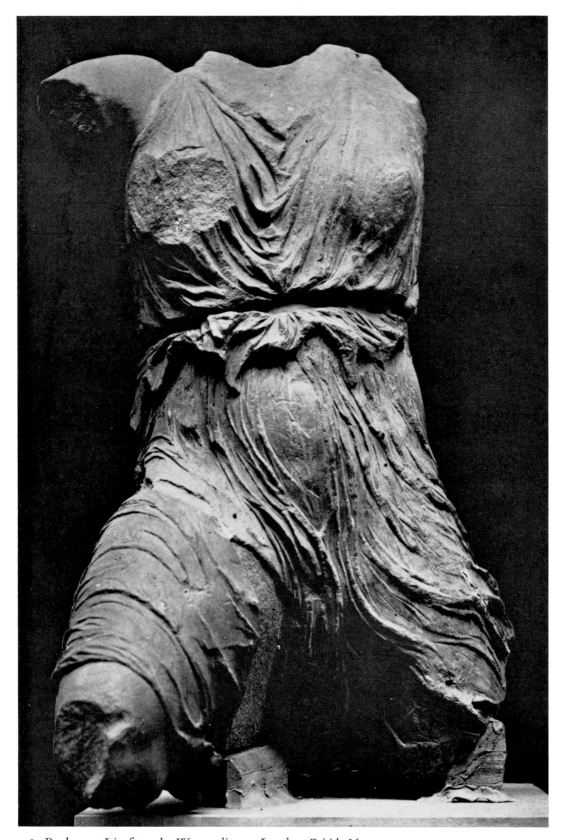

128. Parthenon: Iris, from the West pediment. London, British Museum

pediment an obvious contrast between the solidity and sobriety of Demeter and Persephone and the luxurious indolence of the reclining woman on the other side of the pediment (Figs. 124, 126). True, there is a difference of style, but there is also a difference of subject, which very much enhances the contrast. Anyhow, little of all these subtleties could be seen from the ground.

What was essayed tentatively at Olympia is here a primary assumption – that the forms of the body and drapery are intended to express both the nature of the beings represented and their state of mind. Obvious instances are the team of Helios, bounding away as horses do when released from their stable in the morning (Fig. 125); and the outer horse of Selene's chariot, with that amazing study of the effects of weariness on the contours of the muzzle and the line of the lips (Fig. 127).

Or take that splendid figure of Iris from the west pediment: only about half of it is left, but it is instinct with life in every square inch that survives (Fig. 128). This is not simply a study of thin drapery over a well-developed body: this is the spirit of the air, and the motive that runs through the whole of the body and drapery is speed – in the resilience of the body, in the tension of the legs, and in the clothing, forced into a series of ripples on the right thigh, pressed flat against the body itself, and fluttering away at the edges as the air streams through it: every single fold bespeaks the action of the wind. Its subtleties will repay unlimited study.

These words of Plutarch about the works of the Periclean age are often quoted, but they seem to me as profoundly true as when he first wrote them: 'They were created in a short time for all time. Each one was at once antique in its beauty, but in its vigour fresh and newly-cut even today. Such is the bloom of youth upon them, that they look always untouched by time, as if they were suffused with unfailing life, and a spirit that cannot grow old.'

V

The Parthenon

THE FRIEZE:
QUESTIONS STILL UNANSWERED

A<small>N</small> ancient Greek stranger coming for the first time to the Acropolis at Athens and looking up at the sculptural decoration of the Parthenon might well have been excused for believing that its architect had taken leave of his senses. The metopes were so small and distant that the figures looked like puppets – good and bad were hardly distinguishable – whilst the pedimental figures were at least fifty feet away, and two-thirds totally invisible. When he came closer, his original impression would have been strengthened by his discovery of where the frieze was hidden, nearly forty feet from the floor and at an angle of vision so sharp that it was difficult to distinguish the main actions, and impossible to see details (Fig. 108).[67] The light too was unfavourable, since it was all reflected up, much diffused, from the pavements, columns and walls.

The decision to have an Ionic frieze, and to have it here, was an extraordinary one, and induces the uneasy feeling that, like the decision to fill all the ninety-two metopes of the outer colonnade with sculpture, it was dictated by a kind of artistic *hubris*, a determination to load every available space with decoration, and to show what unlimited money could do. For a perfect use of the Ionic frieze we have to look at the little Siphnian treasury at Delphi (Fig. 129).[68] It was only twelve feet from the eye, at which height, in the Greek atmosphere, every exquisite detail could be appreciated, and it was framed above and below by massive decorated mouldings, which made it part of the architecture. The Parthenon, however, was a hybrid, and hybrids are apt to exhibit strange features. It was not a pure Doric building nor was its plan quite normal: it had two rooms – one, with its door facing east, containing the cult image, the gold and ivory Athena Parthenos; the other facing west, not connected with the first, and designed to be a treasury (Fig. 105). The roof of this treasury is thought to have been supported by four Ionic columns placed in a square near the middle of the room. Whether there was further Ionic detail inside the Parthenon we cannot say, but round the outside of this complex of two rooms, and of the portico at each end, ran the continuous Ionic frieze

of marble, about three feet three inches high and five hundred and twenty-five feet long – in all about one thousand seven hundred square feet of carving.

The designer chose a single subject, even if a complicated one, for the whole run of the frieze, and the subject he chose was appropriate, the people of Athens honouring their own goddess. Whether this choice was intended as a deliberate democratic counterblast to the long lines of tribute-bearers on the great palace of the Persian Kings at Persepolis, carved a generation before this, we cannot say, but Pericles must have known of Persepolis, and may well have had the contrast in mind. Whether he did or not, it was another innovation in Greece to represent on a temple ordinary human beings, not deities or heroes, even if engaged in doing honour to the gods. Until quite recently the subject has generally been identified as the Panathenaic Procession, but of late this has been strongly challenged (see p. 143). For the moment, we can agree that it is a procession of some kind.

The frieze was, as usual, fully coloured, but almost all traces have now disappeared: the background was probably deep blue, the bodies of the men were brown, the women's paler, the eyes were painted in: horses, armour, clothing and hair were in strong decorative colours. In addition, objects such as spears, sceptres, reins and the fittings of armour and harness, where they were not shown by painting or carving, were added in bronze. The drill-holes for these attachments still remain, and they often serve to make clear exactly what was going on – an action such as

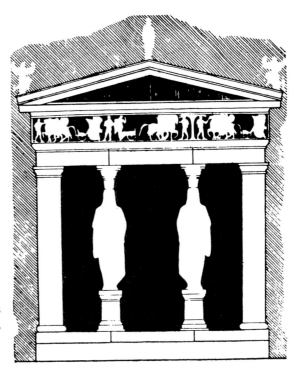

129. Delphi: Elevation of the Siphnian Treasury (from De la Coste-Messelière, *Au musée de Delphes*)

controlling a restive animal can look strangely weak and meaningless when the taut rope or rein, having been of bronze, has completely disappeared.

For the sketch lay-out of the whole frieze, all four sides of it, I assume a single designer, even if some modifications were made by his colleagues afterwards. I assume also a considerable team of sculptors, consisting of a master-sculptor, who was probably the designer himself, a small number, say three or four, of able pupils or colleagues, sculptors in their own right; and perhaps also some carvers, not ori-ginal artists, but capable of following instructions for roughing out the main areas of the design and, under supervision, of copying the models, if there were any.

The main lines of the design could have been in the form of drawings on a fairly small scale, say on whitened boards, which before the common use of parch-ment or papyrus seems to have been a regular method. In individual slabs, however, the complication of the successive receding planes within the relief is often so subtle that it seems to demand something more elaborate and more self-explanatory than a flat drawing, something in three dimensions – a model, in short – if it was to be carved by anyone but the master-sculptor himself or a very able pupil. Further, before anyone put chisel to marble the design must have been drawn, even if only in outline, but certainly with precision, on the face of the block. This original face, we know from one or two small uncarved patches still left, was an even, finely claw-tooled surface.

Let us take some such set-up as this for a working hypothesis and begin by look-ing at one of the slabs simply for its general character and technique (Fig. 130). It is a slab disinterred from Turkish buildings on the Acropolis in 1833, soon after the Turks had left Greece: it comes from the north side of the temple and represents boys carrying water-pots in the procession.

When the slab is looked at from the end (Fig. 131), it can be seen that the designer, trying to do what he can to counteract the steep angle of vision, has arranged that the carving shall be deeper at the top, and shall gradually diminish in depth towards the bottom of the slab. Deep is a relative term, since the greatest depth on any part of the frieze is not more than two-and-a-quarter inches, and within that compass all the richly modelled effects such as this are achieved: it is hardly possible to be-lieve one's eyes. The principle of increasing the depth towards the top is systematically applied throughout the frieze. This was no easy matter, and it must have been the result of a general and quite precise instruction to the whole band of carvers on the frieze how to go about it: an instruction which could only have been transmitted from the master-designer through his expert assistants, who understood the principle, could apply it themselves when carving, could explain it to others less expert and could supervise them in applying it.

The visitor arriving on the Acropolis through the Propylaea, the only public

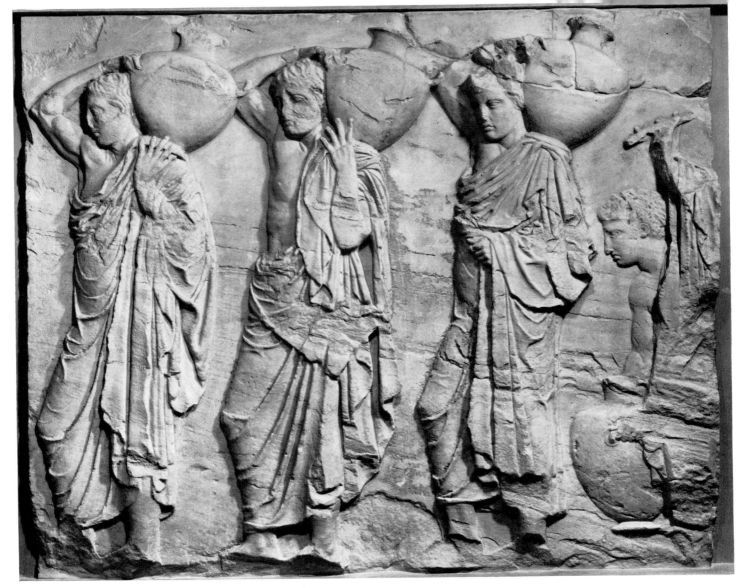

130. Parthenon: Water-carriers on the North frieze. Athens

131. Parthenon:
The slab fig. 130
seen from the left end

132. Parthenon: The subjects of the frieze

approach, saw the Parthenon first from a point slightly north of west; but the west end was the back of the building, and the normal way of reaching the front was to walk along the north side (Figs. 104–5).[69] Thus the visitor would first see the west frieze, so far as this was visible behind the colonnade, and would then pass along the long north side round to the east front, and would be likely to look at the south frieze separately. That is what the designer evidently calculated (Fig. 132): he has divided the procession into two streams: one starts at the south‑west corner, passes northwards along the west side to the north‑west corner, round on to the north side, along the north side and round on to the east. The other stream starts also at the south‑west corner, but it is heading directly east: it passes along the south side and round on to the east front from the other direction. The elements of the procession, almost identical in each branch of it, are these: horsemen at the rear, chariots in front of them, and in front of them those on foot – elders, musicians and young men bearing ritual vessels and driving victims to the sacrifices. On the east front the two branches of the procession converge, and the head of each consists of women being received by officials. In the centre of the frieze, over the main entrance to the temple, a sacred garment is being handled, and on each side of it is seated a group of the Olympian gods. So far as the general design is concerned, the most important action occurs, naturally, in the middle of the east frieze, over the main doorway: over the west doorway the central slab bears an unusual subject, which we

120

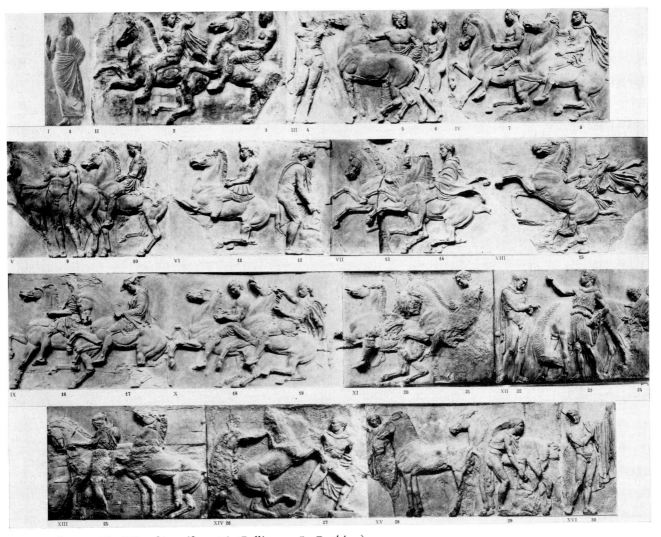

133. Parthenon: The West frieze (from M. Collignon, *Le Parthénon*)

shall consider in a moment. On the long sides of the building, where there were no entrances, the frieze runs continuously, without central focus.

We start with the west frieze, as the normal visitor would (Fig. 133). A fairly quiet, upright figure at the south end: he is straightening a cloak, which falls in vertical folds and thus provides a strong perpendicular note at the corner, where the architecture calls for it. The whole scene is one of preparation, horsemen forming up for the procession. Some are not yet mounted but are preparing to mount: one is lacing up a boot, another fastening a cloak more securely, another putting a headstall on a horse, another adjusting the reins. The horses already mounted are still restive, stamping and frisking about in the way that a fresh horse is apt to do if it is reined in before it really gets going. These little tricks of behaviour are acutely observed and recorded, and made to enhance the general effect of things getting under way. There is a rhythm of standing, moving, checking, which opens out at the north end with a couple of horsemen starting to canter. This gradually increasing

121

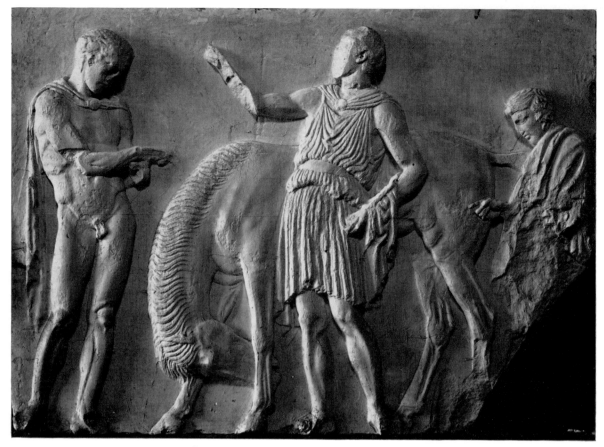

134. Parthenon: Horsemen preparing, from the West frieze. Athens (from a cast)

forward movement is punctuated not only by single figures standing still, or even facing in the opposite direction, but also by what might be called panel-pictures, that is, self-contained compositions designed to fill a single slab. In one of them, for example (Fig. 134), a horseman and his attendant are making ready: the boy carries a huge cloak: it does not belong to him, of course, but to his master – who may well be his elder brother; no need to assume that the small boys are all slaves – who has just taken it off. The actions of these two are uncertain, because the things they were holding have perished: the boy may have been holding the reins, whilst his master adjusted something; or maybe the master himself held the reins. Anyhow the horse seizes this moment to rub his nose vigorously against his foreleg, and the noble curve of his neck is a leading element in the composition.

Another slab, one with more movement and one of the finest, shows two horsemen just mounted, one wearing a broad-brimmed felt hat, the first horse checking a little as it is reined in, the other curvetting. The head of this horse is surely one of the noblest ever carved (Fig. 135).

On the central slab,[70] the one that comes over the western doorway, is a striking scene, a man restraining a lively, excited horse that is trying to break away (Fig. 136). Could this possibly have an allegorical reference to the art of government?

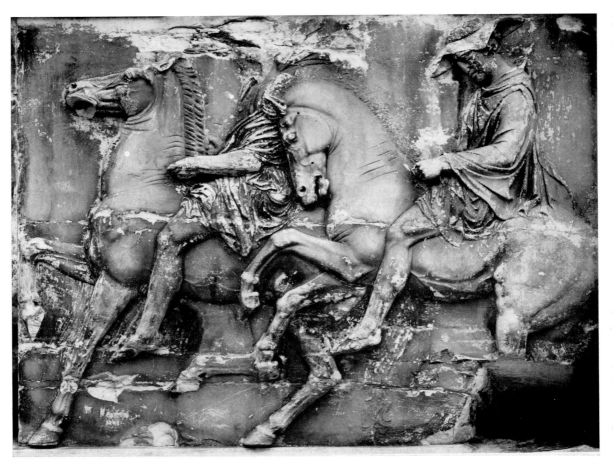

135. Parthenon: Two horsemen from the West frieze. Athens

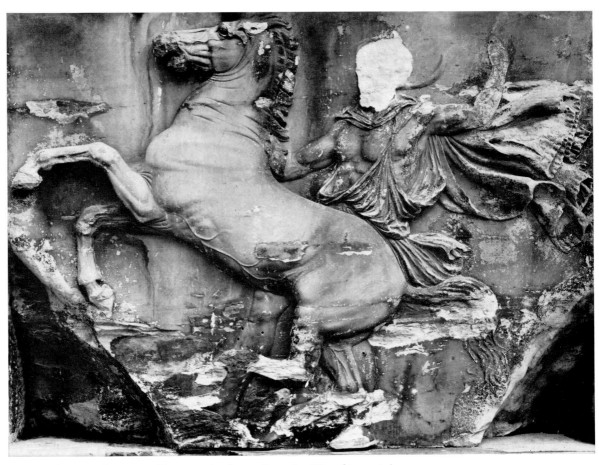

136. Parthenon: Man controlling a restive horse, from the West frieze. Athens

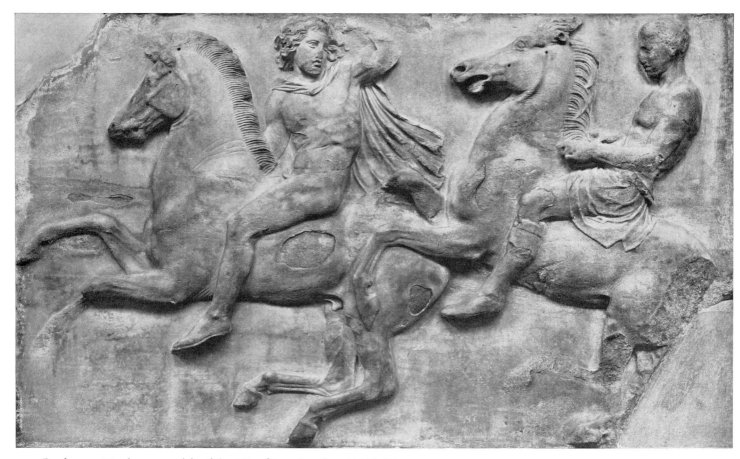

137. Parthenon: Northernmost slab of the West frieze. London, British Museum

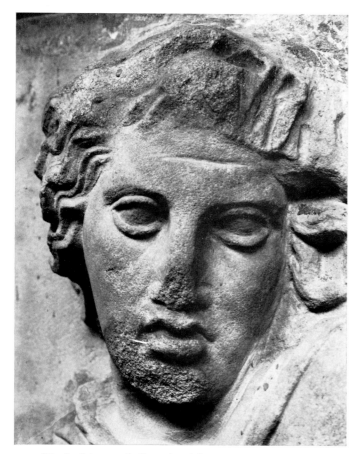

138. Head of the youth from the slab fig. 137

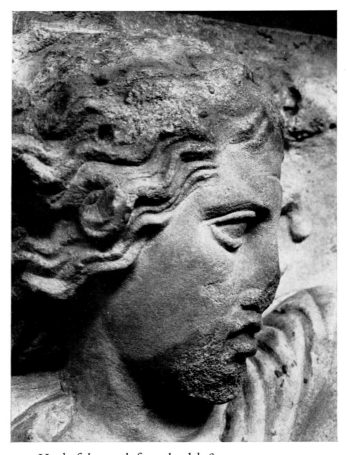

139. Head of the youth from the slab fig. 137

140. Head of a triton from the Odeion
in the Agora at Athens
(from Homer Thompson, *Hesperia*)

Pericles, who at this very moment was struggling to maintain his precarious control of the Athenian demos, may well have seen some such vision as this in his dreams.

The most northerly slab of the west frieze, with two horsemen just breaking into a canter (Fig. 137), points the way to a new phase, the full cavalcade. New but not disconnected, for the leader looks back and raises his left arm: the look, the gesture and the turn of the body serve to carry the eye and the mind back over all the scenes we have just been looking at. He is an exceptional youth, both in cast of feature and in his long, flowing hair; the artist might well have had some particular boy in mind: it is not exactly a portrait, but is less generalized than many of the other heads, and it is carved with such assurance and such gusto that it looks as if one of the leading sculptors insisted on putting the finishing touches to this figure himself (Figs. 138–9). Who that sculptor was we have no idea, but at a sheer guess he might have been the author of the Poseidon of the west pediment, whose head survives only in a copy which, as Homer Thompson has shown,[65] was adapted to make a triton in front of the Odeion in the Agora (Fig. 140), when it was recon-structed in the second century A.D.

You will notice that on this west frieze it is not only the static scenes which are confined within the boundaries of one slab: all the groups are designed not to over-

125

lap, or not to overlap seriously, on to an adjacent slab (Fig. 133). A tail or a hoof may go over one edge, but the main elements never.

This is the moment to pose for the first time one of our major questions: When were the friezes carved? To recall the main dates: work on the Parthenon started in 447: during the first four or five years the building was being constructed and the metopes carved. An entry in the accounts for 442 suggests that the column-capitals were then in place. Until these and the architraves above them were in place the frieze blocks could not have been installed. On the other hand, the colossal statue was dedicated in 438, and the frieze blocks, whether carved or uncarved, *must* have been installed by then, and probably well before then, because the roof had to be built on top of them, and there must have been a roof to protect the statue. So the questions to which we want answers are these:—

1. Were the friezes carved on the ground and then hoisted into position?
2. Were they roughed out on the ground and finished in position?
3. Were they carved entirely in position?

Because there are remains of a guide-strip, a narrow rebate at the top of all the friezes, Dinsmoor believes that all four sides of the frieze were carved when already in position on the building, between 443 and 439, but this is difficult to reconcile with the evidence we have just been studying from the west frieze. There we have a series of blocks of varying sizes, in each of which the design fits the block. There are two possible reasons for this. One would be that the designs were made to fit a series of blocks cut casually to various sizes. The second is that a series of blocks were quarried to specified sizes in order to accommodate a series of designs of which the scale-drawings or models, not necessarily full scale, had already been made. This, the second alternative, that the blocks were cut to fit the designs, must surely be the correct one. And if that is so, why were blocks of special sizes quarried for each group in the design? The only reason for doing so would be in order that they could be carved, if need be, independently of one another, on the ground; or, to put it the other way round, if the west frieze had been built in as a single continuous band of marble, uncarved, with the jointing perfect, as it would have had to be, why should the designer take the slightest notice of the joints? The joints are vir-tually ignored on the north and south friezes.

We can surely infer that, whether or not the west frieze was actually carved on the ground, the intention had certainly been to carve it there, and to place the carved slabs in position when the architraves were ready to receive them, which the evidence of the inscription seems to show was not before 442. Does this mean that the west frieze was the earliest? I think it shows that it was earlier than the north and south friezes, which were not carved on the system of 'one group to one slab', and were

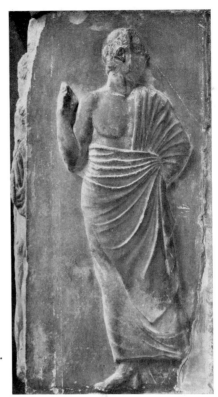

141. Parthenon: The last figure
on the North of the West frieze.
London, British Museum

therefore presumably carved in position, which means that they *could* not have been carved before 442, because the architraves were not ready to receive them before then; whereas the west frieze could be started on the ground at any time.

The slab at the north end of the west frieze (Fig. 141) bears the single figure of a marshal who, with the simple lines of his drapery and the staff that he is holding, again makes a strong vertical note at the corner. This slab is in fact the return face of the first slab on the north frieze (Fig. 142), and this first slab is the only one on the north frieze where the design takes any account of the joints of the slabs: it includes two complete horses, and the joint exactly misses the rump of the horse in front on the next slab: I think we can safely say that this angle block was also quarried to a special length to take this subject. The north side of the frieze is so familiar that we will not work through it systematically, but will walk along it, picking out casually any points of style, technique or subject that seem interesting.

This first slab of the north frieze shows a slight pause again: a scene of prepara-tion – a boy adjusting his master's tunic, a man adjusting his wreath – and so connects in motive with the west frieze. Yet there is already a difference: the proces-sion is thickening up. On the slabs of the west frieze there are never more than two horses and two men, in recession, in or behind the front plane. Here there are four horses, three men in the front plane and one behind it. And that is one of the features that have often been praised in the north frieze: the extraordinary skill with which, within his maximum depth of two and a quarter inches, the designer has managed to suggest, and the carver to render plausible, a cavalcade in which sometimes no less

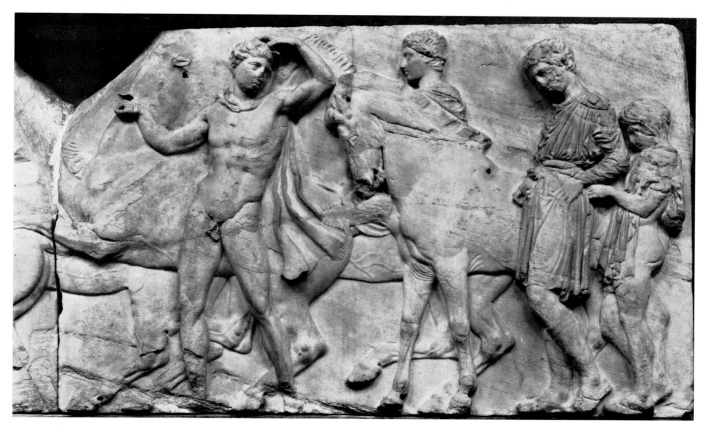

142. Parthenon: The most Westerly slab of the North frieze. London, British Museum

than seven horsemen are overlapping: not abreast it is true – there are limits to human skill – but in echelon. If you study the cavalcade in its whole length you will find that it is not a steady surge forward, but a rhythmic progress in which some of the horses trot, some are cantering, but most are prancing. This reflects exactly what happens when restive horses are constantly being reined in.

Nowhere is the artificiality of art more evident than in the representation of horses in movement. The still camera rarely or never catches a horse in a pose that would be acceptable to an artist, and a moving picture, run slowly, shows the reason – such poses hardly exist. The eye of the artist, however, makes a selection from the movements he sees and re-combines them into what, for him, is an animal moving in a credible fashion (see p. 161). On the friezes of the Parthenon these movements are recomposed into such a convincing picture that one cannot believe there is any tampering with nature.

There was another way in which some adjustment of nature was necessary, and that is in the matter of relative sizes. The riding-horses in the procession are shown as ponies. They may, it is true, have been small, but they can hardly have been quite so small in relation to their riders as this. The designer had to change the scale for two reasons: one, that the men should not be dwarfed by the size of their horses when they were dismounted: and second, that there should be room for the riders, when mounted, between the horse's back and the top of the slab. The problem was solved,

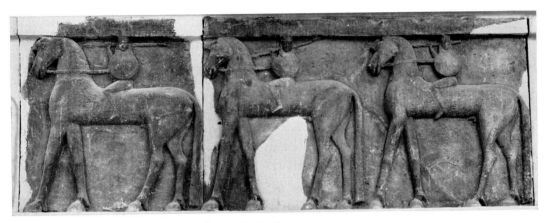

143. Mounted warriors, from a temple at Prinià, about 600 B.C.

and as with other problems in the frieze – and in life – when they are solved one soon forgets that they ever existed. The reality of the problem may be brought home to us by the effort of an earlier Greek sculptor to solve it two centuries before: he had been driven by its difficulties to reduce the riders to dimensions that are too small by any standard – even those of a jockey-club (Fig. 143).

We are handicapped in judging exactly how the north and south friezes were carved because of what is missing, but where there is a fairly continuous run two things are evident. One is that the whole *design* in each frieze is so consistent, and so carefully planned for the space it has to cover, that it must be the work of one man. The second is that in the north and south friezes the *execution* varies every few feet. This can be tested by looking at a series of heads where they are preserved: two or three or four are so similar that they must have been chiselled by one man: then in the next two or three the touch changes a little, or greatly; and so throughout.

How many assistants there were we do not know; but if the frieze had survived complete, I imagine it would have been quite simple to demonstrate where one carver left off and another started, and how occasionally a carver was taken from one part of the frieze and brought over to another part to work there: in this way one could have calculated the total number employed. It is irrelevant whether the designer himself took a hand in the carving: he may well have done; but, if so, at that moment he was just another carver. We must always remember to distinguish between the making of the design and the executing of it.

As an example of the difficulties of identifying individual carvers, take the heads of four horsemen from two slabs on the north frieze (Figs. 144–5). The first and second are so similar as to be almost indistinguishable (Figs. 146–7). The third is in the front plane of the relief, therefore more fully modelled, more rounded in its contours (Fig. 148). Is it by the same hand or not? Move along to the next head

129

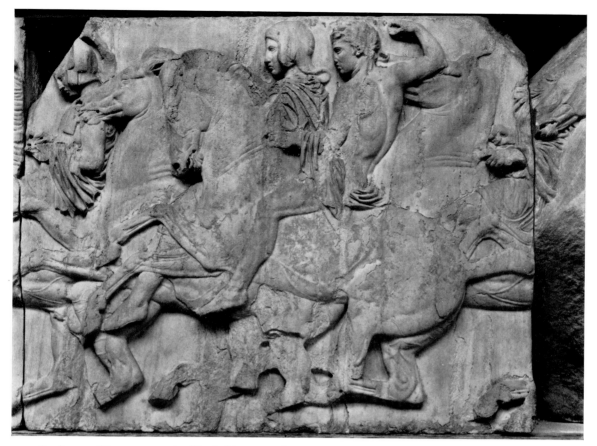

144. Parthenon: Horsemen on the North frieze. London, British Museum

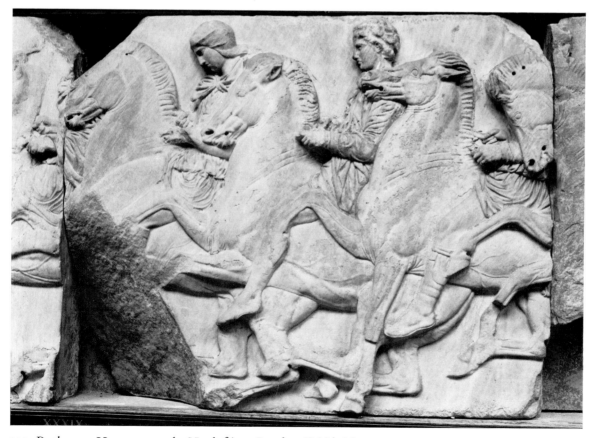

145. Parthenon: Horsemen on the North frieze. London, British Museum

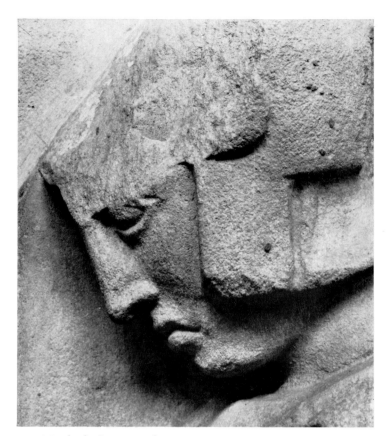

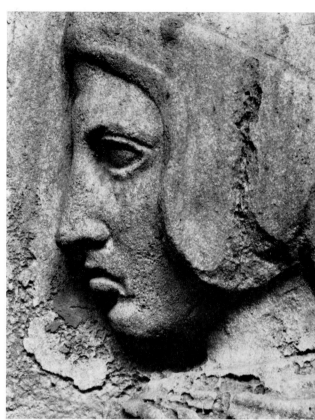

146. Head of a horseman from fig. 144

147. Head of a horseman from fig. 144

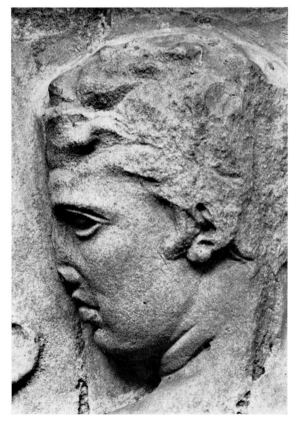

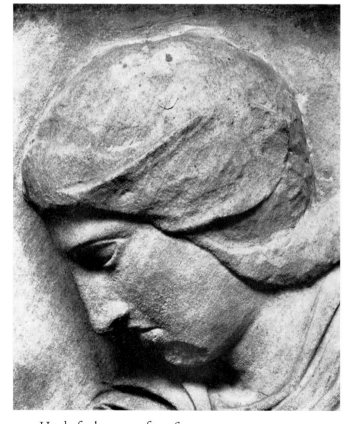

148. Head of a horseman from fig. 144

149. Head of a horseman from fig. 145

150. Gravestone of a girl with her doves, from Paros. New York, Metropolitan Museum of Art

151. Head of the girl
from fig. 150

(Fig. 149): the style seems very nearly the same, but not quite. Is it by a different carver, or the same carver on a different day?

And what of style? In the Metropolitan Museum there is an exquisite grave-relief from Paros of a girl saying good-bye to her doves (Figs. 150-1).[71] I cannot believe that a sculptor of this ability would have stayed on Paros when every sculptor in the Greek world was needed in Athens: if he was in Athens, we should expect to find his work somewhere on the Parthenon, and it is in this part of the frieze that I should be inclined to look for it.

There was a new problem when it came to the chariots (Fig. 152). Greek chariot-horses were commonly of a different build from riding-horses – larger, and longer in the barrel. This meant that on the frieze they had to be reduced even more than the riding-horses in order to preserve their proportions, and the charioteer had to be reduced too, in order that he could be accommodated at the top of the relief. Or to

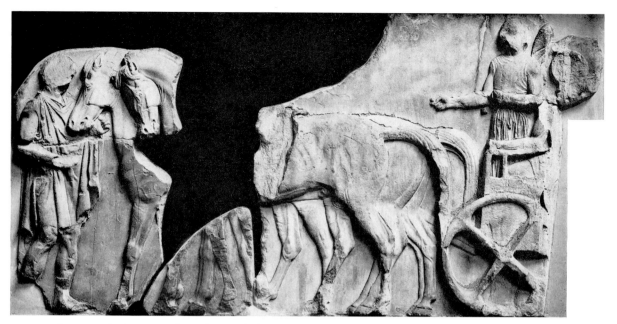

152. Parthenon: Chariot at rest from the North frieze. London, British Museum

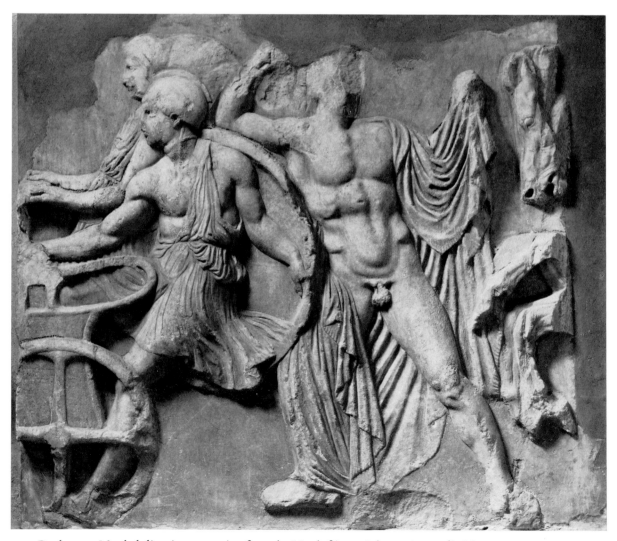

153. Parthenon: Marshal directing procession from the North frieze. Athens, Acropolis Museum

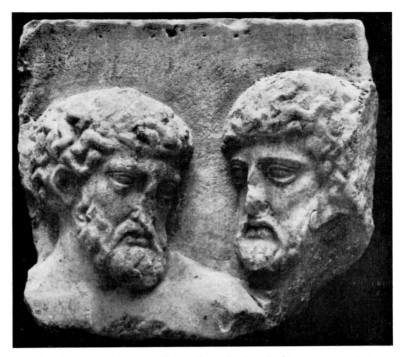

154. Parthenon: Old men talking, from the North frieze. Vienna, Kunst‑
historisches Museum

put it more bluntly: if the head of a man standing on the ground almost touches
the top of the relief, what happens when he steps up into a chariot?

In front of the chariots came the procession on foot, and one of the tasks of the
marshals was to prevent the pedestrians being run over from behind. One marshal
has had to step aside smartly in order to avoid being run down himself, and in
doing so he very nearly loses his cloak (Fig. 153). A fine composition, but the design
of higher quality than the execution: in other words a superb designer but not so
good a carver. The rear of this procession consists of the thallophori, the old men
who carried little branches of olive in honour of the goddess and of her great gift to
Athens, the olive‑tree. Just two of their heads are well preserved (Fig. 154); and the
sculptor has contrived, partly by their poise, partly by subtle modelling, to show
that the old man on the left had just been making a remark, and that the other is
considering it. Not a joyous conversation, but excellently characterized, despite the
small size.

In front of the old men were musicians, now much destroyed, and in front of
them again the boys carrying water‑jars (Fig. 130). On the right of this slab the
designer has attempted, in an effort to suggest a little more depth in space, the ren‑
dering of a figure in much lower relief as if he were more distant. This is a device
often used by Roman sculptors and never with much success. Even here the head
of the boy, who is just lifting his jar from the ground – the procession is about to
move on again after a halt – looks insubstantial, especially since the other heads on
this slab are exceptionally bold and solid.

135

We now overtake the victims. The horned sheep appear only on the north frieze (Fig. 155). I cannot recall ever having seen such stately animals: they must have been deliberately enlarged by the designer in order to maintain the focus of interest fairly high on the slab. We then reach the larger victims, the heifers (Fig. 156). It is noteworthy that both here and in the corresponding place on the south frieze it is the middle of the file of heifers that is giving trouble, resisting and trying to break loose; and this may well be intended to suggest the difficulty the drivers had in inducing their charges to mount the rocky ascent on the west of the Acropolis. The loss of the ropes, which were made separately in bronze, often impairs both the meaning of the action and strength of the composition. The leading heifers have calmed down, and the designer presents us with a contrast, now becoming familiar, between the great smooth flank of the animal, in its comfortably-fitting natural hide, and the artificial exterior surface of the human being, the cloak, with its loose but harmonious series of folds. It is in this unhurried, unsensational revelation of the beauties of the commonplace that the classical artist excels, and in order to show that he does not forget the quality of the real surface of the human body, he gives us on the right of the slab this chest and these shoulders, in perfect youthful contours.

We now go back to the south-west corner and glance at the procession which moves eastwards up the south side. Its make-up is much the same as the procession on the north, except that there are no sheep and no boys with water-pots, and every-one moves from left to right instead of from right to left, as if the spectator were looking at the procession from the other side of the street. The general impression one gets from the south frieze, so far as its very fragmentary condition allows one to judge, is of a certain unevenness of quality: it seems to contain some of the weakest and some of the noblest work of all the friezes. My own guess is that there may have been some hurry to complete it. Being on the least important or anyhow the least urgent side, because it was the side out of sight when one first came up on to the Acropolis and the area round it was covered with workshops, it may have lagged behind the others. Then someone gave orders that it must be finished and finished quickly, perhaps in time for some particular celebration of the Panathenaea, per-haps even because the war was looming up. Working at high speed, poorer sculp-tors may lose their nerve, but the fine sculptors may be stirred to display another facet of their talent. There is an inspired touch – almost that of an impressionist painter – about one of the chariots at full speed (Fig. 157), and Ruskin's apprecia-tion of it has never been bettered: 'The projection' he says, 'of the heads of the four horses, one behind the other, is certainly not more, altogether, than three-quarters of an inch from the flat ground, and the one in front does not in reality project more than the one behind it, yet, by mere drawing, you see the sculptor has got them to appear to recede in due order, and by the soft rounding of the flesh surfaces and

155. Parthenon: Youths leading sheep, from the North frieze. Athens, Acropolis Museum

156. Parthenon: Youths leading heifers, from the North frieze. Athens, Acropolis Museum

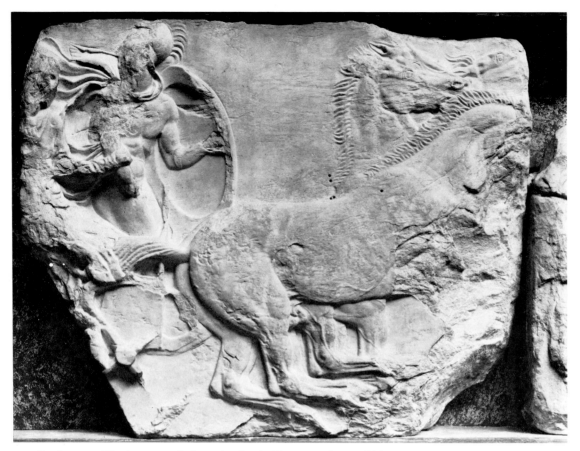

157. Parthenon: Chariot at speed, from the South frieze. London, British Museum

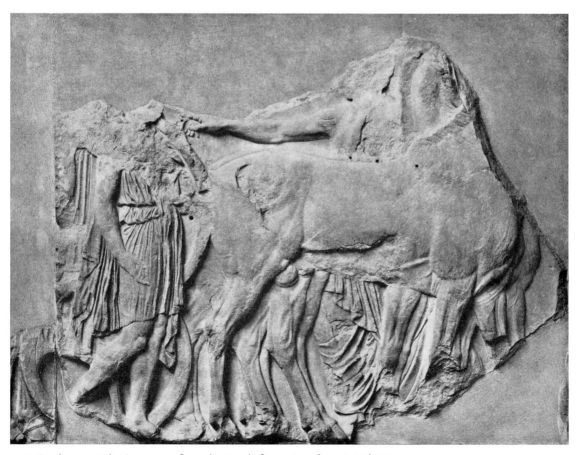

158. Parthenon: Chariot at rest, from the South frieze. London, British Museum

159. Hermes, Orpheus and Eurydice.
Roman copy of a Greek relief of about
415 B.C. Naples, Museo Nazionale.
(The faces and other details are restored or
retouched.)

modulation of the veins he has taken away all look of flatness from the necks. He
has drawn the eyes and nostrils with dark incisions, careful as the finest touches of
a painter's pencil: and then, at last, when he comes to the manes he has let fly hand
and chisel with their full force, and where a base workman (above all, if he had
modelled the thing in clay first), would have lost himself in laborious imitation of
hair, the Greek has struck the tresses out with angular incisions, deep driven, every
one in appointed place and deliberate curve, yet flowing so free under his noble
hand that you cannot alter, without harm, the bending of any single ridge, nor
contract nor extend a part of them.'

In a different spirit, but of equally high quality, is a chariot at rest with its pas-
senger standing beside it, and on the far side a marshal who, with his arm stretched
out, is giving directions to someone out of sight, perhaps the charioteer (Fig. 158).
It would be difficult to surpass that arm in the knowledge it displays of the hard and
the soft, the muscle and the bone, the tense and the slack, or in the restraint with
which they are rendered. The standing figure must in some way, either directly or
indirectly, have served as a model for Hermes in the relief of Orpheus and Eurydice,
the original of which – this is only a copy and the faces are restored – Homer
Thompson ascribed to the Altar of Pity in the Agora at Athens (Fig. 159).[72]
This must have been fifteen or twenty years later than the Parthenon, and extremely
close in style to parts of the parapet of Athena Nike; and it is characteristic of the
later period that the right hand of Hermes should have been given a slightly senti-
mental twist: its fingers toy with the folds. It is the embarrassed gesture of a not
insensitive envoy who, as conductor of the souls of the dead, has the duty of leading
Eurydice back to the Underworld, but who has first to witness the parting.

139

160. Parthenon: The East frieze (from M. Collignon, *Le Parthénon*)

Now for the east frieze. The quarries on Pentelicus seem to have produced blocks of about four feet long without much difficulty. The slabs of the west frieze are of this size, and the north and south friezes each consist of forty-one of these four-foot blocks with half-a-dozen rather longer ones at the ends. The east frieze, however, differs from the other three friezes. It was composed, not of a series of small blocks of almost uniform size, but of five exceptionally large blocks about three times the normal size, with one small one at one end (Fig. 160). The central block is a magnificent piece of marble nearly fifteen feet long: there can be little doubt that it was quarried to measure, to take the design consisting of the central ceremony with the two main pairs of gods, Zeus and Hera, Athena and Hephaestus, on each side of it: the design ends neatly at each end of the slab with no overlapping, except the toes of Hera, on to the adjacent slab (Fig. 161).

140

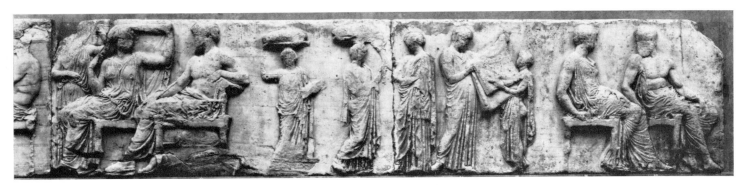

161. Parthenon: Central slab of the East frieze, originally a single block, now broken into two

The slab to our right of the central one is broken in two, and parts are missing, but it seems to have been only a foot or so shorter than the central slab: it fits the design exactly, and there is no overlapping at the ends. The slab to our left of the central one is rather shorter, but still over eleven feet long, and again tailored to take a particular design with no overlapping. The slabs on either side further out are almost a pair, about eleven feet long and again without overlaps. The small slab at the end is fragmentary, but the design seems not to overlap the end. In fact the whole of the east frieze could have been carved on the ground, but one wonders whether with such large slabs there would not have been a great risk of damaging the sculpture, if it had been completely finished, whilst hoisting them into position. Also they give the impression of being different in style from the west frieze, and though no finer as sculpture, rather more facile, in fact a little later, perhaps by a younger group of sculptors. They could of course have been roughed out on the ground and finished in position, when too the colour and metal attachments are likely to have been applied. We have no means of deciding.

Now perhaps we can attempt answers to the questions we asked earlier.

1. No part of the frieze could have been placed or carved *in position* before 442, because the building was not ready for the frieze-blocks to be laid before then.

2. The west frieze was intended to be carved on the ground and probably was carved there, before 442, whilst the building was going up. Perhaps finishing touches were given and colour was added when in position.

3. The east frieze could have been carved on the ground, but the danger of damaging completely finished sculpture on blocks of this size, when hoisting them, would have been great. Therefore it is possible they were finished, and the colour added, when they were in position. But this should all have been completed before 438, to leave the east front clear of scaffolding when the statue of the Parthenos was dedicated.

4. In the north and south friezes no notice is taken of the jointing of the slabs. Therefore they were carved in position and therefore not before 442. Carving could have continued on them even after the Parthenos was dedicated in 438, especially on the less public south side, because a wooden gallery for the carvers

to stand on could easily have been fixed inconspicuously above the columns between the outer colonnade and the main building. There is one slight difficulty: the beams carrying the ceiling are raised above the frieze by a moulding only a foot high: and this, though perhaps just adequate, is not generous for a man wielding a sculptor's mallet.

Let us now turn from the technique to the subjects depicted. Both the procession on the north and that on the south are alike converging on to the east front, and when they turn the corners on to the east we are at once in a different atmosphere. It is like a sudden hush. There have been no women in the procession so far. Now they are all women (Fig. 162). They stand waiting, silent, and their quiet poses and soft, heavy, voluminous drapery serve as a foil to the speed and clatter of the horses and chariots below, and the slower movement of those on foot who are climbing up the slope to the Acropolis.

The composition of the east frieze is by no means a simple one, and this arises from the difficulty of showing on a narrow continuous band of sculpture, in which the figures are almost as tall as the band itself, and where there can be no elaborate perspective, no diminution of size, no haziness of outline, in short none of the devices by which a painter can indicate recession in space – the difficulty in these circumstances of showing that one action is taking place behind or in front of another: all have an equal right to the front plane. Not all these groups are thought of as being in strict line with one another or of equal status: but the component parts are fairly clear. At right and left the heads of the two processions, each consisting of two girls with nothing in their hands, are being received by officials. Then there are

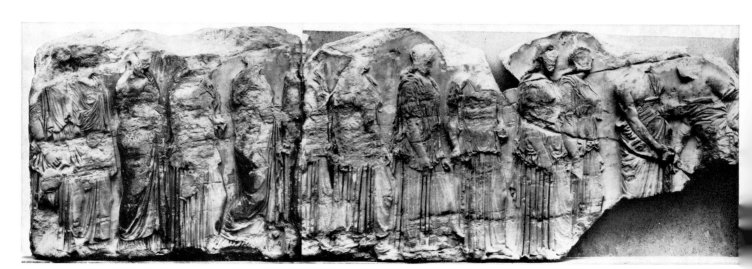

162. Parthenon: Women at the head of the procession, from the East frieze. London, British Museum

two groups of four men each, who seemingly have little to do with them. In the centre is the culminating event of the procession, whatever it may be, but certainly concerned with a sacred garment, and on either side of this scene two groups of deities who seem to be turning their backs on it. The gods are conceived as being exactly like human beings and are depicted with an affectionate sympathy for the peculiarities of human character. Here again the designer was faced with a problem of scale, and he solved it so skilfully by making the gods seated and by keeping the heads of all the figures level – a principle followed throughout the frieze – that, except where the small and the large are in close juxtaposition, the discrepancy of scale is not disturbing; yet the increased scale tells, even if one is not all the time conscious of it.

Until quite lately it has generally been assumed that the gods were seated in a semi-circle on the Acropolis itself, invisibly present at Athena's special festival. Professor Fehl, however, has pointed to certain narrow rough projections under the feet of some of them and has claimed that they are rocks.[73] The gods, he thinks, are seated on the rocky summit of Mount Olympus, engaged in Olympian conversation, and displaying a not too passionate interest in what is going on below.

Another new suggestion relates to the central group between the deities (Fig. 163). This is usually interpreted as the handing over of the sacred peplos, woven every four years by specially chosen maidens, the arrhephoroi, for the adornment of a primitive image of Athena in another temple on the Acropolis. The women at the head of the procession who stand empty-handed are thought to be the arrhephoroi, the man who is handling the peplos the archon Basileus, who had inherited the religious functions of the ancient kings of Athens, and the boy a carefully selected boy of high family who typified the city's youth, and the city's hope for the future. The woman would be the priestess of Athena, directing a girl, one of a pair, each of whom carries on her head a stool on which is a cushion or folded cloth. It is thought that they are setting out the stools in the Theoxenia, a symbolic invitation to the gods to be present at the festival. This explanation, though possible, is not entirely satisfactory, and it is a little strange, first that the interest of the scene is divided between the two actions of folding up the peplos, with no suggestion of what is to be done with it next, and the Theoxenia: and second that the main incident, that concerning the peplos, should be off-centre.

Miss Kardara has advanced a new theory, making the boy on the right the principal actor.[74] He is, she thinks, Erichthonios, son of Hephaestus and the earth goddess Ge, and foster-child of Athena. Erichthonios is usually identified with Erechtheus, and his position next to Athena and Hephaestus on the frieze would hint at that relationship. He would be initiating, as the literary tradition affirms he did, the whole ritual of the peplos, and handing over the archetypal peplos with

its woven design of gods and giants, as a model for all subsequent peploi to imitate, to Kekrops, the first king of Athens. For the artistic type of the child wearing this rather unusual and rather old-fashioned dress Miss Kardara cites a parallel on a cup, found on the Acropolis, where Erichthonios, with Athena beside him, is tasting a libation.[75] The boy on the frieze would then be Erichthonios-Erechtheus, the man Kekrops, the woman the goddess Ge, the girls two daughters of Kekrops, whilst the stools are being set out to receive Erichthonios and his mother Ge among the gods.

In detail there are several difficulties about this theory, but on general grounds it has much to recommend it. It would certainly be more satisfactory if the friezes represented a unique occasion, the original institution of the ritual of the peplos, rather than just any celebration of it. And the preponderance of horses and chariots in the procession would be explained by the fact that it was Erechtheus who taught the Athenians to bring horses under control, and invented the chariot. The theory would also explain the absence of the Panathenaic ship, moving on rollers, on the mast of which the peplos was carried in the procession: if the peplos was being handed out instead of handed in, the vehicle would be unnecessary.

More recently still, Mr Ross Holloway accepts the identification of the boy as Erichthonios-Erechtheus, but takes a different view of what is being done with the peplos, and of the general purpose of the procession.[76] He thinks that, just as the Parthenon was a restoration of its predecessor on the same spot, the procession is a restoration – 'a triumphant renewal', to use his words – of the dedications on the archaic Acropolis, which had perished in the Persian sack. The peplos is a token replacement of the old peploi which had been destroyed, the riders stand for the statues of riders, the animals are substitutes for the statues of animals once dedicated on the Acropolis: even the water-pots, which would be of metal, represent the wealth of smaller votives of the archaic age. I do not find this concept an easy one to digest, but it is worth thinking about, and one of its merits is that it does account for the absence from this procession of four elements which we know from literature to have formed part of the Panathenaic procession, namely the Panathenaic ship, the hoplites in full armour, the women basket-carriers and the women water-carriers.

Whatever the occasion was, whether the original institution of the ceremony of the peplos or a subsequent celebration of it, the designer has solved most ingeniously the problem of depicting it. The artist who portrays an historical scene, because he wants to tell the whole story and not only one incident in it, is often faced with the necessity of showing, as simultaneous, events which did not in fact happen simultaneously; and this usually passes unnoticed or is tolerated.[77] Not always: a naval historian once wrote as follows of Turner's famous painting of the Battle of Trafalgar:

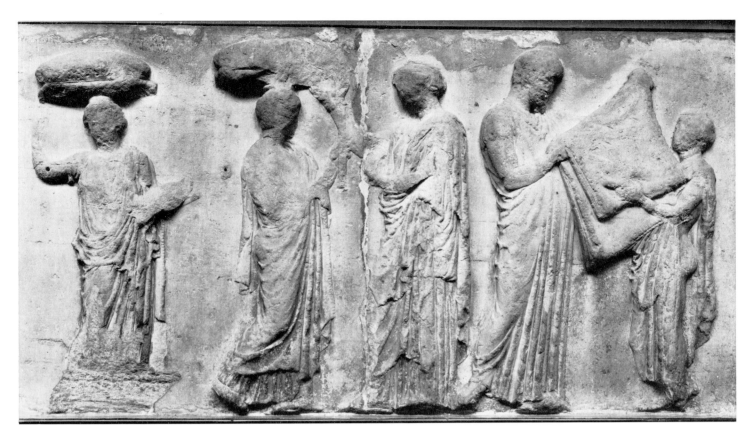

163. Parthenon: Central group from the East frieze. London, British Museum

'The telegraphic message is going up' (that was the famous signal 'England expects that every man this day will do his duty') 'which was hoisted at about 11.40: the mizzen topmast is falling, which went about one o'clock: a strong light is reflected upon the Victory's bow and sides from the burning Achille, which ship did not catch fire until 4.30; and the Redoubtable is sinking under the bows of the Victory, although she did not sink until the night of the 22nd and then under the stern of the Swiftsure.'[78]

Less obviously than this, the designer of the frieze of the Parthenon has also taken some liberties with time and place. His was not a canvas a few feet square, but five hundred feet of continuous picture which could not all be seen at one time. He has realized this and taken advantage of it. This is not just a procession – whether the Panathenaic or another – frozen into marble at a particular moment in its progress. There is no unity of time, because events which happened in succession are shown as happening simultaneously. There is no unity of place, for they happen in widely separated places in Athens, and on Olympus as well as in Athens. Yet although there is no static unity there is a dynamic unity. In reliefs both earlier and later than this, but especially in the art of later antiquity, the so-called continuous style unites a number of successive scenes, which are displayed as one continuous composition, by repeating at intervals an easily recognizable important figure – in Roman reliefs, for instance, the Emperor. In the Parthenon the spectator, walking

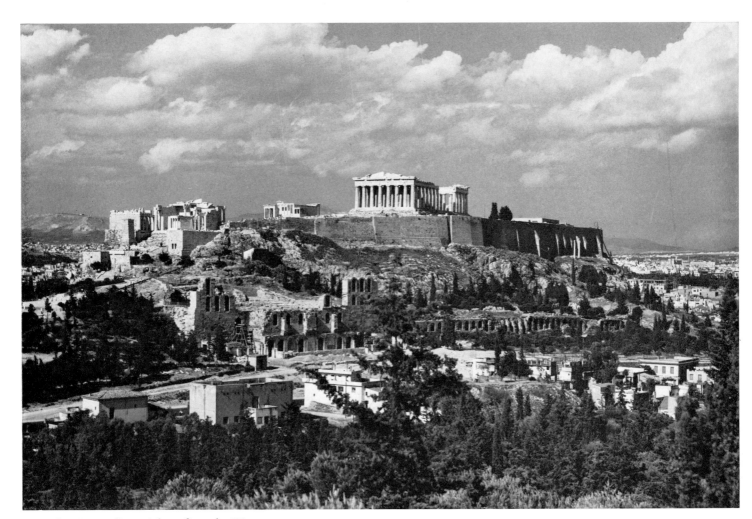

164. The Acropolis at Athens from the West

along the frieze, as we have done, and as a visitor normally would, from the back to the front, himself supplies the unifying factor. He sees one by one all the elements that compose the procession, just as if he were himself taking part. He can share in spirit the preparations – the awkward moments of persuading one's horse to behave and of getting on to it; the gradual speeding-up – and as he moves up the long sides of the temple he finds that he is among the horsemen in full career. He then leaves the horses and chariots behind in the lower city, and accompanies those on foot who are making their way up to the Acropolis; and when he arrives in front of the temple, he finds that he is still not too late to witness the culminating ceremony.

VI

The Tomb of Mausolus

DESIGNERS AND CARVERS

WHEN it was at last finished, the Parthenon, glistening white and resplendent with colour and gold, must have towered over Athens in a way that we can hardly imagine; for we know only its battered shell (Fig. 164), and even the height of the Acropolis itself is diminished by the modern buildings near it. Bitter irony that within a few years of its completion the Peloponnesian War and the plague had broken out, and had produced appalling conditions inside the city; that Pheidias and Pericles were dead, and that the great army of craftsmen whose skill created it had melted away. Let us hope that those who survived and looked up at the Acro-polis felt that, despite their own distress, here was something that would endure in midst of other woe.

At least one great sculptor of the school of Pheidias lived on, the unknown man whom Rhys Carpenter called Master E, and whose carving on the parapet of the temple of Athena Nike, about 415 B.C., is like a last but perfect flower (Fig. 165).[79]

The next generation, if we judge from the grave-reliefs, went on working in the Pheidian or sub-Pheidian tradition. At Epidaurus, however, alongside these relics of the old style are the beginnings of something new, which showed itself in the use of heavy drapery to create great pools of shadow against which the contours of limbs could be displayed, as in a statue of Hygieia found there (Fig. 166).[80]

Some time in this period, the second quarter of the fourth century, Scopas of Paros was given a commission to rebuild the temple of Athena Alea at Tegea. Parts of the figures from the pediments of this temple have survived, and they really are something new, carrying on, perhaps unknowingly, the attempts made by some of the sculptors at Olympia to express emotion in the face. The heads are square and massive, all the forms somewhat heavy, and the wide-open eyes are set deeply into the head, under lowering brows (Fig. 167). At about the same time, in Athens, Cephisodotus and Praxiteles, reacting against the work of their immediate predecessors, initiated a new movement based on the sculptures of a hundred years before; and from this there developed the famous Praxitelean style, which everyone recognizes, even if he does not quite know how.

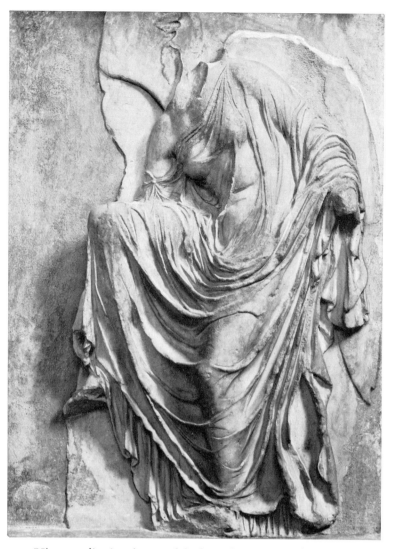

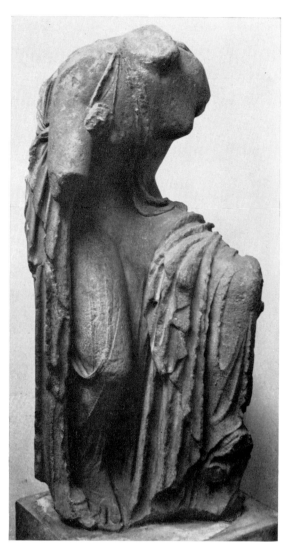

165. Victory adjusting her sandal, from the parapet of the temple of Athena Nike. Athens, Acropolis Museum

166. Hygieia from Epidauros. Athens, National Museum

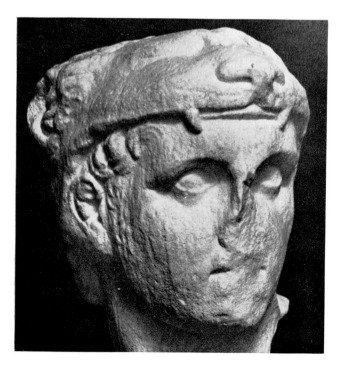

167. Head of Heracles from a pediment of the temple of Athena Alea, Tegea. Athens, National Museum (from a cast)

Such was the artistic scene about 375 B.C., when Mausolus succeeded his father Hecatomnus as Satrap of Caria under the King of Persia. His wife, a sister whom he had married according to Carian custom, bore the same name, Artemisia, as her predecessor whose dashing conduct at the Battle of Salamis, in sinking what turned out afterwards to be a friendly ship, provoked Xerxes to his famous remark that his men had behaved like women and the women like men. Mausolus took the opportunity offered by the troubled state of the Persian Empire at this time to become almost an independent monarch, and to enlarge his own dominions. He derived an immense revenue from the countries he had conquered, and this enabled him to take a major decision to move his capital from Mylasa, up among the hills thirty miles from the sea, down to Halicarnassus on the coast, and to rebuild this city on a new and comprehensive plan, with materials drawn from all over the Greek world, Paros, Pentelicus, Thasos, even as far afield as Proconnesus in the sea of Marmara; and with Greek architects and sculptors.

Vitruvius, writing three hundred years later, describes this layout so vividly that one might imagine he was in the city when writing it.[81] In fact he might have been standing on the spot from which this picture was taken (Fig. 168), behind the town, looking south over it, with a range of rugged hills behind him, and the fine deep-water bay at his feet. 'The shape of the city', he says, 'is like the curved shape of

168. Bodrum, looking Northwest from the Castle of St Peter. The Mausoleum lay halfway up the slope above the minaret on the shore. Foundations under water on the right of the bay

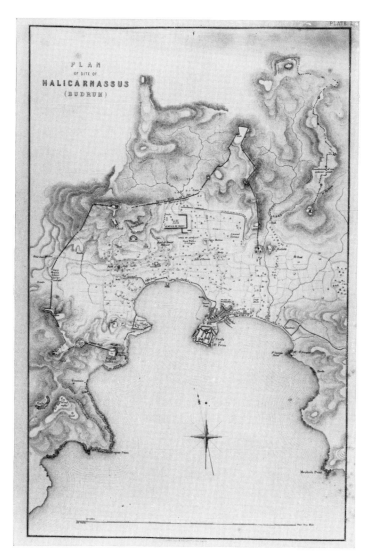

169. Plan of Bodrum (Halicarnassus).
From Newton, *Discoveries*

170. Bodrum, looking South

a theatre' – that is, of course, an ancient theatre, a fan-shaped hollow, and he imagines the bay as being the circular orchestra (Fig. 168). 'In the front row of seats by the harbour was the market-place. About half-way up the concave slope, at the point where the main cross-gangway is in a theatre, a wide piazza was laid out, in the middle of which was built the Mausoleum, a work so remarkable that it ranks among the seven wonders of the world. At the top of the hill in the centre is the temple of Mars; on the extreme right the temple of Venus and Mercury . . . and corresponding to it on the extreme left the royal palace which Mausolus built in accordance with a plan all his own. To the right it commands a view of the market-place, the harbour and the entire line of fortifications, while just below it to the left there is a concealed harbour hidden under the walls in such a way that nobody could see or know what was going on in it. Only the king himself could, in case of need, give orders from his own palace to the oarsmen and soldiers, without the knowledge of anyone else.'

Mausolus died in 353. His wife is said to have commissioned this magnificent tomb, but Vitruvius's account suggests that it was an integral part of the lay-out of the city, and therefore planned by Mausolus himself before his death, which is what one or two other ancient authors tell us. The fullest description of the Mauso-leum is given by Pliny, writing in the first century A.D., and this is an abbreviated version of it:

'This tomb was made by his wife Artemisia for Mausolus prince of Caria. That this work is among the seven wonders is due mainly to the artists. On the south and north sides it extends sixty-three feet: less on the façades. The whole circuit is four hundred and forty feet. It rises to a height of twenty-five cubits. It is surrounded by thirty-six columns. Scopas carved on the east, Bryaxis on the north, Timotheos on the south, Leochares on the west. The queen died before they finished [this was in 351]: but the artists did not abandon the work until it was completed, judging that it would be a monument of their own glory and of their art: and to this day their hands compete. A fifth artist joined them: for above the colonnade a pyramid equals the lower [some word understood, "pyramid" would be the natural word to supply if one takes the Latin literally] in height, tapering with twenty-four steps to the summit of a cone. On the top stands a four-horse chariot in marble, which Pythis made. This addition completes the whole work with a height of one hun-dred and forty feet.' [82]

Without entering into a discussion on disputed points, we can infer from this and from excavations that it was a rectangular building, the long sides of which were sixty-three feet long, surrounded by an Ionic colonnade of thirty-six columns and surmounted by a stepped pyramid, on the very top of which was a four-horse chariot. There is some doubt whether the thirty-six columns were arranged in a

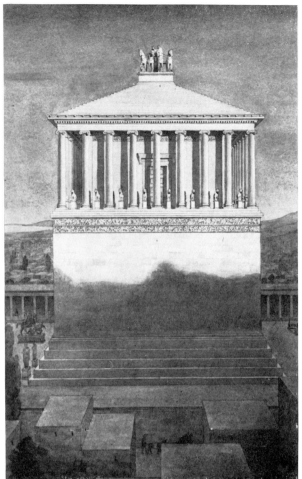

171. Mausoleum: Conjectural reconstruction by
F. Krischen (from *Zeitschrift für Bauwesen*)

172. Mausoleum: Conjectural reconstruction by J. J. Stevenson
(from *The Builder*)

single or a double row; the single row gives a building much longer than sixty-three feet (Fig. 171). The total height was one hundred and forty feet, and since the columns were only thirty feet high, the whole thing must have stood upon a high sub-structure, which most scholars restore with perpendicular sides (Fig. 172), but one or two, taking the text of Pliny literally, restore as a pyramid below the colonnade in addition to the one above it (Fig. 173). And since the whole circuit is given as four hundred and forty feet, there must also have been some sort of precinct round it with sides about one hundred feet long; and this is what the excavations suggest.

The Mausoleum stood intact throughout antiquity, and is still mentioned as complete in the twelfth century A.D., but seems to have been thrown down by an earthquake in the thirteenth. In 1402 the Knights of St John took possession of Halicarnassus and began to build the Castle of St Peter. For materials they drew on the remains of the ancient town and harbour, which were very handy, and no fragments of the Mausoleum have been recognized in this earlier part of the Castle. In 1522, however, when they were being threatened by the Turks, they seem to have

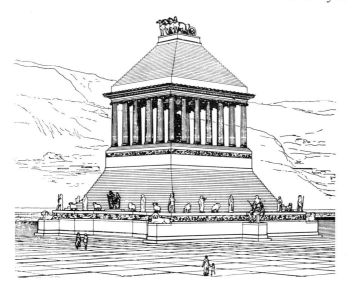

173. Mausoleum: Conjectural re-construction by H. W. Law (from *Journal of Hellenic Studies*)

gone a little further afield and to have discovered, according to an almost contem-porary account, a stepped platform of marble which grew wider the deeper they dug, and yielded much material both for building and for lime. For four or five days they demolished this and then came to a small opening leading down: they lighted a candle and let themselves down through it, finding themselves in a large square apartment elaborately ornamented with architecture, and sculpture in relief. 'Having at first admired these works' the chronicle goes on, 'and entertained their fancy with the singularity of the sculpture, they pulled it to pieces and broke up the whole of it, applying it to the same purpose as the rest.' In a low room adjoining they also found a marble sarcophagus, but they then withdrew for the night, and when they returned next day this had been despoiled, and the earth all round was strewn with fragments of cloth of gold and spangles of the same metal. This story has been doubted, but unjustly: the flimsy gold ornaments, a common feature of Greek burials, are convincing. That the Knights did plunder the Mausoleum is quite evident, and they built thirteen slabs from its friezes into the walls of the castle, as can be seen from an aquatint of 1803 (Fig. 174). These were eventually given by the Sultan of Turkey to Sir Stratford Canning, the British Ambassador, and are now in the British Museum.

In 1856 the site of the Mausoleum was excavated by C. T. Newton, on behalf of the British Government. He found that it had been almost completely despoiled, both by the Knights and subsequently by the Turks, who had continued to dig deeply down, converting what they found into rubble, with which they built their houses; until it became dangerously deep, after which the hollows had been allowed to fill up with soil (Fig. 175).

174. Reliefs from the Mausoleum built into the Castle of St Peter, Bodrum (after L. Mayer in R. Ainslie, *Views in the Ottoman Empire*)

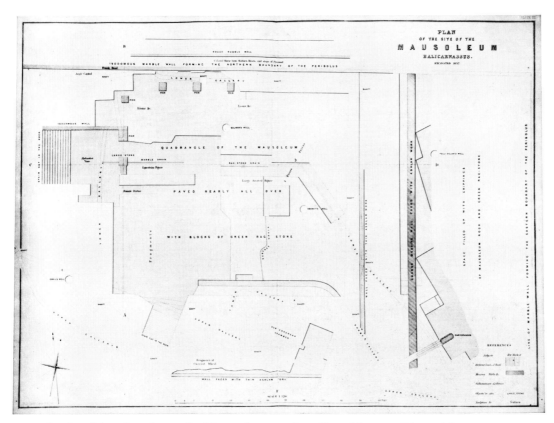

175. The site of the Mausoleum after Newton's excavations (from Newton, *Discoveries*)

So far as the architecture is concerned, Newton was able to establish the height and spacing of the columns, and he found a foundation-platform for the whole structure made of a soft local limestone of greenish colour. This platform was rather over a hundred feet square, with a rough rock-cut staircase thirty feet wide leading down to it on the west, which he conjectured had been used once only, for the interment of the body in the basement of the tomb, and then covered with earth. He also found a huge block, of the same green limestone, which had evidently been lowered into place after the burial in order to form an impenetrable barrier to the tomb-chamber (Fig. 176). Let into it below were two cunningly-devised bronze dowels intended to drop, when it was in position, and lock into the pavement below, as an extra precaution against tomb-robbers: but these dowels never fell into place, either by accident, or by the prudent action of some workman with an eye on the future.

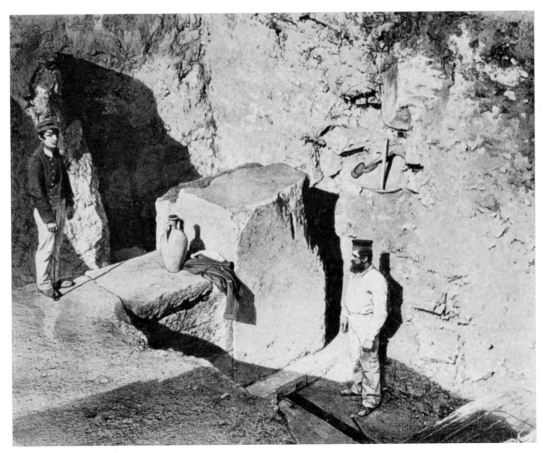

176. The great stone sealing the tomb-chamber of the Mausoleum (from Newton, *Discoveries*)

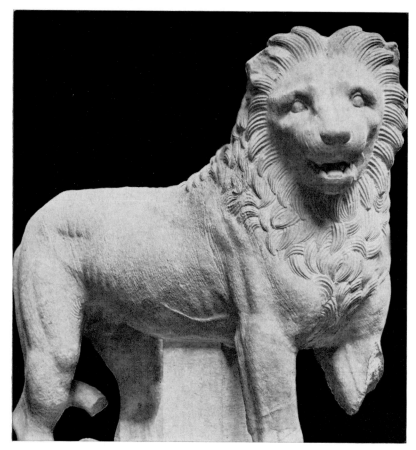

177. Mausoleum: Lion, about 350 B.C. London, British Museum

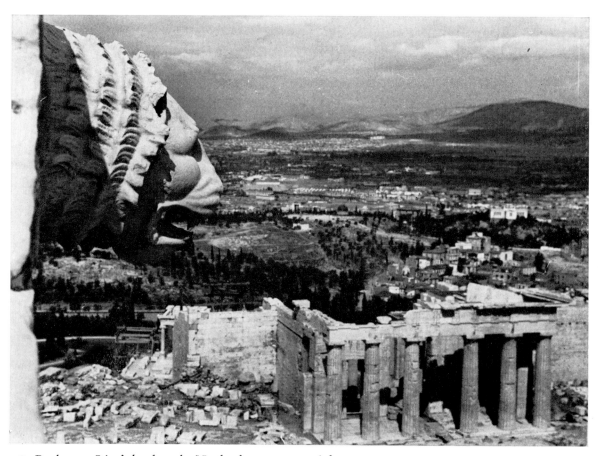

178. Parthenon: Lion's head on the North, about 440 B.C. Athens

179–180. Head of the statue fig. 181

We are concerned chiefly with the sculptures in relief, but we must just glance at the sculptures in the round. Newton found a number of lions – there must have been well over twenty originally – all of the same pattern except that some look to the left and some to the right. They may have stood between the columns of the colonnade or round the edge of the roof, and by tradition they were guardians of the tomb; but they hardly seem to realize what was expected of them, and stand about with a rather listless expression. It is interesting to compare these with the lion's head gutter-spouts at Olympia or the magnificent heads on the Parthenon (Figs. 76, 177–8) and to gauge what has been lost in monumental quality in a hundred years. Newton found also part of the colossal horses and chariot from the top of the monument; a wonderful torso of a horse over life-size, with part of its rider in Persian dress; and several figures nine or ten feet high, mostly very fragmentary, but evidently portraits. The best preserved of these has been thought to be Mausolus himself (Figs. 179–81), and, since it is hard to believe that these features were not studied from an actual person, and since it resembles fairly closely a portrait of Mausolus on his coinage for the island of Cos, this may well be so.

Before studying the sculptures in relief we must consider for a moment the vexed question of the artists, and look again at Pliny's statement. He is discussing the leading Greek sculptors in marble, and says 'Scopas had rivals of the same age, Bryaxis, Timotheos and Leochares, who must be discussed together since all alike sculptured the Mausoleum. [The word Pliny uses for sculpture is *caelare*, of which the normal meanings are to inlay in metal, to carve in relief, or simply to decorate.]

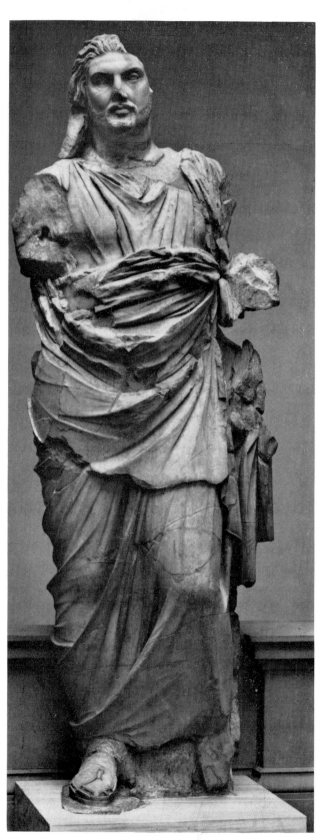

181. Colossal statue, probably Mausolus. London, British
Museum

Scopas sculptured on the east, Bryaxis on the north, Timotheos on the south and Leochares on the west.'

What exactly does this mean? Does it mean that everything – free sculpture as well as relief sculpture – to the east of the building was carved by Scopas, everything on the north carved by Bryaxis and so on? This is sometimes assumed, but it is most unlikely. For instance, twenty or thirty lions alone represent years of work, and some of them are manifestly not by leading sculptors.

Vitruvius, however, also mentions the sculptors of the Mausoleum, and he puts it in a more acceptable way. He says: 'Separate artists each took one of the sides in competition with one another, for decorating and approving [*ad ornandum et probandum*], Leochares, Bryaxis, Scopas, Praxiteles, and some think also Timotheos.' Archaeologists have tacitly dropped Praxiteles, finding him awkward to fit in, but Vitruvius's words do suggest a practicable scheme of work, namely that each sculptor designed the decoration for one side, in accordance with the scale and height of relief prescribed by the architect, and then carved some of it himself and supervised the carving of the rest by his own team, ensuring that the whole side for which he was responsible was up to standard. This is the assumption I shall make, and it is, broadly speaking, borne out by the variations of style which one detects in the relief sculpture: and wherever the free sculptures may have been, the relief sculptures must have formed part of the building.

Newton discovered the remains of three sculptural friezes, one of a chariot-race, one, very fragmentary, of a battle of Lapiths and centaurs, and one of a battle of Greeks and Amazons. The chariot frieze is two feet nine and a half inches high and is carved on thin slabs of Pentelic marble, the background now being between four and seven inches thick according to how deeply the carver has cut his relief. It is mostly in very small pieces, so shattered that one cannot even make up one complete chariot-team. Some of the fragments are in almost perfect condition, some severely weathered, from which we can deduce that much of the weathering probably took place after the building was in ruins, and not because one aspect is rainier and windier than another. We can further deduce that the frieze was in a sheltered position, either, as Krischen suggests, inside the colonnade in a place analogous to the frieze of the Parthenon or, as I think possible, actually round the inside of the sepulchral chamber. The thin slabs, the not very deep joins between them, and the moulding below painted rather than sculptured, would all agree with this. In its conception of relief the chariot frieze differs from anything we have seen before – unlike the Parthenon in that it projects in parts as much as eight inches from the background, and unlike the frieze of the Erechtheum in that some parts are in extremely low relief. Nearest perhaps to the parapet of Athena Nike, but there no figures overlap one another.

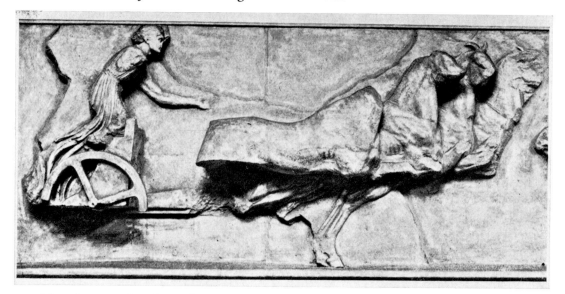

182. Mausoleum: Racing chariot from a frieze, made up of casts from several slabs

183. A modern horse-race (from *The Times*, 1966)

I. Fall of ʟ.ʜ.

II. Fall of ʀ.ʜ.

III. Fall of ʟ.ғ.

IV. Fall of ʀ.ғ.

S. Suspension, all feet bunched together.

184. The action of a galloping horse (from E. Sandars, *A Beast Book*)

The subject is a simple one, but technically difficult, since it was necessary to show a side view of all four horses in the team (Fig. 182). As in the east pediment at Olympia, the horses are set not abreast but in echelon and, as there, this has the double effect of giving the sculptor a little more marble to work with, and of allow, ing all the heads to be shown. The silhouettes are clear: the chariots are not in the act of overtaking one another – that would have been too difficult even for a designer of this ability – but the enormous power of a team of four horses pulling a light car must have been brought out excellently. They are at the gallop, and the sculptor has compromised with nature by extending all the legs: it is as if he had perpetuated an instantaneous view of the start, when the horses rear up and leap away.

One has only to look at any picture of horse,racing (Fig. 183) to see the difficulty of representing horses in action. On the frieze of the Parthenon the horses are not at a gallop: here they are. The movements of a living horse can be analysed: this is what happens, and this is how the hooves fall (Fig. 184). This will not do for the artist; so, in hunting or racing pictures of the eighteenth century, the horses are usually in what one may call the rocking,horse position, with all four legs extended, which does not exist in nature. A biologist, Edmund Sandars, explains this well in his book from which the diagram was taken. 'Artists,' he says, 'drew a gallop so, because the eye registers only the moments when each leg is motionless for an instant at full stretch, and the resultant picture was truer to human vision than the modern artist, who copies the camera.'[83]

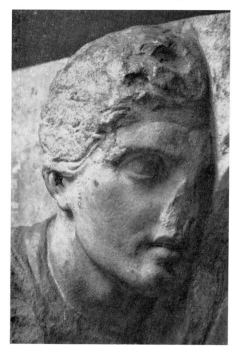 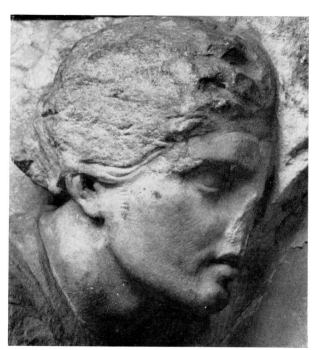

185–186. Head of the charioteer fig. 187

As for the style of the best-preserved head of the frieze (Figs. 185–7), the delicacy of the structure and the general feeling for form suggest an Athenian sculptor to me, but as the textbooks tell us that Scopas of Paros was the sculptor of passion, any head that shows traces of emotion is apt to be ascribed to him, and so is this. The long hair here, which caused Newton and others to describe the charioteer as female, was a Carian fashion for men; and the features are masculine.

As a subject, chariot-racing had both a direct appeal and a symbolic meaning. It was the most spectacular of ancient sports, and had been a feature of heroic funerals from the funeral-games of Patroclus onwards. Perhaps partly for this reason, but chiefly because of the processions of chariots which were a feature of funerals in Greece – as we know especially from pictures on vases – the chariot, and the horse, came to be regarded as the means by which the dead passed to the other world. This would also explain the chariot that was set on the summit of this very building.

The centaur frieze is the least attractive of the three, so far as its very fragmentary condition allows one to judge. It is about the same height as the chariot frieze, two feet eleven inches, but it is narrowed by a heavy and unique moulding below, with a deep overhang. Jeppesen has suggested that this was a precaution against damage by kicking, and that the frieze was therefore on ground level somewhere, perhaps a

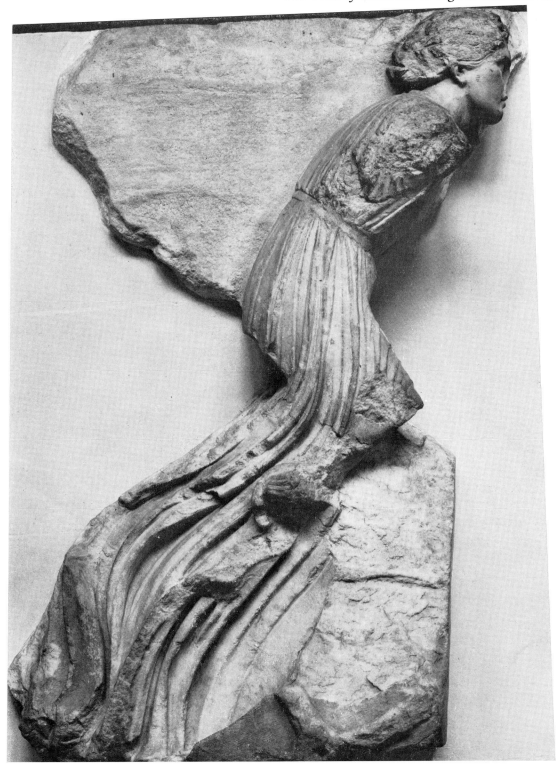

187. Mausoleum: Charioteer from a frieze. London, British Museum

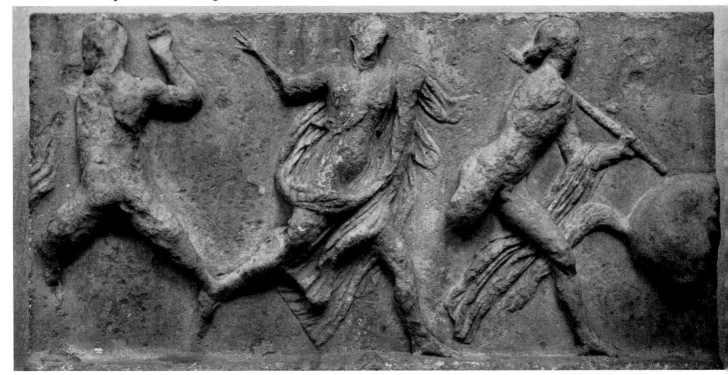

188. Mausoleum: Centaur frieze, slab 1032. London, British Museum

balustrade – a possible but not certain explanation. One slab only is at all well preserved – even that is battered, and the style is difficult to assess (Fig. 188). The relief is high, but no parts are disengaged from the background, and one has a feel‑ing, very rare in Greek reliefs but not uncommon in Roman, that the figure has been sliced in half and placed against the background.

It is a constant source of amazement that the Greeks, possessing a mythology full of stories of absorbing interest, the richest mythology in the world, should time after time choose to represent these tedious subjects, the battle with the centaurs and the battle with the Amazons. When they were fairly new and apposite, as at Olympia or even on the shield of the Parthenos, they had interest and meaning; later, not only is their repetition tiresome in itself, it is exasperating in that one cannot help thinking of dozens of subjects of greater interest which might have been used instead. On the tomb of a great fighter, however, as Mausolus was, battle scenes are appropriate, and in Caria – which, in the two Artemisias, the one who fought at Salamis and the one who at this very moment, just after her husband's death, was ruthlessly subduing the Rhodians,[84] possessed two of the most notable women‑warriors in history – Amazons might well be given a place of honour; and Caria had another link with

164

the Amazons, in that the battle-axe which Heracles took from Hippolyte their queen still existed in the temple of Zeus at Labranda.

There is yet another reason for the choice of this kind of subject. Sculpture set high on a building, to be effective as decoration, and even to be intelligible, must have clear silhouettes and a plain story to tell. The same reason underlies the develop-ment of this type of relief in which each of the figures has its own piece of back-ground, against which it stands out clearly. A tangled mass of bodies does not tell the story, and does not tell as sculpture. The action must have been made clearer still by the contrast of colour, the white bodies of the Amazons against the brown bodies of the Greeks, a piquant contrast which must, I fear, have contributed to the popularity of the subject.

The frieze of the Amazons is the best preserved of the three. It is a shade larger than the others – just under three feet high – and carved on the face of massive blocks of marble about a foot thick. If we assume that it ran all the way round the building it would originally have been about two hundred and thirty feet long. Of this we possess eighty-six feet, which is more than a third. It is curious that we have no returns, no angle slabs: possibly such slabs never existed, the corners being finished in some other way, with pilasters for instance; or it may be mere coincidence that they have not survived.

Newton thought that the Amazon frieze was the frieze of the order, that is to say outside, above the columns of the colonnade; but it now seems more likely that it ran round the top edge of the substructure.[85] The argument briefly is this: the blocks of the Amazon frieze are tooled at the back in a unique way (Fig. 189):

189. Mausoleum: Back of a slab of the Amazon frieze

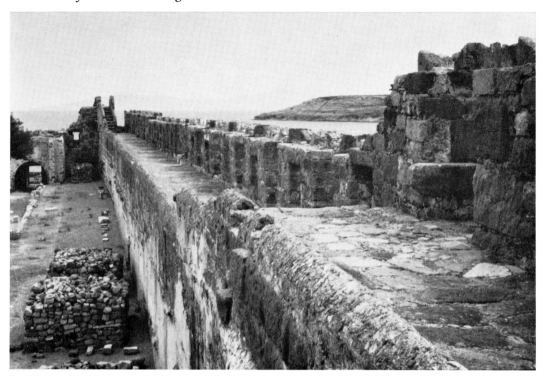

190. Inside the Castle of St. Peter: greenish limestone blocks from the Mausoleum

they are three feet high and have two broad, flat, horizontal bands and a narrower one at the top. There also exist blocks of white marble of the same thickness as the Amazon frieze and with similar tooling (with only two flat bands) at the back, but plain, not sculptured, on the front, and only two feet high. The substructure of the Mausoleum was made of blocks of the local green limestone, of which there is still an enormous quantity in the Castle of St Peter (Fig. 190): these limestone blocks were one foot high. The suggestion is that the whole of the outside of the substructure was faced with the plain marble slabs, and that the two horizontal bands on the back of them coincided with two courses of the green limestone blocks, each of which was one foot high. Then, that the Amazon frieze came at the top of the substructure, but being three feet high and having three horizontal bands, it covered three courses of the limestone.[86] This, if correct, would rule out Krischen's suggestion that the centaur-frieze came immediately below the Amazon frieze (Fig. 171), because the centaur frieze is not only thinner, but does not have the peculiar tooling at the back.

The Amazon frieze in that position, at the top edge of the substructure, would be about thirty feet up but not masked in any way, and although it would be too distant to see much detail, the angle of sight need not have been too steep if one stood away from the building a little. The blocks of the Amazon frieze vary in length – they

seem mostly to have been five or six feet long – and sometimes seem to be quarried to take a particular composition, but more often not, and there is considerable overlapping from slab to slab; sometimes the joint of the slab comes right in the middle of a figure.[87] With reliefs as high as this, it would have been impossible to carve two blocks that share a figure in this way, independently of one another, and then to unite them. They must have been joined first, and then carved as if they were a single block of marble. There is so little overlapping of one figure over another – each one has its own piece of background – that I doubt if a model of any kind would have been necessary: a drawing would have been sufficient; but occasionally the grouping is complex, and there perhaps preliminary studies in clay or wax may have been used, as a precaution against damaging the block irreparably.

Newton in 1856, and Biliotti in 1865, found on the site of the Mausoleum a great number of small fragments of the friezes, mostly arms and legs, all of which Dr Donald Strong and I have worked through and catalogued. It soon became apparent to us when handling them that they must have been produced by more than four sculptors. Both quality and style vary: some are exquisite, some second-rate; and anyone else handling these fragments would, I feel sure, come to the same conclusion. This undermines the usual interpretation of Pliny's statement about the four leading sculptors carving one side of the building each; and it is disconcerting that for a hundred years scholars have spent their time and ingenuity in trying to assign every slab by name: small wonder that their results have all been different.

However, there is no reason to reject the story completely. Very likely the four sculptors were allotted a side each, and having been told the subject and the measurements, were given a fairly free hand; but they must have consulted together, presumably under the direction of the architect, so as to make the four sides reasonably harmonious, and must have agreed at least on the general size of the figures, and the height of the relief. And they must inevitably have influenced each other whilst at work: complete secrecy, even if desired, would have been impossible among Greeks.

Otherwise, I think that our study of Olympia and the Parthenon has already suggested what the usual method was – leading sculptor, one or two pupils perhaps, and a number of carvers, according to the size and the urgency of the task. Even on a comparatively small building like the Mausoleum the leading sculptors cannot have done all the work on the reliefs themselves: we are fairly certain that they were doing free sculpture at the same time, and we know that the time was short.

This does not mean that there are not recognizable differences of style in the friezes and that we should not try to detect and classify them, and even speculate on their origin; but there is no need to abandon commonsense. And when we come to identifying leading sculptors, the crucial differences resolve themselves into two only, first, differences of proportions in the figures, and second, where the work is

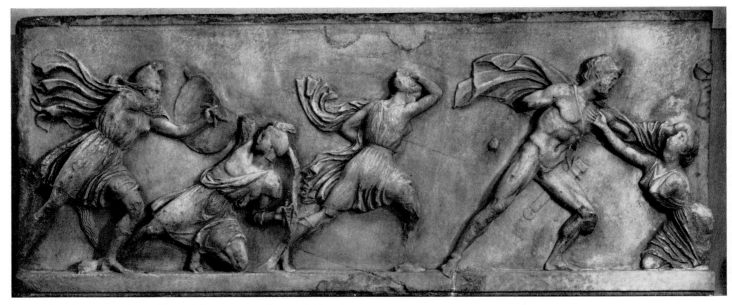

191. Mausoleum: Amazon frieze, slab 1022. London, British Museum

obviously of the highest quality, differences of style. Where the work is mediocre, the question of who made the original design from which an assistant has done the carving is the only question we can attempt to answer. It seems a meagre field to work in, but it is meagre only if one is obsessed with names: the general quality of the work is so high that – the puzzle of authorship apart – there are a hundred other points of interest and delight.

The slabs of the Amazon frieze now in the British Museum reached there in three ways. First, from the walls of the Castle of St Peter (Fig. 174), second, from Newton's excavations, and third, a single slab, from Genoa, which had been taken to Italy as a souvenir by one of the Knights of St John, and was purchased by the British Museum in 1865 (Fig. 191). It is convenient to begin with this slab from Genoa, because it is unlike the rest in having been re⁄cut slightly whilst it was in Italy: the delicate bead⁄and⁄reel moulding at the top has been cut away, and the slight forward curve of the slab at the top has been tooled flat, which gives it a rather bald appearance. The surface generally has been drastically cleaned and there may have been some re⁄touching of details.

The spacing of the figures on this slab is rather wider than elsewhere on the frieze, and the speed at which the combatants move is greater, as if this was on the out⁄skirts of the battle, where there was more room for manoeuvre. The individual movements are violent, and the expression of the faces wild (Figs. 192–3): the drapery seems to have caught the infection, and flies out violently, even if in a rather man⁄nered way. The proportions of the figures are noteworthy, because these are due to the original designer and not just to a carver. Here the tall figures are distinctive, as they are on two slabs which join one another and in which the joint cuts one of

168

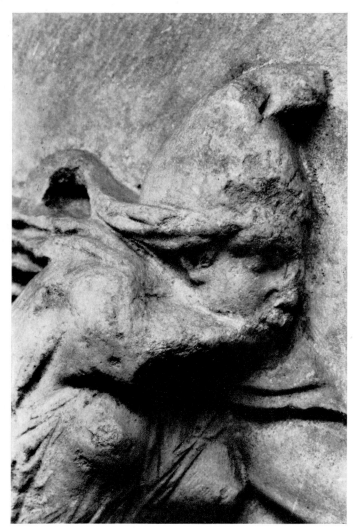

192. Head of an Amazon from the slab fig. 191

193. Head of a Greek from the slab fig. 191

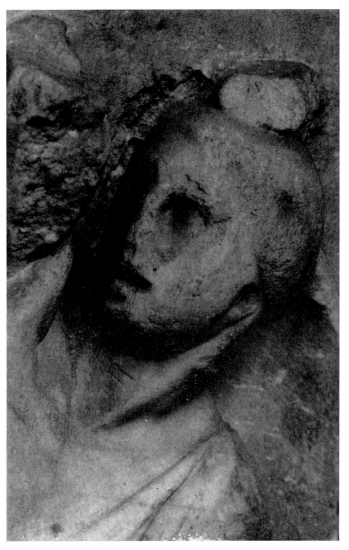

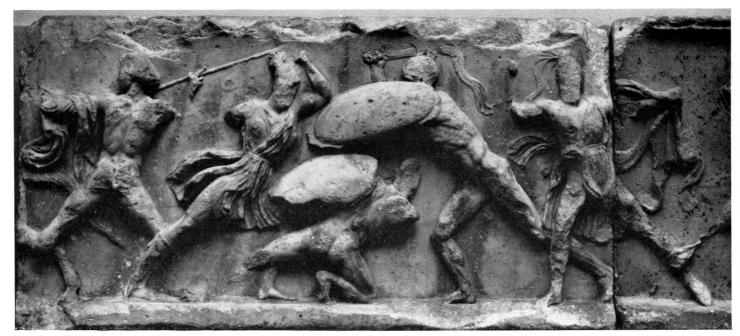

194. Mausoleum: Amazon frieze, slab 1020. London, British Museum

the figures almost in half (Figs. 194–5). These slabs must have been amongst the most impressive, but unfortunately the one on the right has suffered terribly from Turkish musketry. It would be fair to assume the same designer for both: he has a taste for spectacular three-figure groups. The group on the right-hand slab is the more complicated and would have been difficult to understand if it had not been for a drawing made in 1749 by Richard Dalton, when the slabs were still built into the castle (Fig. 196). Dalton had not very much idea of drawing, which is perhaps why he took to librarianship later, but he did record the action here, and was the first to guess that the slabs had come from the Mausoleum.

A Greek is collapsing under the blows of an Amazon's axe, whilst a comrade holds him by the right wrist and tries to protect him with his shield. The position of the falling man is complicated and quite momentary: the inside of his left hand bends under as it strikes the ground, and his right knee is still in the air. The Greek on the right (Fig. 197) is making a furious backhanded slash at an Amazon, who, again, is in the moment of falling: these uncompleted movements increase the excitement and vividness of the scene. The Greek is in three-quarter back view – a masterly piece of foreshortening – and the contour of his shoulder is framed by the deep vault of shadow formed by the shield: deeper originally, when the rim was intact. The drapery adds greatly to the effect by its own violent movement: it swirls off, not directly to the side, but away into the air behind.

The figure at the junction of the two slabs is a puzzle. It is enormously tall and wears a tall helmet with a crest, whereas Amazons are normally bare-headed or wear a Phrygian type of helmet or cap: yet it seems to be wearing boots, which the Greeks here do not, and is also carrying a huge skin as a shield, which is unusual

170

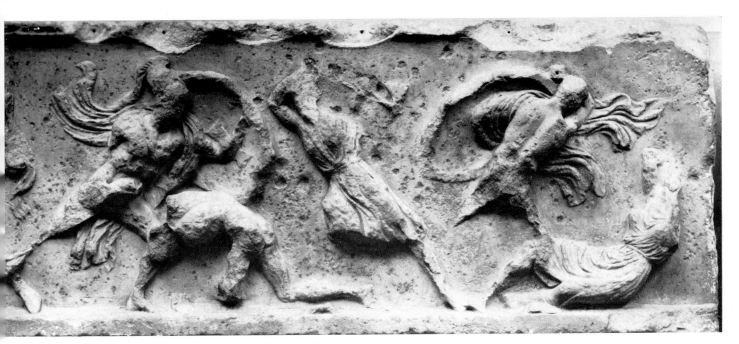

195. Mausoleum: Amazon frieze, slab 1021. London, British Museum

but not impossible for a Greek. The breast is so damaged that one cannot tell whether it is male or female; but on balance it seems likely to be an Amazon. It would be helpful if one knew whom she was attacking, but there is no obvious opponent: the action must be that of launching a spear at a distant adversary, and this serves to break the processional effect that is almost unavoidable in any frieze. Another interesting point about this figure which suggests that, whoever the designer was, two carvers were at work on it, is the skin used for a shield. As held out on the left arm it is undoubtedly a skin, with hanging paws and characteristic heavy, sparse folds, but it passes behind the Amazon's back and comes out the other side as drapery: certainly it looks as if the carver here had forgotten that it was in-

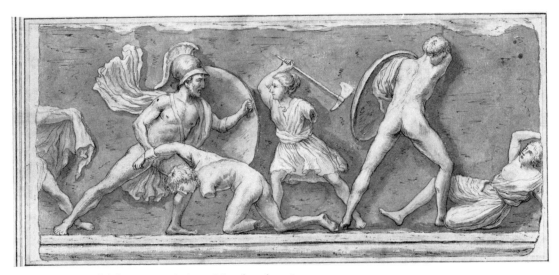

196. Drawing of slab 1021 made by Richard Dalton in 1749

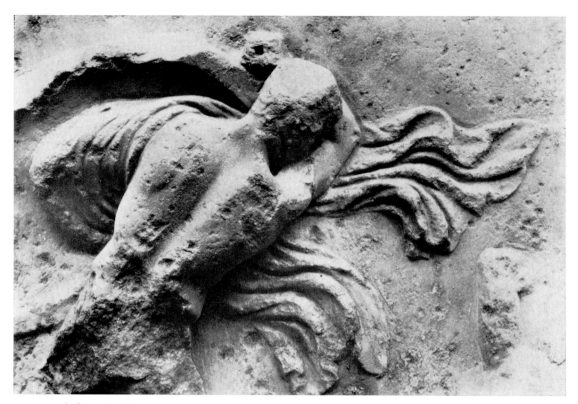

197. Greek from the slab fig. 195

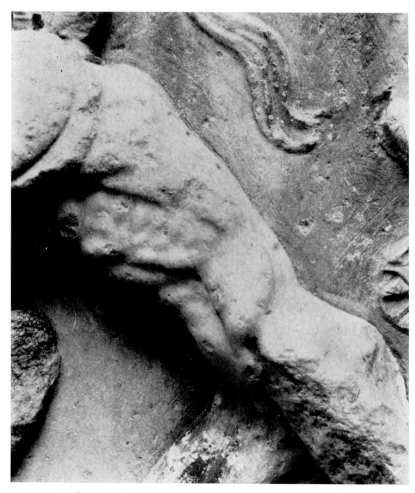

198. Greek from the slab fig. 194

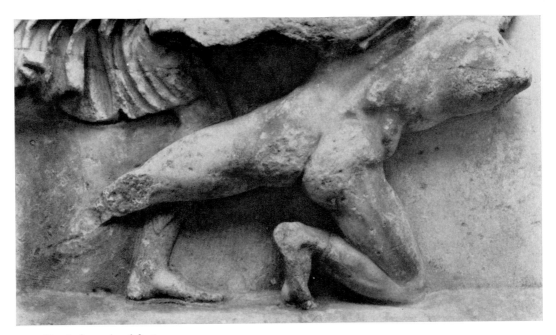

199. Greek from the slab fig. 194

tended to be a skin, and this seems much more likely to happen to a subordinate than to the man who made the original design.

The central group does bespeak the same designer as the last slab, with the two great figures poised over a third. Another Greek, attacked by an Amazon and defended by a comrade, has been forced down on to his knee (Fig. 199). Again, a fine piece of foreshortening, but the camera is a little too high to do justice to the recession of that right leg. This reminds one that the relief-sculptor has a problem from which an artist drawing on a flat surface is free. The draughtsman has to worry about one angle of sight only, that of the person looking at the flat sheet of paper, the canvas or the surface of the wall. The relief-sculptor's figures also have to look as if they are in the round, but it is a drawback, not an advantage, that they are partly in the round already, because this means that his foreshortenings have to look tolerable from a good many points of view: and perfect from one; which, theoretically, might tell us the height at which the relief was intended to be set.

The defending Greek is tremendous (Fig. 198), practically a giant, lean and terrifying, striding forward with only his eyes showing over the rim of his shield: his torso is immensely long and very carefully studied: one might say perhaps too carefully. This looks like the beginning of a certain kind of Hellenistic sculpture which is so concerned with recording subsidiary details that the main forms tend to be confused; and if it is compared with almost any one of the sculptures from Olympia (e.g., Fig. 33) it can be seen that the later sculptor knows more about anatomy, but that it does not help him towards creating a greater work of art. The one is an easy naturalism assisted by a sure instinct for generalization, the other is studied realism, adding literal details to what by now are traditional formulae.

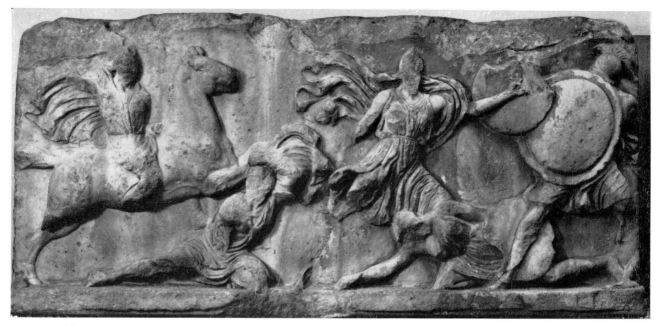

200. Mausoleum: Amazon frieze, slab 1019. London, British Museum

Pass on to a slab in which the proportions of the figures and the general feeling for grouping seem to be much the same (Fig. 200). Another of these gigantic creatures – they must be a special contingent with these fine helmets, perhaps the queen's bodyguard – she is striding to the right and thrusting her shield against that of an opposing Greek, who seems to be retiring in good order, leaving a wounded enemy in a state of collapse. Notice the long cloak lying across the upper arm and streaming back in the wind: introduced, one suspects, for its decorative effect, certainly not for practical convenience, and stylized at the end in much the same way as on the Genoa slab. Charging in on this scene from the left is another Amazon, on a muscular horse, who rides down a Greek crouching on the ground and defending himself with his cloak wrapped round his arm. The four slabs seem to go roughly together so far as proportions, and grouping, and violence of action are concerned (Figs. 191, 194, 195, 200).

Two other slabs differ from them in several points (Figs. 201–3). The figures are not quite so tall, have larger heads and are more solidly built. The Greek was pulling his spear out of the body of a fallen Amazon, whilst one of her comrades was shooting him with bow and arrow at extremely short range. The drapery is curiously indecisive, and it is possible that these figures are not quite finished. Here again a figure is cut in two by the joint of the slabs. The much mutilated slab on the right is interesting in that it has a mythological character, Heracles, who is recognizable by his club and his lion's skin and, as Dalton aptly remarked, is 'destroying a

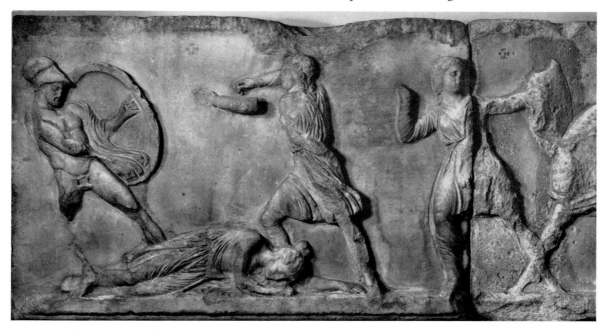

201. Mausoleum: Amazon frieze, slab 1007. London, British Museum

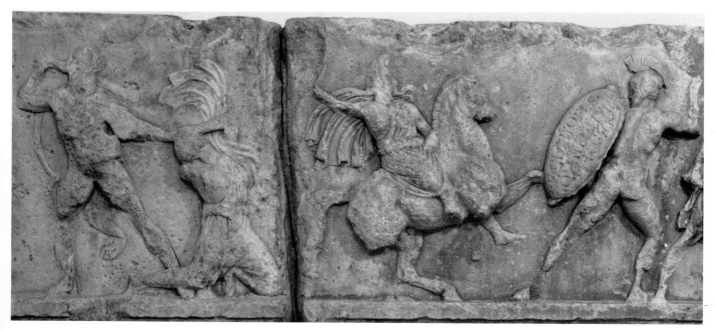

202. Mausoleum: Amazon frieze, slabs 1008 and 1010. London, British Museum

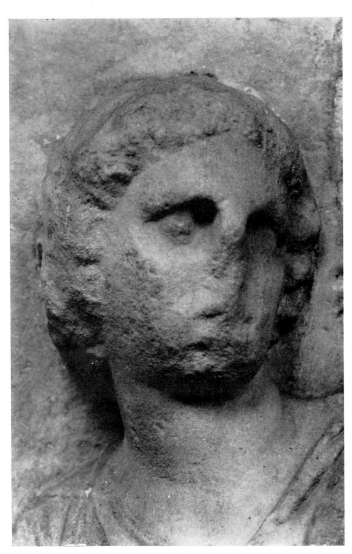

203. Amazon from the slab fig. 201

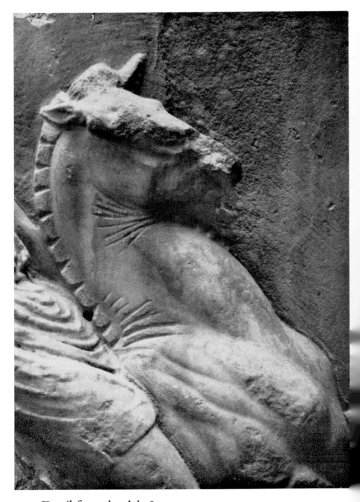

204. Detail from the slab fig. 205

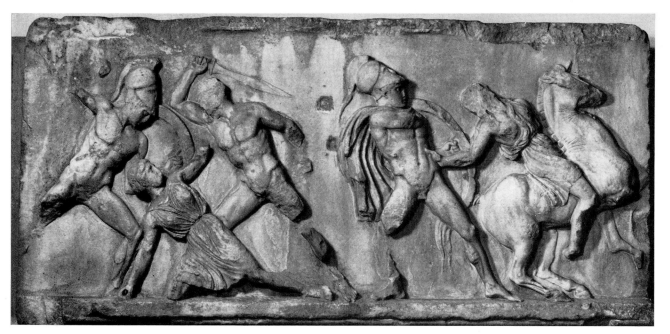

205. Mausoleum: Amazon frieze, slab 1006. London, British Museum

principal Amazonian lady.' This presumably is Hippolyte, and the occasion that on which the famous axe exhibited in the temple at Labranda was first obtained.[88] One would expect a sculptor to have given this slab special attention, but it is so battered that no judgment is possible on the style. On the companion slab the heavy head, deep-set eyes and pathetic expression (Fig. 203) are the nearest parallel that can be found on the frieze to the heads from the Tegean pediments, which are thought to be connected with Scopas.

From these two slabs we pass to a single one, of different style again (Fig. 205). The figures are shorter than on the last slabs, and much shorter than on the first four we looked at. The action, though by its nature violent, is lacking in conviction, and the figures are posed almost as in a ballet or *tableau vivant*. The composition on this slab divides into two independent groups: that on the left consists of two Greeks, one with a spear, the other with a sword, poised above an Amazon who is begging for mercy with her outstretched left hand, whilst her right must have been holding the shaft of an axe made separately of bronze. The other group shows a Greek, stocky in build and with a formidable jaw, who has seized an Amazon by her hair and is pulling her from her horse: she tries to fend him off with her hand against his hip, and at the same time to save herself from falling by clinging to the horse's neck with her other hand: her fingers are trying to grip but are gradually slipping off the taut, rounded surface of the neck, and the horse's muscles strain as it staggers backward (Fig. 204). The technique is bold: the mane and the wrinkles on the neck are blocked out with heavy strokes, and the main muscular structure is kept simple, a treatment which would tell as well or better at a distance than a more minute finish would have done.

177

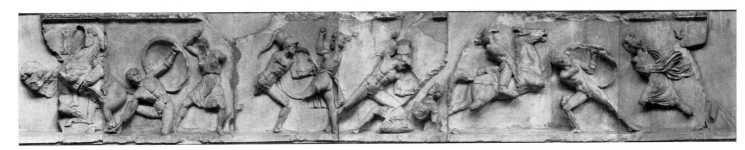

206–208. Mausoleum: Amazon frieze, slabs 1013, 1014, 1015. London British Museum

Fairly closely related to this slab, but in most places carved with rather more vigour and delicacy, are three beautifully preserved slabs, which all belong together, discovered by Newton in his excavations near the north-east corner of the building. These provide us with the longest sequence that we have, and it looks rather as if the blocks had been quarried to avoid serious overlapping of the figures from one block to another (Figs. 206–8).

With the three slabs set together end to end, one can see the whole design at once, even though on a small scale, and appreciate the way in which it has been knit together. The group in the middle, of a stand-up fight between a Greek and an Amazon, is flanked on the left by an Amazon striking at a Greek who is down, and on the right by a Greek striking at an Amazon who is down. These in turn are flanked on the left and on the right by Amazons on horseback. Another Greek leans back towards the horse as he receives the charge of another Amazon, and he balances the opponent (now missing) of the horsewoman on the extreme left.

I should like at this point to make a short digression, and explain how we have been able to add an extra fragment to Newton's slabs. In 1964 Professor Jeppesen of Aarhus University, Dr Donald Strong and I went together to Bodrum. We had all been working on the problems of the Mausoleum, and we all thought that it ought to be possible to learn more about it by studying further the remains that had been incorporated in the Castle of St Peter; and that there was a fair chance of finding other small fragments of sculpture built in. In theory the task was simple. As you remember, the backs of the Amazon slabs are tooled in a peculiar way with three smooth horizontal bands (see p. 165 and Fig. 189). The ends of these slabs are also distinctive, being tooled smooth to make a perfect joint with the next slab, except in the middle, where the surface is cut back with the point, neatly in some, less neatly in others, but clearly under the same general instructions. It was our task to discern whether any of the fairly numerous stones of which the castle is composed were tooled in one of these two ways. It was not quite as simple as this, because, you may remember, there were in the Mausoleum unsculptured blocks of marble, of the same thickness as the Amazon slabs, tooled in a similar way at the back, but only two-thirds their height.

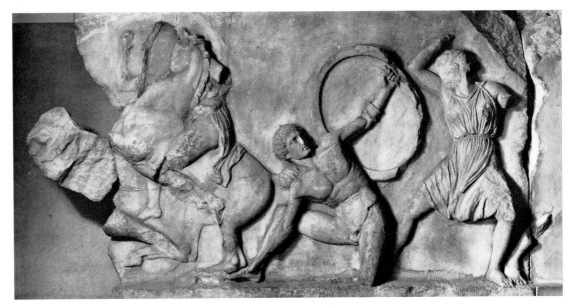

206. Mausoleum: Amazon frieze, slab 1013. London, British Museum

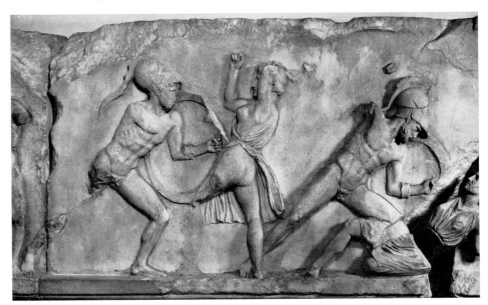

207. Mausoleum: Amazon frieze, slab 1014. London, British Museum

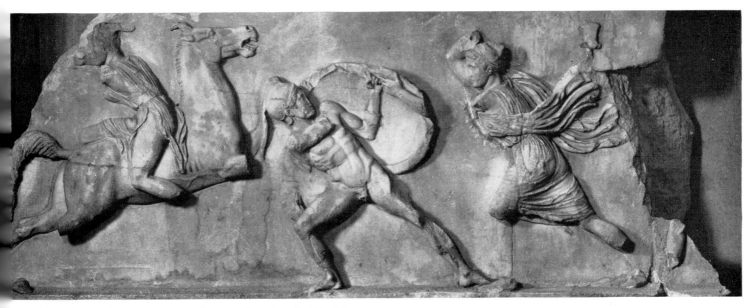

208. Mausoleum: Amazon frieze, slab 1015. London, British Museum

209. Fragments built into the wall of the West fosse, Castle of St Peter, Bodrum

The most likely candidates are built into one of the walls of the courtyard in the West Fosse (Fig. 209). They are covered with thick whitewash because they had formed part of the back wall of a temporary building, and are eight or twelve feet up the wall. Theoretically, if any of them is more than two-thirds of the height of the Amazon frieze, it should be sculptured on the face that is hidden: if it is less, then it may be a plain block. It was not possible at that time to obtain permission to extract them, but there is every hope now that the Turkish authorities will experiment.

Since these were inaccessible, we looked round for others, and at the foot of the ramp which had originally been connected with the first gateway by a drawbridge and had been built when the defences were strengthened in 1510, Professor Jeppesen found a slab built in but with its edge showing, and this had the kind of tooling we were looking for (Fig. 210).

It was built in face upwards, and one could just feel the edge of a projection which seemed like the hindquarters of a horse but which proved afterwards to be a shield. Our great concern now was to prevent it being damaged by enthusiastic assistants; but by starting our demolition well above the slab itself we finally extracted it unhurt. It had been mortared in firmly with an abundance of fine mortar, no doubt produced by the burning of other sculptures.

210. Fragment of the Amazon frieze being extracted from the Castle of St Peter, Bodrum, in 1964

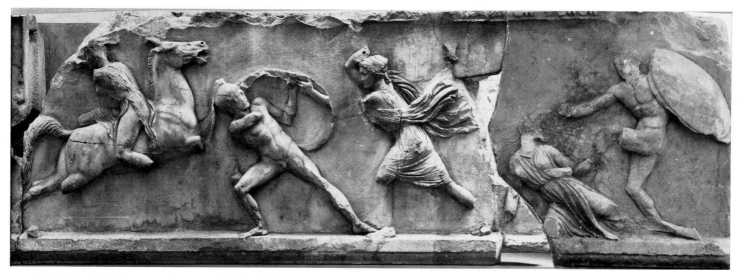

211. The join of the fragment fig. 210 with the slab fig. 208

Even when first extracted, and still covered with mortar, its style could be iden-
tified with certainty: it was similar to that of Newton's three slabs; and our judgment
was quickly confirmed by finding that evening that the new fragment would actually
fit the right end of Newton's right-hand slab (Fig. 211).[89]

It is well worth looking at some of the figures in this comparatively long stretch
of the frieze (Fig. 206). On the left of the left-hand slab is a Greek who has fallen
on one knee and is warding off a blow: a spectacular figure, seen from the front
with the lower left leg not truly foreshortened but compressed into the background
out of sight; naked, for reasons more artistic than practical, and with that slight air
of the ballet – the pose a little too static – that we noticed elsewhere.

In the next group (Fig. 212) a Greek is pressing forward with shield and sword
against an Amazon who raises her axe for a downward blow: the weapons are
missing, and this weakens the effect, but it can be seen that the sculptor has chosen
a quite fleeting moment, when the axe is on the point of descending, and the Ama-
zon is being thrust off balance by the edge of the shield pressing against her body.
Weathering has coarsened the detail, but it is still remarkably delicate: natural
lighting from above brings out the extraordinary way in which the third dimension
is realized, and how the figures seem to be freely moving in space.

In the faces there is no ferocity, only a calm determination, as in the head of the
Greek in the next group. This must be by a rather old-fashioned sculptor – Athenian,
I should guess – who preserves something of the classic calm of the fifth century: his
men in the thick of battle fight, and kill, with a demeanour completely free of sav-
agery, and even of animosity (Fig. 213).

On the last of Newton's slabs is an Amazon seated backwards on her horse and
shooting with the bow (Fig. 214). This is a marvellous study of the general poise
and the action, and equally sensitive in its understanding and rendering of both

182

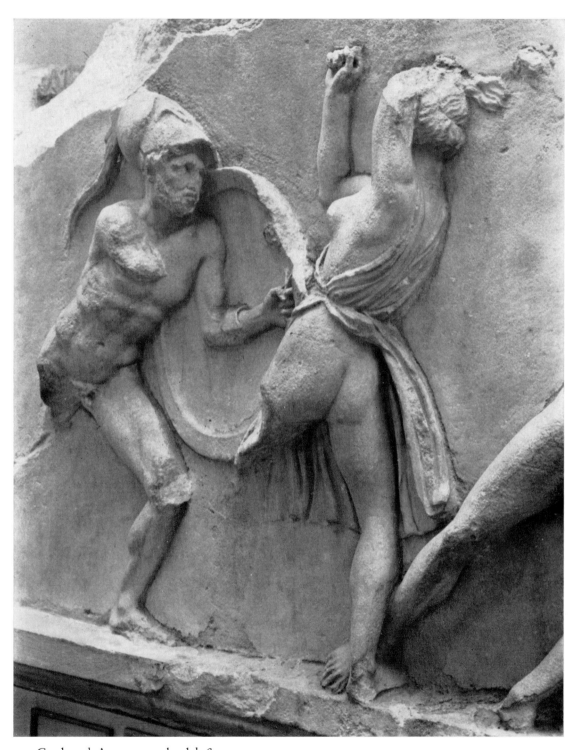

212. Greek and Amazon on the slab fig. 207

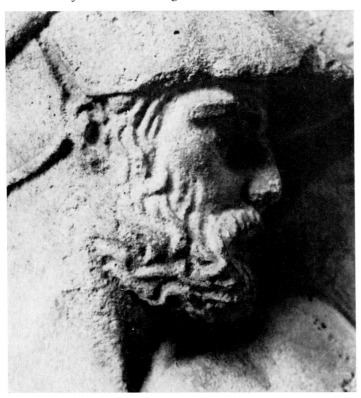

213. Head of a Greek on the slab fig. 207

body and drapery: every line of the drapery elucidates the forms of the body. Any-one who has ridden a horse bare-back, even the right way round, will appreciate the movement of the far leg, the contour lines of which have been a little coarsened by weathering, as indeed has all the drapery; and it is a tragedy that the upper part of the face has gone, because what is left is of exquisite delicacy.

How far is this new? How far traditional? It seems to be in the direct line of descent from the parapet of Athena Nike at Athens (Fig. 215), in which the drapery is used in much the same way to enhance and explain the forms of the body: and it is a living line of descent, the sculptor of the fourth century giving a little more personality to his figures, making them more like individuals.

The horse's head is a careful and sensitive study. The bit pulls back the lower jaw and the animal leaps up and starts away, narrowly missing a Greek, already heavily engaged with an Amazon on foot, who is trying to tear away his shield with her left hand in order to kill him with a blow from her great axe. The position of the axe-head shows that its shaft would be over three feet long, and an iron axe-head of that shape would weigh five pounds or more. Yet what are the emotions of the woman wielding this fearful weapon, with the intention, it is clear, of getting the

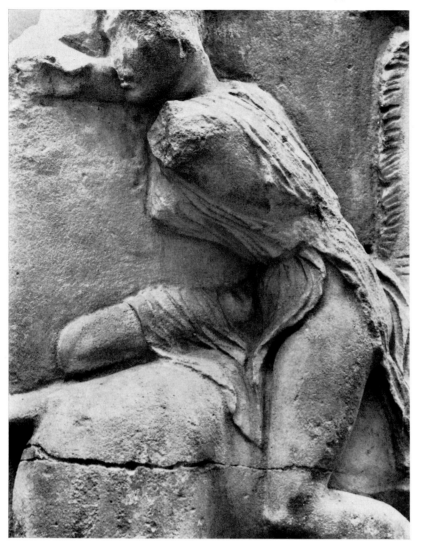

214. Amazon from the slab fig. 208

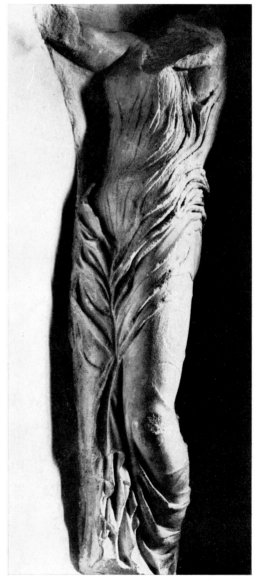

215. Victory erecting a trophy,
from the parapet of the temple of
Athena Nike, Athens, about 415 B.C.
Athens, Acropolis Museum

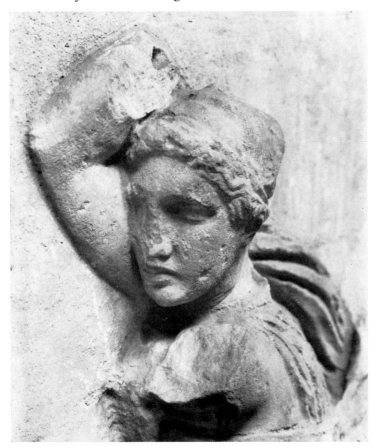

216. Head of Amazon, from the slab fig. 208

maximum results? Slightly sad, and, it would hardly be an exaggeration to say, almost tender (Fig. 216).

At this point our new fragment joins (Fig. 211). It seems to be the end of a composition, coming neatly at the end of a slab, with no overlap on to any slab on its right: and it could conceivably be the end of one side of the whole building, although there is no return angle to the block. The subject is a Greek who seizes an Amazon by the top of her pointed helmet, at the same time planting his foot on her middle in order to get leverage to tear the helmet off. A curious technical point: the right knee of the Amazon is flat, and flush with the lower moulding: it has not been broken off: it has simply never existed. It may have been eked out with stucco, but since this would have made it project over the moulding, which none of the other reliefs do, it was perhaps represented in paint. It looks like a sheer miscalculation on the sculptor's part, as if he had proceeded too far with his carving before he realized that he had not allowed enough marble to give the thigh its proper length.

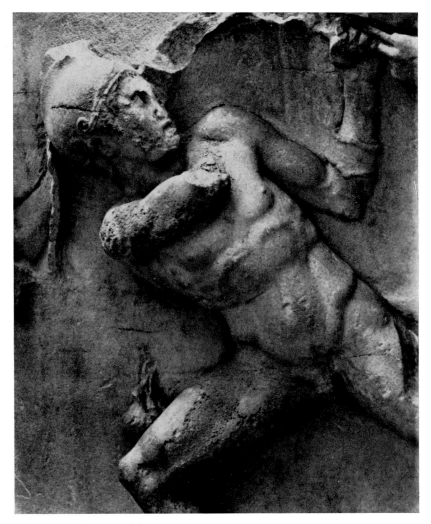

217. Greek from the slab fig. 208

Then the action. The Amazon's leg is extended to our right: the Greek is bal-
anced on his right leg and brings the left over in front of it. This particular composi-
tion, of an elegance that again suggests the dancing-school, appears to be without
parallel in Greek sculpture. True, on another slab of the frieze another Greek is also
kicking an Amazon in the stomach, but he does it in a more workmanlike way,
without the artistic touch.

I should like to finish by drawing a few general conclusions from these lectures,
but that is impossible in words, because the differences of aim and of achievement
between one period and another can be detected by the eye and grasped by the mind,
but they cannot be adequately described. Where the subjects are similar, however,
visual comparison does help to point these differences.

On the frieze of the Mausoleum a sculptor has his Greek twisting freely in space
(Fig. 217). At Olympia, in the metope of the bull (Fig. 88), there is evidently an

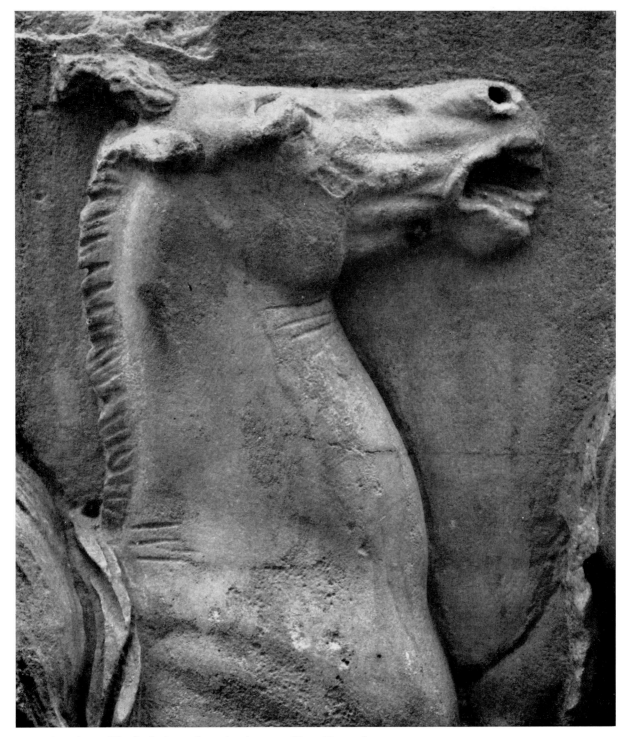

218. Mausoleum: Head of a horse from the Amazon frieze (fig. 208)

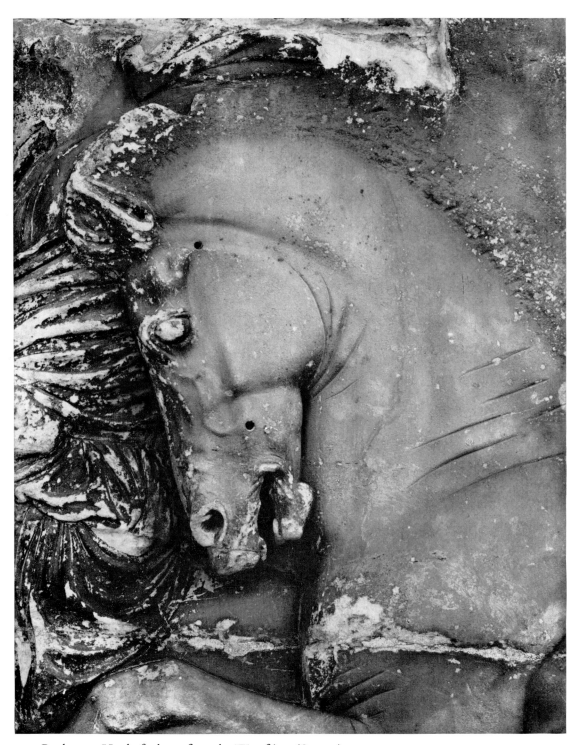

219. Parthenon: Head of a horse from the West frieze (fig. 135)

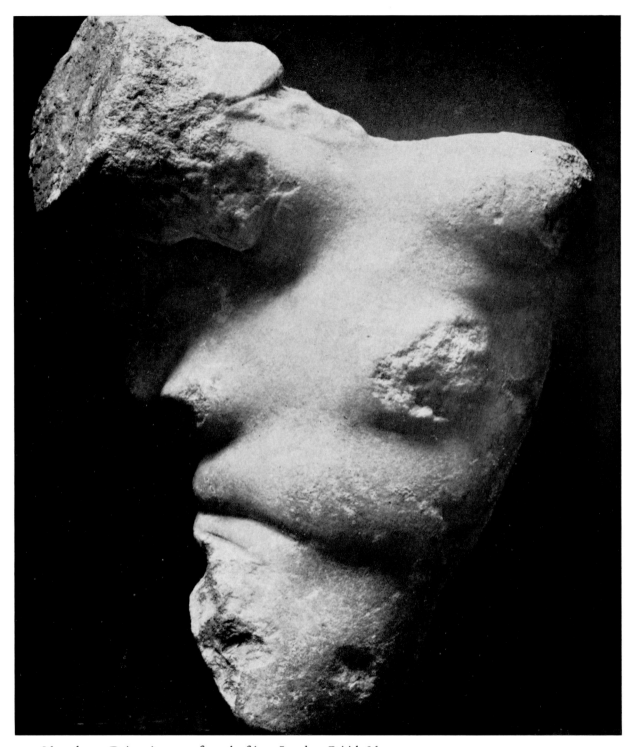

220. Mausoleum: Dying Amazon, from the frieze. London, British Museum

attempt at a similar effect, but the result is still a strongly frontal view of the torso of Heracles. In the metope of the Parthenon (Fig. 114), the effect of space is achieved largely by the sheer depth of the carving, and by the cloak suspended in the background with the centaur's body intervening. There is no obvious effort to suggest any twist into the third dimension, and the man's body is almost a statue in the round, modelled with that apparently effortless generalization which marks the high classical.

In the Mausoleum the sculptor has attempted to add something more: the whole action is highly dramatic – in many of the slabs the actions are perhaps over-dramatized – and by his attention to the minor contours of the surface he has contrived to show that the body is breathing, pulsating; flesh rather than marble. These are individual people. There is also that deliberate contrast, of which we saw the beginnings at Olympia, but here carried much further, between the sinewy male torsos and limbs, and the softer more rounded forms of the Amazons, who still retain their femininity in spite of the life they lead.

There are contrasts even more subtle: in the torso of a dying Amazon, less than a foot high and broken from a lost slab of the Amazonomachy (Fig. 220), we have not only perhaps the finest female nude that has survived from classical antiquity, but also the unique study not of a body pulsating with life, but of a body from which the life is ebbing, and the flesh sagging as the muscles lose control.

How far there is gain and how far loss in this can be assessed, even if imperfectly, by comparing the heads of two horses, the one from the frieze of the Mausoleum, and the other from the frieze of the Parthenon (Figs. 218–19): it is a fair criterion, because in ancient times, even more than now, the horse enjoyed immense prestige. In the Mausoleum you have a brilliant and sensitive study of an individual animal – a frightened pony: the sculptor can produce such a study because he has, by now, centuries of tradition behind him, and can draw well and carve well almost by instinct. Yet his work lacks what one can only call the sublimity of the other, and that – to quote what was once said of Michelangelo[90] – is the result of a generalization so profound as to reveal to us the very archetypes of form, such as we might conceive to dwell in the mind of a divine creator.

NOTES TO THE TEXT

NOTES TO THE TEXT

NOTES TO CHAPTER I

1. On Greek building methods in general much has been written, notably by A. K. Orlandos (his latest work, in French translation, is *Les matériaux de construction et la technique architecturale des anciens Grecs*, Pt. II, 1968), and there are many studies of the technical procedure in individual buildings: references to these, and much valuable new material on the subject, will be found in R. Martin, *Manuel d'architecture grecque* I (1965), which had not appeared when I first wrote these lectures. Their aim is to make more vivid the practical problems that arose from day to day when a building with sculptural decoration was being planned and constructed; and here I am especially indebted to Dr Alison Burford's articles: *Heavy transport in classical antiquity* (Economic History Review 13 (1960), pp. 1–18); *The builders of the Parthenon* (*Greece and Rome*, Suppt. to Vol. 10 (1963), pp. 23–35); *The economics of Greek temple building* (*Proc. Cambridge Philol. Soc.* 191 (1965), p. 21); and *Notes on the Epidaurian building-inscriptions* (*B.S.A.* 61 (1966), pp. 254–334); also to R. S. Stanier's *Cost of the Parthenon* in *J.H.S.* 73 (1953), pp. 68–76.

I am also most grateful to P. von Blanckenhagen, D. von Bothmer, B. Cook, P. Corbett, Evelyn Harrison, C. Hugh Smyth, C. Kraay, A. H. S. Megaw, Mary Moore, C. M. Robertson, D. Strong, Homer and Dorothy Thompson, for help in various ways.

Two others have made the book far more attractive than it otherwise would have been: Miss Alison Frantz, who generously allowed me to use a whole series of her splendid photographs, and Dr I. Grafe, who gave much patient advice, and devoted his skill to its production.

I dedicate it to my wife, who, after helping with the lectures, enjoyed with me the hospitality of Mr and Mrs Charles Wrightsman and the companionship of many colleagues whilst they were being delivered in New York.

2. L. Dyer, *The Olympian council-house and council (Harvard Studies in Classical Philology* 19 (1908)).

3. Dinsmoor, *Eph. Arch.* 1937, pp. 507–11. G. Downey *B.C.H.* 91 (1967), pp. 51–86. For relative values of ancient and modern money see Noble, *Technique of painted Attic pottery* (1965), p. xiv.

4. On the earliest precinct see B. Bergquist, *The archaic Greek temenos* (1967), pp. 39–41, plates 21–2. The so-called Heraion is mentioned by Pausanias, and it is he who tells us of the wooden column, the helmeted Zeus and the primitive style of the two statues (V, 16, 17). The temple is in all the text-books (e.g. D. S. Robertson, *Handbook*, p. 63) because of the evidence it provides for the wooden origin of the Doric order. A noteworthy discovery of recent years is that both the stadium and the chariot race-course were close to the new temple: evidently the Games were closely connected with the cult. Later, in the fourth century B.C., the stadium was moved further to the north-east, and, like the race-course, was cut off from the sanctuary by the building of the so-called Echo Colonnade. (See esp. Kunze, *V. Bericht über die Ausgrabungen in Olympia*, p. 12, plate 5).

5. Pliny, *Nat. Hist.* XXXVI, 21 (95).

6. Berve-Gruben, *Greek Temples* (1963), p. 413.

7. This is not quite conclusive: it might be argued that a Doric portico consisting of two columns between antae would normally be surmounted by six metopes.

8. E. Langlotz, *Die Kunst der Westgriechen* (1963), p. 41, plates 100–8.

9. L. Casson, *The ancient mariners* (1959), p. 79. On the size and capacity of ancient merchant-

ships see p. 126. On the quarrying and transport of marble, see R. Martin, *Manuel d'architecture*, I, ch. II *passim*. In Hellenistic times there were special ships for carrying marble (Martin, *Manuel*, p. 165), and earlier there must have been special arrangements for dealing with exceptional loads. For instance, neither the colossus of the Naxians nor its base (Richter, *Kouroi*, p. 51, no. 15) could have been carried to Delos on an ordinary ship. Possibly a raft was used, and buoyancy provided by inflated skins.

10. L. Goldscheider, *Michelangelo* (4th ed.), p. 19, plates 219–20.

11. There were other devices besides these, for which see R. Martin, *Manuel*, I, pp. 201 ff. One regarded as essential today, the 'block-and-tackle' embodying the principle of gears, seems to have been invented by the fifth century B.C.

12. P. F. de la Coste-Messelière, *Au musée de Delphes* (1936), pp. 246, 249.

13. Ward Perkins, *JRS* 46 (1956), p. 14.

14. A well-known later example is the block eventually used by Michelangelo for his statue of David: this had been abandoned forty years earlier, perhaps because of a flaw: M. Weinberger, *Michelangelo* (1967), pp. 77–92.

15. Strabo VIII, 378.

16. For the excavation of the diolkos see N. Verdelis, *Athenische Mitteilungen* 71 (1956), pp. 51–9; *Eph. Arch.* 1956 (1959), *Chron.* 2; *Illustrated London News*, 19 Oct. 1957, pp. 649 ff.: earlier discussion by J. G. O'Neill, *Ancient Corinth*,

Pt. I (1930), p. 10; E. Curtius, *Peloponnesos* II (1851–2), p. 546.

17. J. Platthy, *Sources on the earliest Greek libraries* (Amsterdam, 1968).

18. Euripides, *Heracles* 181.

19. Modern attempts to reproduce ancient colour-effects, however unsuccessful in other ways, do demonstrate how the coloured background in a relief clarifies both the outlines of the figures and their actions, as may be seen in the version of the frieze of the Parthenon, carved in Bath stone for the outside of the Athenaeum Club in London in 1829, with the background coloured blue. At Toronto there is an heroic attempt at restoring some metopes and parts of the frieze in full and painfully realistic colours. On the whole problem see P. Reuters-wärd, *Studien zur Polychromie der Plastik: Griechenland und Rom* (1960).

20. In the pediments of Aegina, however, there are tentative efforts to show the effects of pain in the face. The best known is the southernmost figure of the east pediment (Lullies-Hirmer, *Greek Sculpture* plates 84–5; notes, pp. 67–8), where the set teeth and the line from the nostril seem to impose a more closely-observed feature on an otherwise conventional archaic head; and in the southernmost figure of the west pediment the mouth, open to express pain, preserves the traces of an archaic smile *id.*, plates 74–5. The dying man from the north corner of the west pediment (Richter, *Archaic Greek Art* (1949), fig. 251) is quite another matter – a direct study by a masterly sculptor under circumstances at which we can only guess.

NOTES TO CHAPTER II

21. Pausanias V, 14. 6. Frazer, *Pausanias* III, p. 561.

22. Pausanias VIII, 14. 10.

23. What was believed to be his tomb, a tumulus surrounded by a wall, still existed, west of the Cladeos, in the time of Pausanias (VI, 21. 3).

24. Pausanias (VI, 21. 6) saw the tomb of the mares of Marmax, first of the suitors. Oenomaus is said to have killed them too, μεταδοῦναι μέντοι καὶ ταύταις ταφῆναι.

25. Pausanias V, 20. 8.

26. Pausanias V, 10. 6. For the various arrangements of the pedimental figures proposed by different scholars see G. Becatti, *Il maestro di Olimpia* (1943). Those shown in figs. 27 and 28 are of small plaster reproductions which are not to be trusted for details. Later discussion: E. Simon in *Ath. Mitt.* 83 (1968), pp. 147–66; M.-L. Säflund, *Studies in Mediterranean Archaeology*, vol. XXVII (1970); Becatti, *Studi Miscellanei* 18 (1971).

27. The most obvious is the east pediment of the treasury of the Siphnians at Delphi, a building noted otherwise for the excellent, though variable, quality of its sculptures. It is only fair to add that this pediment could conceivably have been put up at the last moment when Siphnos had been defeated by the Samians (Herodotus III, 57–8), and, the other craftsmen having gone home to see what had happened to their families, some unfortunate assistant may have been left to finish as best he could. The whole building, however, shows signs of haste (de la Coste-Messelière, *Au musée de Delphes*, p. 251).

28. The photographs which Miss Alison Frantz has kindly allowed me to use were made in 1964 and 1965 for our book with N. Yalouris (*Olympia, The sculptures of the temple of Zeus*). The old museum at Olympia has a gently dominant toplight from clerestory windows, and by waiting throughout the day Miss Frantz found that, as the sun moved round, almost every piece of sculpture in the pediments sooner or later came into a good light with the maximum of detail, in other words with everything that the sculptor had carved. Fortunately the system now fashionable in museums of excluding or ignoring daylight and using spot-lights, which obliterate or falsify much of the finer modelling, had not then reached Olympia.

29. Somewhat similar renderings over the hip of Alpheios (A) and over the ankles of the seer (N) in the east pediment (Ashmole, Yalouris and Frantz, *Olympia*, plates 3, 39).

30. Herodotus IX, 33 ff.

31. There are, however, versions of the myth that distinguish two battles with the centaurs, one at the wedding and the second when the centaurs returned to the attack later: the burying of Caineus would have taken place during the second.

32. E.g. F. Dornseiff, *Greifswalder Beiträge,* 1936 and 1938, *Beiheft* I.

33. If the statue was roughed out in the quarry, there is also the question at what moment the block, quarried horizontally, was set in its vertical position: only after this could the sculptor work all round it and complete the whole design.

34. Pausanias V, 20. 10.

35. E. Lapalus, *Le fronton sculpté en Grèce* (1947), pp. 142 ff. J. White, *Perspective in ancient drawing and painting* (1956), pp. 11–23. G. M. A. Richter, *Perspective in Greek and Roman Art* (1970), p. 16.

36. Treu (*Jahrbuch* 10 (1895), p. 13) thought that the pediments were modelled as sketches in relief rather than in the round, thus accounting for defects in the composition of some of the groups.

37. On the significance of the fall of the drapery see B. Shefton, *Hesperia* 31 (1962), pp. 356–60; on the relationship of the sculpture to a great wall-painting, J. Barron, *J.H.S.* 92 (1972), pp. 20ff.

NOTES TO CHAPTER III

38. F. Brommer, *Herakles* (1953), p. 53.

39. Cf. H. Lloyd-Jones, *Heracles at Eleusis* in *Maia*, N.S. Fasc. III, Anno XIX (1967), pp. 206 ff. and esp. p. 212.

40. *Annuario della Scuola Archeologica di Atene* 30–32 (N.S. XIV–XVI), 1952–4, pp. 117 ff.: a thoughtful study, calculated to deepen understanding and appreciation of both pediments and metopes, even if not all the conclusions are accepted.

41. See Yalouris in Ashmole, Yalouris and Frantz, *Olympia*, pp. 171 ff.

42. Pausanias VIII, 22. 4–6.

43. A later example is the vase in Gotha (A. B. Cook, *Zeus* III, plate 63) where Perseus presents Athena with the Gorgon's head, the danger of which explains the unusual composition.

44. Cf. A. B. Cook, *Zeus*, III, p. 224. 'The goddess was named *Athene* like the rock, because at the outset she *was* the rock, a mountain-mother of the usual Anatolian sort.'

45. The statue of Athena in Frankfurt (*Antike Denkmäler* III, p. 8, plate 9; Richter, *Sculpture and Sculptors*, p. 209) and that of Marsyas in the Lateran (Helbig, *Führer*⁴ I, p. 764, no. 1065) are generally accepted as copies of this group, but the Marsyas is not accepted by Rhys Carpenter (*Memoirs Am. Acad. in Rome* 18, pp. 5–18).

46. Furtwängler's hypothesis, that the combination of the head in Bologna and the body in Dresden reproduces the Lemnia of Pheidias, remains extremely probable. They are, however, copies only; how far the original was superior we can only guess; but superior it must have been (Richter, *Sculpture and Sculptors*, pp. 227–8).

47. By this I mean simply that if the master-sculptors had been Corinthian one would expect to see in use at least one helmet of the type perfected in Corinth (Snodgrass, *Arms and Armour*, p. 51). The argument is negative, and the use of the 'Attic' helmet here does not prove, although it does not preclude, that the sculptors were Attic.

NOTES TO CHAPTER IV

48. For instance by P. Corbett, *The sculpture of the Parthenon* (1959); and by C. M. Robertson in *Parthenos and Parthenon*, Supplement to vol. 10 of *Greece and Rome* (1963), with a good critical bibliography.

49. For an excellent brief discussion see R. Meiggs, *The political implications of the Parthenon*, Suppt. to *Greece and Rome*, vol. 10 (1963). An entirely new aspect of this problem has now been opened up by Rhys Carpenter in *The Architects of the Parthenon* (Pelican Books 1970). He advances with clarity and force a theory that the Parthenon as we see it today is 'a rebuilding, on enlarged scale, of an already partially completed temple by a different architect . . . the later building incorporating the earlier one by re-using much of its material.' He believes that under the auspices of Cimon, employing Callicrates as architect, the outer colonnade had already been completed, and even some of the metopes now on the Parthenon had been carved for this earlier temple; but that in 448, when Pericles assumed power after Cimon's death in 450, a new and more ambitious plan was conceived. Iktinos was appointed as architect to replace Callicrates and he dismantled and used in different positions the columns of the Cimonian temple. Carpenter's theories are summarized on page 67 of his book.

50. Plutarch, *Pericles* XII.

51. W. B. Dinsmoor, *A.J.A.* 17 (1913), pp. 53–80, and 25 (1921), pp. 233–47.

52. Small is a relative term: it was larger than the temple of Zeus at Olympia but not so large as the Ionic temples of Samos and Ephesus or some of the Doric temples of Sicily. In Athens itself, the vast Peisistratid temple of Zeus Olympios, which might be regarded as a rival of the Samian and Ephesian temples, is believed by Dinsmoor to have been started as a Doric building *(Architect. of Anc. Greece* (1950), p. 91); it ended six hundred years later as Corinthian.

53. R. Martin, *Manuel* I, p. 190.

54. On quarrying in general and the mechanical devices available see R. Martin, *Manuel* I, ch. 2.

55. The monumental publications by F. Brommer, *Die Skulpturen der Parthenon-Giebel* (1963) and *Die Metopen des Parthenon* (1967), contain a vast quantity of information on every aspect of the sculptures.

56. For the structure of the Parthenos see G. P. Stevens, *Hesperia* 24 (1955), pp. 240-76; for its subsequent history W. B. Dinsmoor, *A.J.A.* 38 (1934), pp. 93-106.

57. Lucian, *Zeus Tragodos* 8.

58. See Mallwitz and Schiering, *Olympische For-schungen* 5 (1964).

59. Plutarch, *Pericles* XXXI: cf. Thucydides II, 13. Albizzati, *J.H.S.* 36 (1916), p. 399 calculated the thickness of the gold as one millimetre, Dinsmoor (*A.J.A.* 38 (1934), pp. 93-106) as three-quarters of a millimetre, and suggested that after the plates were stolen by Lachares gold-leaf was later substituted.

60. *Arch. Anz.* 1933, pp. 401-5.

61. The relationship with Myron's Athena and with the lost original of the Demeter of Cherchel was remarked long ago by B. Schweitzer, *Meister am Parthenon* in *Festgabe zur Winckelmannfeier*, Leipzig, Dec. 1936.

62. See Corbett, *Sculpture of the Parthenon*, p. 30.

63. *Athenische Mitteilungen* 69, p. 58: *Skulpturen der Parthenon-Giebel*, plates 7, 79, pp. 56, 144, 162, 164. In several of the eighteenth- and nineteenth-century drawings an object can be seen in the north corner of the west pediment, *id.* plates 65-7, 69-71, 73: *Arch. Anz.* 1967, pp. 363 f. It does not look like a piece of sculpture, but it might well be a block of stone or marble. There is a fragment of stone in the hollow here, first noticed by Penrose, *Principles*[2] p. 46, n. 2.

64. If this bollard were high enough to abut on the ceiling of the pediment it would be capable of withstanding immense strains. Cf. Vitruvius X, ch. 2.

65. *Hesperia* 19 (1950), pp. 31-141.

66. Evelyn Harrison's thorough study of the east pediment in *A.J.A.* 71 (1967), pp. 27-58, shows that the relative scale of each figure is determined by its status. This curiously primitive concept (tolerable in the simple contrast between god and man on votive reliefs) is here disguised, and just saved from absurdity, partly by the designer's skilful manipulation, partly because the remains are so fragmentary.

NOTES TO CHAPTER V

67. See, however, R. Stillwell, *Hesperia* 38 (1969), pp. 231-41, an important study of these problems.

68. De la Coste-Messelière, *Au musée de Delphes*, Pt. II, pp. 237 ff.; Lullies-Hirmer, *Greek Sculpture*, plates 44-51, p. 43f.

69. See G. P. Stevens, *Hesperia*, Suppt. III (1940).

70. Not quite central; and this weakens the argument.

71. Richter, *Cat. of Greek Sculptures* (1954), p. 49, no. 73.

72. *Hesperia* 21 (1952), pp. 60 ff.

73. *Journal of Warburg and Courtauld Institutes* 24 (1961), pp. 1 ff.

74. *Eph. Arch.* 1960 (1963), pp. 185-202; *id.* 1961 (1964), pp. 61-158.

75. *Charisterion* (*A. K. Orlandos*) 2 (1964), pp. 22-4.

76. R. Holloway, *Art Bulletin* 48 (1966), p. 223; Chr. Kardara, *Eph. Arch.* 1961 2 (1964), pp. 61-158.

77. On the whole question see *Narration in Ancient Art: A symposium*, *A.J.A.* 61 (1957), pp. 43-91.

78. James, *Naval History* (1902), III, p. 473.

NOTES TO CHAPTER VI

79. *Nike Temple Parapet* (1929), pp. 57–63.

80. S. Adam, *Technique* (1966), pp. 92–4.

81. Vitruvius II, 8. 11.

82. *Nat. Hist.* XXXVI, 30. Two recent important studies of the Mausoleum are the article on Pytheos, its architect, by H. Riemann in Pauly-Wissowa *R.E.* 24 (1963), pp. 372–45; and K. Jeppesen's *Paradeigmata* (1958), *Jutland Archaeol. Soc. Publications* 4, pp. 1–67. In 1966–7 Jeppesen led a Danish expedition to Bodrum, the preliminary report of which appeared as *Explorations at Halicarnassus: Excavations at the site of the Mausoleum* (Copenhagen, 1968) = *Acta Archaeologica* 38.

83. *Beast Book for the pocket* (1949), pp. 256–7.

84. Vitruvius II, 8. 14, 15.

85. See K. Jeppesen, *Paradeigmata*, pp. 21–8.

86. It was Jeppesen (*l.c.* note 85) who showed that the Amazon frieze was used in conjunction with the plain marble slabs two feet high, probably as the facing of the substructure; but there is some doubt whether this substructure was a large platform in the centre of which the tomb was placed, or the high podium of the tomb itself. Jeppesen's first restoration shows a substructure about forty feet high faced with about twelve hundred of the two-foot slabs and crowned at its top edge with a band, between four and five hundred feet long, of the Amazon frieze. On this platform, amid a menagerie of some fifty lions, stands the tomb itself, of the so-called 'small' plan i.e. with the thirty-six columns in two rows, on a high podium, round the upper edge of which is the chariot frieze. The number of steps in the pyramid above, twenty-four according to Pliny, is reduced to eleven. After his excavations at Bodrum Jeppesen changed to the 'large' plan, in which the columns are arranged in a single row and the vast substructure becomes the podium of the tomb itself. For references see note 82 and for the whole problem Riemann's article on Pytheos cited there.

87. For instance, slab 1008 shares the figure at its left end with 1007.

88. Since delivering this lecture I have discovered that the right edge of this slab joins the left of 1010 and produces an exceptionally large slab with the two heroes Heracles and Theseus in battle with two leading Amazons. It is therefore presumably the centrepiece of one side of the building (*J.H.S.* 89 (1969), pp. 22 f.).

89. *Acta Archaeologica* 35, pp. 195–203.

90. So C. T. Newton *Discoveries at Halicarnassus &c.,* II, p. 254, paraphrasing Vasari.

LIST OF ILLUSTRATIONS

The Temple of Zeus at Olympia: The Pediments

The Temple of Zeus at Olympia: The Metopes

The Parthenon: The Metopes and Pediments

The Parthenon: The Frieze

The Tomb of Mausolus

INDEX